# Watercolour Landscapes for the Absolute Beginner

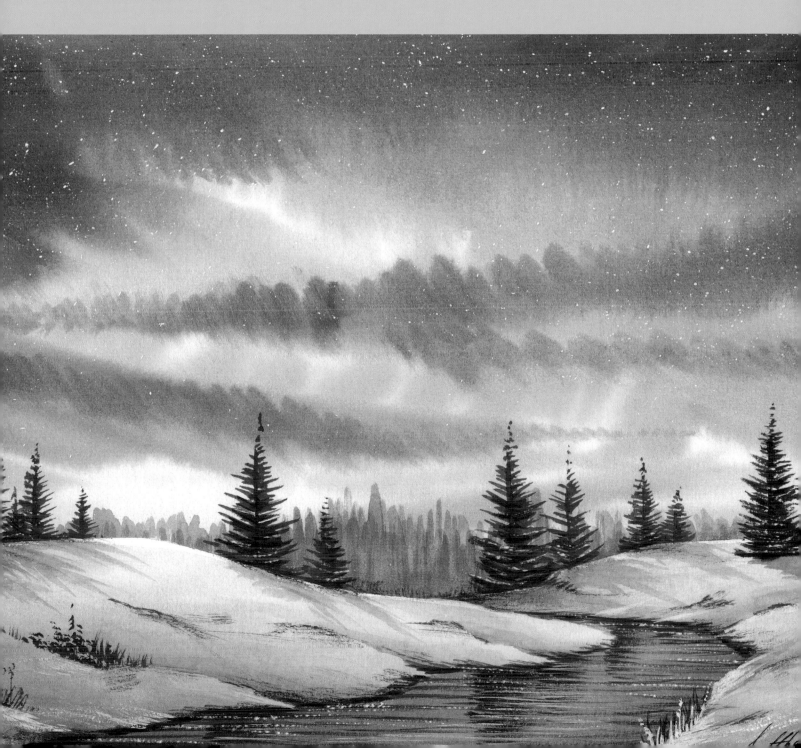

# Dedication

This book is dedicated to my wife Sarah
and sons Jacob and Theo.
Your endless support is amazing.
I love you all so very much x

# Watercolour Landscapes for the
# Absolute Beginner

**MATTHEW PALMER**

Search Press

This edition published in 2022
Search Press Limited
Wellwood, North Farm Road,
Tunbridge Wells, Kent TN2 3DR

Includes material originally published in 2018 as:
*Matthew Palmer's Step-by-Step Guide to Watercolour Painting*

Illustrations and text copyright © Matthew Palmer, 2022

Photographs on pages 8, 9, 10–11, 14, 26, 30, 31, 36, 38 (bottom), 42, 54 (top), 74–80, 85 (top), 88–131 and 168 (middle) by Mark Davison at Search Press Studios. Photographs on pages 16, 17, 18, 20, 75 (middle and bottom), 78 (bottom), 79 (top) and 80 (bottom) by Matthew Palmer. All other photographs by Paul Bricknell at Search Press Studios.

Photographs and design copyright © Search Press Ltd. 2022

ISBN: 978-1-78221-910-1
ebook ISBN: 978-1-78126-911-4

The Publishers and author can accept no responsibility for any consequences arising from the information, advice or instructions given in this publication.

### Suppliers

If you have difficulty in obtaining any of the materials and equipment mentioned in this book, please visit Matthew's website: www.watercolour.tv

Alternatively, visit the Search Press website: www.searchpress.com

You are invited to visit the author's website for watercolour workshops and video tutorials with Matthew Palmer: www.watercolour.tv

### Publishers' note

All the step-by-step photographs in this book feature the author, Matthew Palmer, demonstrating how to paint in watercolour. No models have been used.

Extra copies of the outlines in the middle of the book are available to download from www.bookmarkedhub.com

## Acknowledgements

Thanks to all at Search Press for your continued support and hard work, especially Katie French, Edward Ralph and Lyndsey Dodd. Thank you also to Beth Harwood for all your work on the original version of this book and to Mark Davison and Paul Bricknell for the photography. Thanks to all at the SAA for everything you do. A special thank-you to my family for being there: my wonderful wife Sarah and sons Jacob and Theo.

*Page 1*

**The Northern Lights**

*38 x 28cm (15 x 11in) painted on 300gsm (140lb) Not surface watercolour paper.*

*Pages 2–3*

**Mundesley in Norfolk, UK**

*50.8 x 38cm (20 x 15in) painted on 300gsm (140lb) Not surface watercolour paper.*

*Page 4*

**Lake Windermere**

*50.8 x 38cm (20 x 15in) painted on 300gsm (140lb) Not surface watercolour paper.*

*Opposite*

**Beams in Sherwood Forest**

*50.8 x 38cm (20 x 15in) painted on 300gsm (140lb) Not surface watercolour paper.*

# Contents

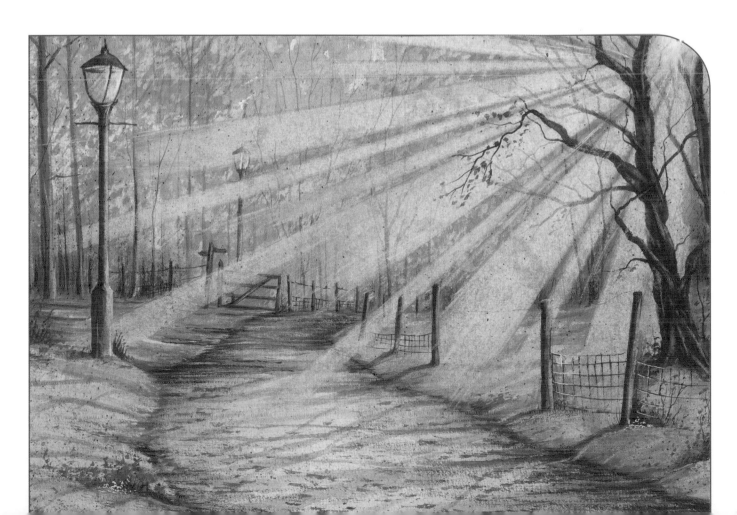

# Introduction

Landscapes are, without question, the most popular painting theme: from rolling hills to snow scenes, seascapes with beaches to stunning sunsets, the choice of scene is endless. Everywhere I go, I see landscape scenes I want to paint. I class seascapes as landscapes – they have shared elements and shared techniques. This book will guide you in step-by-step detail how to paint both land and seascapes.

When I started painting almost 30 years ago, I turned to landscapes and seascapes, as lots of artists do. My watercolour adventure started when I was very young. Of course I made mistakes, but I stuck with it and learned from them. Now one of my sayings is, 'There are no mistakes, only lessons'. In my early days as a self-taught artist, after a few years of struggling, I soon realized that if I persevered with a painting each time I thought it wasn't working, it would look totally different when finished. This is so true and that's why it is essential not to give up if you feel the scene isn't going to plan. I always encourage my students on workshops, painting holidays and lessons to stay calm and carry on. After a few years teaching myself how to use watercolours, I developed my own style which I still use to this day. It is a mixture of loose detail, but adding detail where it matters.

My journey into professional art started way back in 1997 when I taught local classes in the stunning Peak District, UK. From there my teaching increased more and more. I have been teaching watercolour for over 20 years – I teach both online and in-person workshops all around the world and take groups on painting holidays to stunning locations like the Lake District, UK. In 2007, I was approached by the Society for All Artists (SAA) to make TV shows and write for magazines.

This year I also launched the world's first art video-on-demand service: www.watercolour.tv – a membership-based 'how to paint' site, packed full of video lessons for artists of all levels.

The Absolute Beginner books are a best-selling series published by Search Press. I wrote the first ever title in the series – *Watercolour for the Absolute Beginner* – the content of which was based on a book I self-published in 1999. When writing this book and its predecessor, my aim was simple: write the book I wish I'd had when I was learning art, so here it is! It is everything you need to know about watercolour landscapes.

The challenge for beginners is often where to start. In this modern world we all have cameras in our pockets, so it's never been easier to capture reference material to take home and paint from. It's a great way for an absolute beginner to learn watercolour. When painting landscapes, there is a huge variety of techniques to learn. This book takes you through all the essentials you need to start your watercolour adventure. There are dozens of step-by-step tutorials covering all aspects of landscape painting. I take you through the materials you need, how to mix colours, simple drawings, composition, layout and six easy-to-follow step-by-step paintings with outlines included.

Just enjoy it and keep the paint flowing!

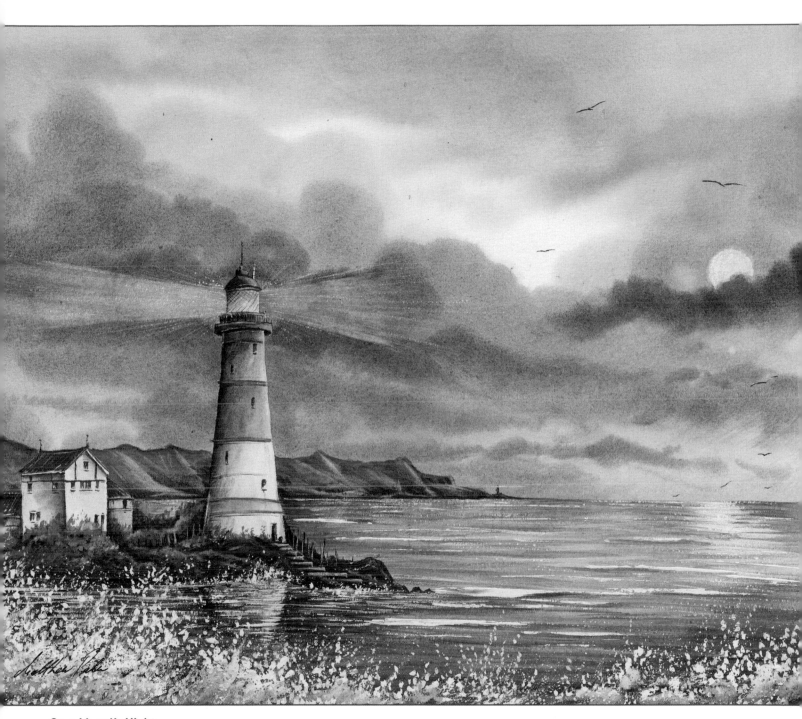

## On a Moonlit Night

*50.8 x 38cm (20 x 15in) painted on 300gsm (140lb) Not surface watercolour paper.*

*For me, landscapes and seascapes fall into the same category. They share elements such as the sky and the cliffs.*

# Materials

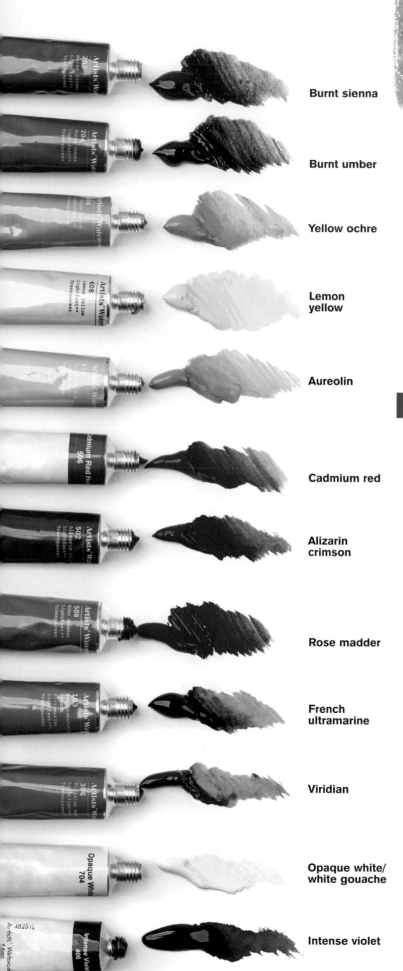

Burnt sienna

Burnt umber

Yellow ochre

Lemon yellow

Aureolin

Cadmium red

Alizarin crimson

Rose madder

French ultramarine

Viridian

Opaque white/ white gouache

Intense violet

There are countless materials available to watercolour artists, and it can be a challenge to know where to begin, and which products are best. The tendency for new artists is to dash out and purchase everything, which complicates matters even further. I have always taught beginners that all they need is a few primary colours and a handful of brushes. That's it! You don't even need to invest in an expensive palette: a ceramic plate will do. As for a water pot, how about simply using a jam jar? The best advice I can give you is, 'buy the best you can afford at the time', especially with paint, brushes and paper. You really do get what you pay for with these materials, as I've discovered with over thirty years' experience.

## ■ Traditional paints

Watercolour paints come in two forms: as pans (little square or rectangular blocks of hard paint) and tubes (soft watercolour in a tube). I would recommend tubes to any artist – I love the way in which you can use strong, heavy paints versus light, watery colours. All you do is simply squirt the paint from the tube into the palette, then lift out a little bit of the pigment with your brush and mix it with water. Pictured here on the left are common colours readily available on the market.

When the paint from a tube dries, simply add a squirt of water to bring the paint back to life again.

# A question of quality

Watercolour materials come in two qualities: artists' quality and students' quality. Artists' quality is the best quality, using the finest materials and produced to the highest standard. Students' quality is still high but is typically manufactured using synthetic materials. For example, artists' brushes are made from natural hair, while students' brushes are made with nylon bristles. In terms of paints, artists' colours comprise gum arabic and, where possible, natural pigment.

Having said all this, it does make a difference working with artists' quality materials, but there are some great-quality students' materials on the market as well. I'm a strong believer in using the best you can afford while learning, as it makes the process much easier.

# Matthew Palmer's Natural Collection

Over the years I have produced my own range of watercolours (pictured here on the right). These are artists' quality and are pre-mixed, allowing the common colours to be used straight from the palette, giving the perfect colour tone. Using pre-mixed paints prevents over-mixing and stops you from making too dark a mix. The use of a 'wrong colour' can often throw out your entire painting. I explore the use of colour, and the benefits of colour-mixing, in more depth on pages 36–45.

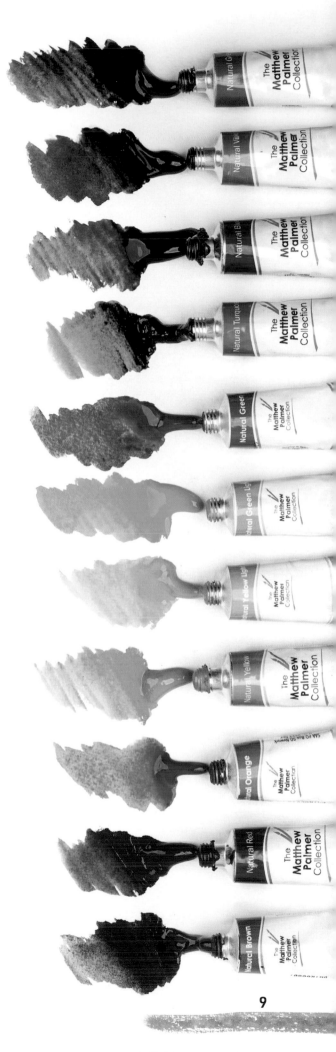

Natural grey

Natural violet

Natural blue

Natural turquoise

Natural green

Natural green light

Natural yellow light

Natural yellow

Natural orange

Natural red

Natural brown

# Brushes

There are hundreds of different brushes available to the artist, from square to round, flat to textured brushes, and knowing which are the best can be a challenge. Here are the brushes I recommend:

**Kolinsky sable** This is the highest quality brush, and therefore the most expensive. Kolinsky hair, gram for gram, is more expensive than gold. These brushes are 100% natural hollow hair, so they hold the most water. They are also known for their fine points, which allow you to achieve great detail from one brush. The downside is that they can be a little too soft.

**Pure or red sable** This is still 100% natural hair, just a slightly lower quality than Kolinsky. They have good watercolour-holding capacity and, again, a great pointed tip. The downside is they are not hardwearing, and you'll soon lose that fine tip.

**Synthetic** A robust, man-made hair, normally made of nylon, these brushes are designed to replicate the properties of sable hair. The individual hairs taper off to a fine point. I started out with these brushes, as did many of my students. The downside is that they don't hold much water, so you will need to dip them repeatedly into your water pot.

**Sable and synthetic mixture** This is my preferred brush, which I use all the time. I love the mix of the watercolour-holding capacity of the sable with the robustness of the synthetic hair. These brushes are reasonably priced and are great all-round, everyday brushes. The downside is that they don't hold as much water as a sable, but I've used these for many years and love the unique blended properties of these brushes.

**Lift-out brushes** These square, flat-tipped brushes are my own range, designed specially for removing paint and creating highlight effects. They are also great for washing out mistakes, such as accidental paint splashes. The super-fine tip is wonderful for adding a fine line of light. These are available in three sizes: small, large and extra-large.

**Tree & Texture brushes**

*These extra-large, large, medium and small brushes are specially designed to make painting leaves easier. They are also great for different textured effects, like markings on a stone wall. The brush is made from a natural hair mix, allowing the brush to open up (see the stippling technique on page 77). The angled tip gives artists a natural painting angle, as well as a longer side to the brush, letting you paint natural-looking grasses. These brushes are not essential, but are very useful.*

## Matthew Palmer's Tree & Texture brushes

These brushes are my own design: the bristles are made with natural hair. Tree & Texture brushes are designed to allow you to paint tree foliage and various textures easily. They have a slanted tip to allow you to paint at an angle and thus produce some wonderful effects. Tree & Texture brushes are available in four sizes, from small to extra-large, and the bristles of each brush produce a different stippled effect, perfect for portraying dense or sparse foliage.

The small brush is ideal for hedgerows; the medium for mid-sized trees and bushes; the large for mid-ground trees; and the extra-large for large, close-up or foreground trees and forests.

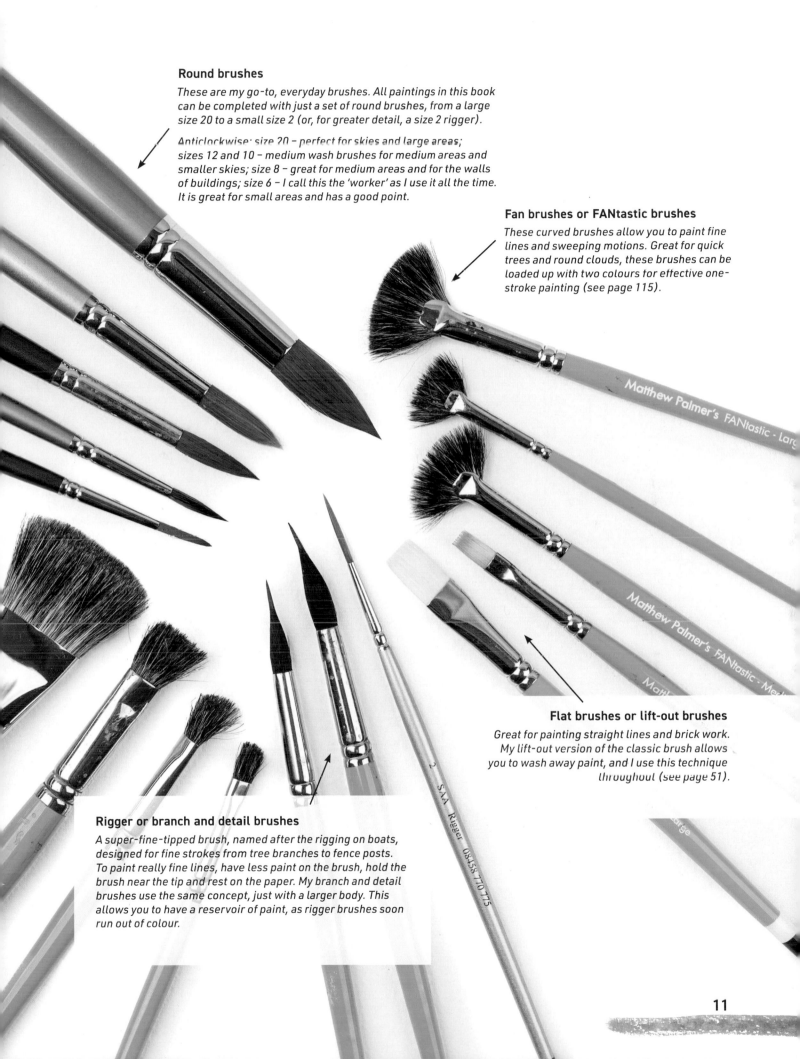

### Round brushes

*These are my go-to, everyday brushes. All paintings in this book can be completed with just a set of round brushes, from a large size 20 to a small size 2 (or, for greater detail, a size 2 rigger).*

*Anticlockwise: size 20 – perfect for skies and large areas; sizes 12 and 10 – medium wash brushes for medium areas and smaller skies; size 8 – great for medium areas and for the walls of buildings; size 6 – I call this the 'worker' as I use it all the time. It is great for small areas and has a good point.*

### Fan brushes or FANtastic brushes

*These curved brushes allow you to paint fine lines and sweeping motions. Great for quick trees and round clouds, these brushes can be loaded up with two colours for effective one-stroke painting (see page 115).*

### Flat brushes or lift-out brushes

*Great for painting straight lines and brick work. My lift-out version of the classic brush allows you to wash away paint, and I use this technique throughout (see page 51).*

### Rigger or branch and detail brushes

*A super-fine-tipped brush, named after the rigging on boats, designed for fine strokes from tree branches to fence posts. To paint really fine lines, have less paint on the brush, hold the brush near the tip and rest on the paper. My branch and detail brushes use the same concept, just with a larger body. This allows you to have a reservoir of paint, as rigger brushes soon run out of colour.*

# Watercolour paper

Watercolour paper is specifically designed to hold the water and the paint you apply to it, and to stay wet or damp for as long as is possible, allowing you plenty of time in which to work. Wherever possible, purchase the best paper you can afford; look for 100% cotton papers – these are artists' quality papers and will make watercolour painting easier as cotton holds water much better than wood-based papers.

It is best to paint on good-quality watercolour paper even before you begin any final work – working on high-quality watercolour paper will help you learn how the paper performs, and how it reacts to water. You will also become familiar with the surface of the paper, which will allow you to apply wonderful and effective techniques such as dry-brush (see page 50).

## Which paper should I buy?

Paper comes in different weights, surfaces, quality and sizes:

**Weight** The higher the gsm (grams per square metre) or lb (pounds per ream) the better. I recommend 300gsm (140lb) papers.

**Size** Traditionally watercolour paper comes in 'imperial sizes': full imperial – 56 x 76cm (22 x 30in); half imperial – 56 x 38cm (22 x 15in), and quarter imperial – 28 x 38cm (11 x 15in). Quarter imperial is the size I recommend and is the size most often used by artists.

**Quality** Both artists' and students' quality papers are available – the packaging of artists' papers state that they contain 100% cotton whereas students' papers are made from wood pulp.

**Surface** This term relates to the texture of the paper – usually Rough, HP (short for 'hot-pressed' and smooth in texture) and CP (short for 'cold-pressed' and also called Not). The watercolour papers I recommend are CP, which have a gently textured surface that makes the most of effects such as the dry-brush technique.

## Do I need to stretch paper?

Stretching watercolour paper is not necessary: I have not stretched a sheet of paper for many years! It is done to keep the paper flat. You submerge it in water, then attach it to a board with a water-based gum tape. This keeps the paper stretched flat as it dries. However, if you use good-quality, heavyweight cotton paper, you should not need to do this.

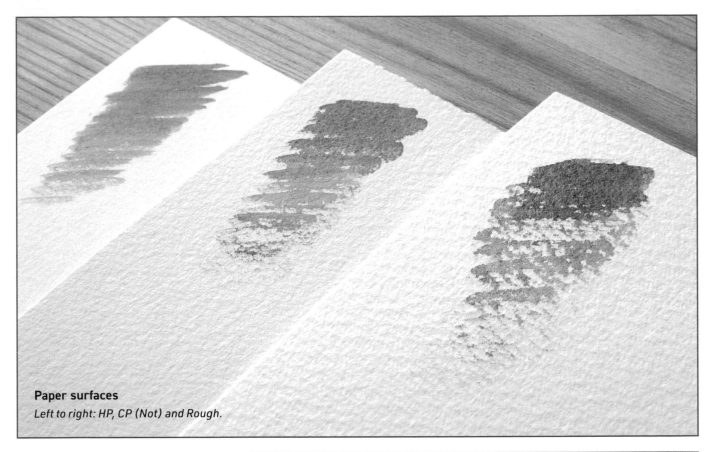

**Paper surfaces**
*Left to right: HP, CP (Not) and Rough.*

## Paper surfaces

**HP (hot-pressed)** A very smooth or very compressed watercolour paper, not ideal for general watercolour painting such as wet into wet (see page 68). HP is best used for sketching and high-detail work.

**CP (cold-pressed)** This surface is also known as Not (not rough and not smooth). This paper is semi-compressed and is perfect for general watercolour painting. I recommend this paper because it has just the right amount of texture for detail and textured work.

**Rough** This loosely compressed paper retains most of its texture for a rough, uneven surface. Rough is great for portraying texture; its downside is that it absorbs lots of paint and water, which can make it quite difficult to paint on.

### Sheets, blocks and boards

You can purchase watercolour paper in loose sheets or blocks: I use either. Loose sheets should be stuck to a board on all four sides with masking tape to keep the paper tight (as pictured here). Blocks, as pictured opposite, are already stuck to a board: once you have used the top sheet on the block, simply remove it using a blunt knife or ruler to reveal the next blank sheet underneath.

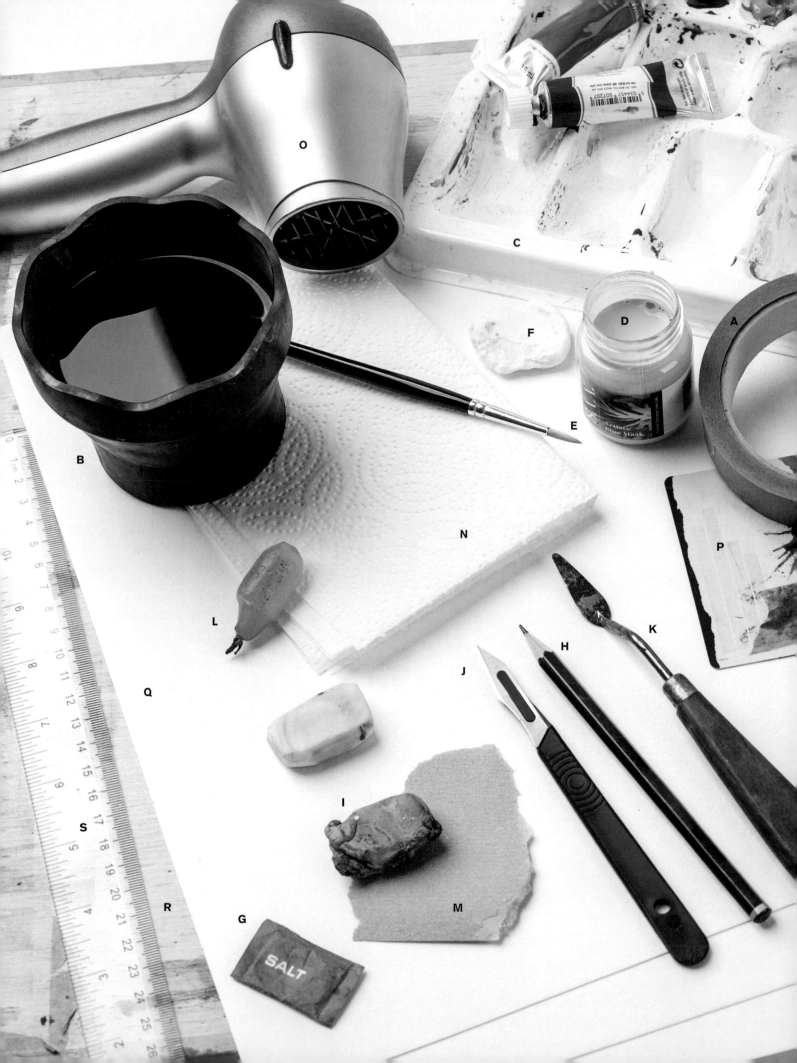

# Other materials

**Masking tape** (A) Used to attach your paper to a board on all four sides, and for various masking effects such as masking the horizon.

**Water pot** (B) Anything from a jam jar to a professional water pot is fine. It is a good idea to use two pots while painting: one for clean water and one for dirty.

**Mixing palette** (C) A good quality plastic or porcelain palette is best. Try to find one with small areas into which you can squeeze out your paints, allowing you to lift and mix the watercolour.

**Masking fluid** (D) A liquid latex solution that allows you to protect any areas of white; for instance, a person walking against a dark background.

**Masking fluid brush** (E) It is a good idea to use an old paintbrush to apply masking fluid, as the fluid can damage your brushes.

**Soap** (F) This acts as a barrier between the brush and the masking fluid: apply it to the brush before use and wash the masking fluid out immediately afterwards.

**Salt** (G) This works well with watercolour: it can be sprinkled on your wet paint to give a snowflake-style textured effect. Add only a few grains to wet paint and allow two to three minutes for the effect to take place. Brush the salt off when the paint is dry.

**Pencil** (H) I recommend an HB or 2B pencil for your watercolour sketch, as the leads are not too hard, so will not scar your paper and can easily be erased.

**Erasers** (I) We all make mistakes! These erasers are made from a soft, malleable rubber and you can shape them to a fine point if required. I also use a plastic eraser.

**Craft knife** (J) This is not only good for sharpening your pencil; it is also a great tool for creating special effects. You can scratch out areas of dry paint to give the effect of sparkle on the sea, or a distant silver birch tree.

**Palette knife** (K) This a useful tool for introducing fine branch details and scraping out distant tree trunks and branches.

**Wax candle** (L) Another special effect tool, great for giving a textured highlight like a waterfall and adding a few waves to the sea, or the wonderful texture of tree bark.

**Sandpaper** (M) Rub this gently over dry paint. Use a fine grain to give wonderful texture to a mountainside or a grassy meadow.

**Kitchen paper** (N) This is the artist's best friend! It is essential for dabbing excess paint from your brush and for lifting out colour from wet paint, for instance to create clouds.

**Hairdryer** (O) This is good for speeding up the drying process.

**Plastic card** (P) This is useful for scraping off the surface of paint to leave behind a textured effect.

**Watercolour paper** (Q) High-quality paper that will hold the water and paint you apply to it.

**Watercolour board** (R) Use something sturdy and light to tape your watercolur paper to.

**Ruler** (S) Perfect for drawing guidelines

**Waterproof and fade-proof pen** (not pictured) Great for pen and wash techniques. Also useful for signing your finished masterpiece.

# Inspiration

Before you paint, you start with one thing: inspiration. Every artist, from beginner to professional, needs inspiration. People often ask me where I get mine from. Well, it's a simple answer – all around me. Everywhere I look I see potential paintings, from the view out of the window to the sight of flowers growing against an old wall. Inspiration really is everywhere, and two great ways to capture this are through your camera – we all have one in our pockets – and through a few rough sketches.

## Painting from photographs

One of the most common sources of painting inspiration is a photograph that you, the artist, have taken. As someone who loves photography, I find this a great way to work. You may not have time to sit and paint a watercolour on location so a perfect solution is to take a photograph, or a series of photographs, and paint the scene once you are back at home or in your studio.

### Defining composition

Composition is simply the act of making a painting or scene look right, or pleasing. A dictionary may define composition as 'the way in which a whole or mixture is put together and arranged', and that is essentially what I mean here. In terms of painting watercolour landscapes, however, a good composition is simply what looks right to you.

### Composing with your camera

A camera is a useful tool in helping you plan the composition of your painting. Use the screen or the viewfinder as a framing tool and work to the 'rule of thirds' – that is, in a well-composed scene one third should be sky and two thirds land or water; or vice versa.

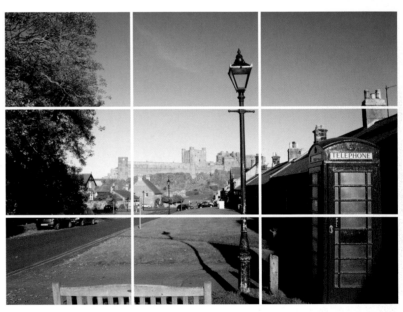

*The rule of thirds.*

The photograph above has been overlaid with a grid that shows the thirds: notice how I have set the horizon one third up the scene, which makes a visually pleasing composition.

On some cameras you may find an option to turn on a grid by pressing a display button. If your digital camera has this function, do use it – you will find it helpful for composing your scene. Some phone cameras may also have this function.

## Composition

*Composition = making a painting or scene look right, or pleasing.*

## Choosing your focal points

The diagram below shows the same rule of thirds grid as shown opposite, but highlights four focal points where the grid lines cross.

Add the main point of interest in your scene to one of these four focal points for a good, well-balanced composition. In this scene of Bamburgh Castle, Northumberland, UK, the main points of interest are the castle itself, the phone box and the lamp. Using the four focal points, position these main areas on one or more of the points. Multiple points can be used. See overleaf for how the final scene was composed.

## A question of ethics

I am often asked, 'can I paint from somebody else's photograph?'. It is always advisable to ask the photographer's permission first, even if the painting is for your own use and enjoyment – but the answer is yes.

If you are a professional artist looking to sell your work, however, the practice of painting from another artist's photography is widely deemed unacceptable.

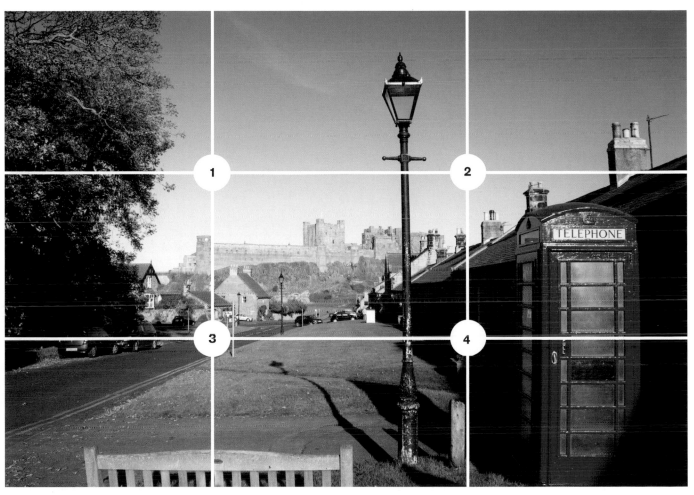

*Choosing your focal points.*

# From photograph to painting

Translating a photograph into a painting is a three-step process, which I explore in more depth later in this chapter.

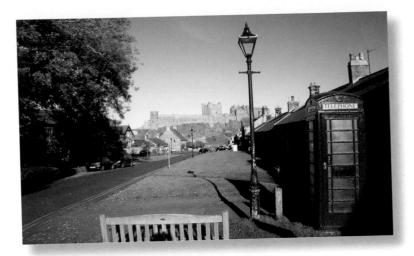

## Step 1  Taking the photograph

The great advantage of digital photography – whether you take photographs on a digital camera, a tablet device or a phone – is that there are few limits on the number of shots you can take. Take a variety of shots of your subject, and avoid discounting any photograph straightaway – quite often, you may be surprised by the photograph that makes an unexpectedly great painting.

## Step 2  Making rough sketches to develop the composition

The rough sketches below and opposite show how I've taken my original photograph (above) and, using artistic licence (see pages 20–21), moved, tweaked and altered the scene to make a more appealing composition. How do you know what makes a good, well-balanced composition? Some people just have an eye for what works, but using the rule of thirds and focal points can help make your painting pleasing to the eye.

Simply draw a rough shape to represent the paper format, in this case, landscape. The sketch can be as small or large as you need it to be. Loosely divide into thirds. The point where the six lines cross is the focal point. By placing the main item over one of the points, or more than one point you will make a great composition and a well-balanced scene that just works! The horizontal lines allow you to place the scene. Having either one third land, two thirds sky or vice versa makes a well balanced scene. These sketches are for your eyes only, so they can be as rough as you like.

Then, develop the composition: sketch the same scene a couple of times, but change a few details each time. A good rule of thumb at this stage is to identify the focal point, such as the main buildings where the rule of thirds grid lines cross. While sketching you are also at liberty to move or shrink objects, omit details, even change the mood of the sky. Make notes on your sketch to remind you of the reason why you have made these changes. This is artistic licence, a powerful tool we all have.

*Sketch 1*

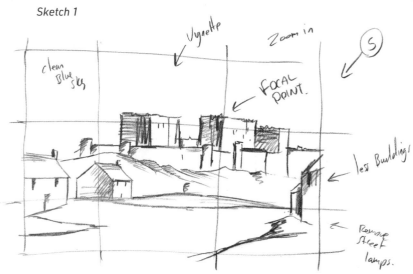

I think of this series of sketches as a film story board. From the photograph opposite, it's essential that we don't remove important objects like the castle. Sketch 1 shows a zoom-in, leaving out the phone box and most buildings, making the castle the star. Sketch 2 shows a zoom-out and details the phone box and more buildings. Notice how the castle towers sit on the focal points – you have artistic licence to make alterations to your scene. I've removed the tall trees, reduced the lamps, moved the phone box closer and put the base of the castle one third up the scene, placing the foreground in the bottom third, the castle in the mid-third and the sky in the top third.

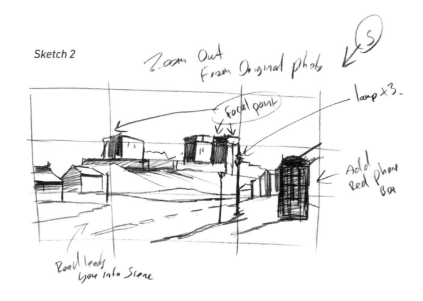

*Sketch 2*

## Step 3  Painting the scene

When you are happy that you have evolved to a final sketch, transfer the outline to a larger sheet of watercolour paper and paint away.

**Bamburgh Castle, Northumberland, UK.**

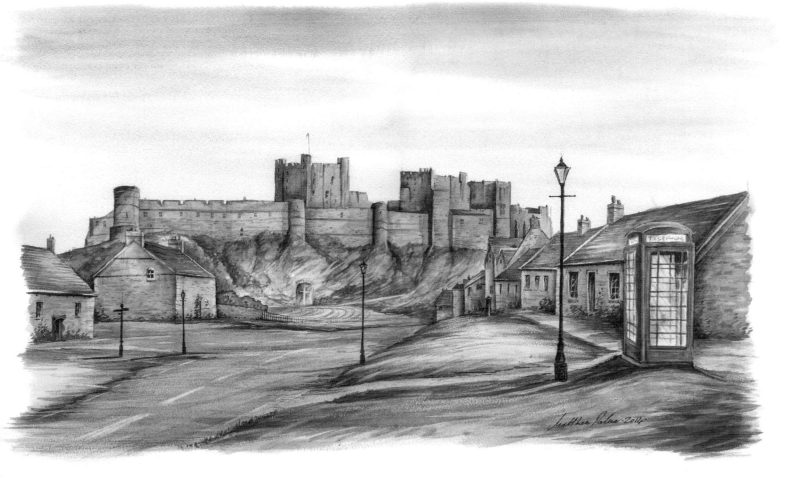

# Artistic licence: adapting the scene

Whenever you are planning a watercolour painting, it is a good idea to decide on a theme before you begin to paint – the theme might be a season such as winter, or weather, such as snow, which is one of my favourite subjects.

The photograph on the right, which inspired the scene on the opposite page and also the *Waterfall in Summer* project on pages 146–161, was taken in the summer, so it required a lot of work – and artistic licence – to translate into a painting. There was too much foliage, and to turn a summer scene into a snowy winter scene I had to strip the foliage back considerably.

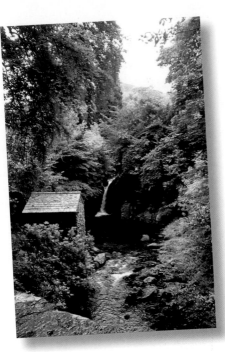

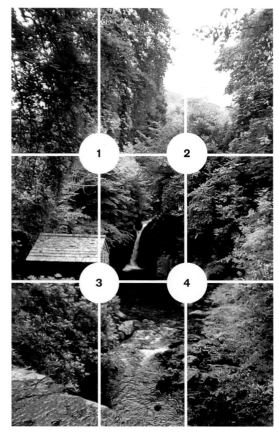

*This shot was taken on my phone's camera while I was teaching a group on a painting holiday in Cumbria, UK. The location was very hard to reach and there was no space in which to sit and paint, so I took a quick photograph to work from at a later time.*

The sketches below illustrate how I removed the foliage, and brought forward the boathouse, placing it at focal point 3 (see photograph, left). I left the waterfall at the centre of the scene, but framed it with tall trees, including a tall, snow-covered pine tree at focal point 2. I also omitted the stone wall in the foreground, and widened the water to the right, to add greater depth to the painting. The photograph on the left demonstrates how the scene can be divided neatly into thirds; the lower third contains the water, the middle third the waterfall and boathouse, and the top third, the sky. The central positioning of the waterfall might have made for a poor composition had I not framed it with the tall trees; this is where sketches come in handy as they allow you to evolve your composition and shift the focal points.

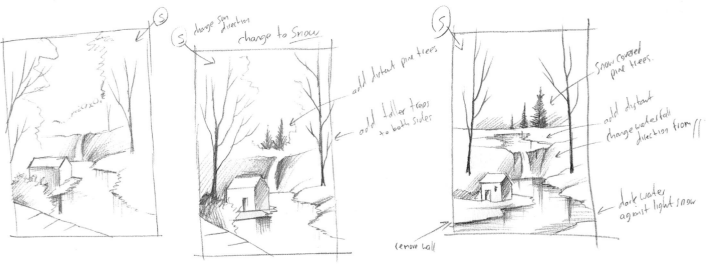

## Developing a painting

A comparison of the original photograph (opposite, top right) and the finished watercolour below shows how much you can develop a painting.

Use the photograph or scene in front of you as a starting point and apply artistic licence to change the scene as much, or as little, as you feel appropriate. I love working like this and I recommend it as good practice: you never know where the paint will end up!

In *Waterfall in Summer* on pages 146–161, the same scene inspires a different variation. You can use the outline provided (outline 5) in the middle of this book to create many different variations on the same composition.

**Waterfall**

*The sky and distant trees went in wet into wet (see page 68), then, using a pale natural green, I painted the tall pine trees, gradually making the colour stronger as I worked towards the taller trees. Masking fluid was used to protect the snow on these trees, the snow on the fine branches and also the roof of the building.*

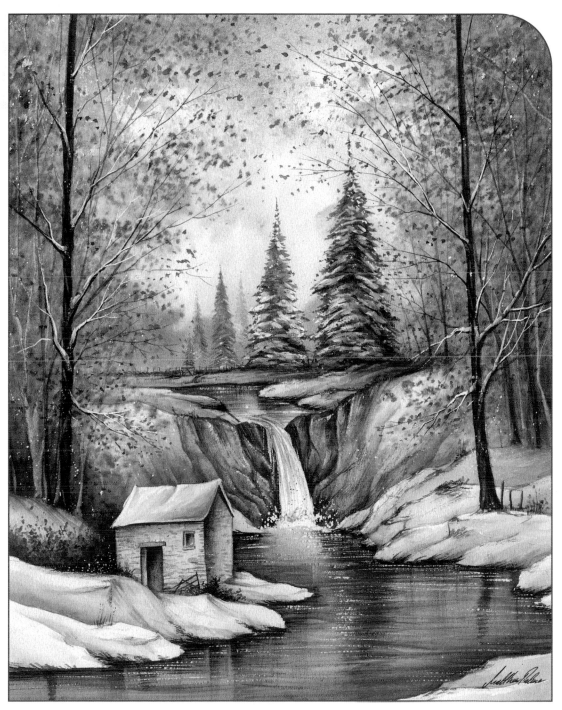

# Sketching

Artists often sketch to set out a scene before painting, but also to capture a scene quickly. It is more memorable to sketch a scene than to take a photograph. The two techniques in this chapter – pencil and wash, and pen and wash (also called line and wash) – involve less painting and more time spent on the process of drawing.

## Pencil and wash

Pencil and wash, particularly, is a great sketching technique that works well on watercolour paper as well as on cartridge or sketching paper. You start by drawing a scene in pencil and add the tones, details and shadows with pencil – essentially creating a monochrome sketch. Then, using transparent, watery watercolour paint, add a wash over the pencil areas – the transparent watercolour allows the pencil tones to show through.

### Tip

*The great thing about pencil is that you can control the tone or darkness of the colour by applying or releasing pressure. Used on Not surface watercolour paper you can also create wonderful texture by using different leads. Using a combination of the three leads below, you can achieve some wonderful pencil sketches and pencil and wash techniques.*

**HB** HB is a standard pencil lead that is halfway between dark and light lead. HB is commonly used for everyday sketching; however, the lead is quite hard, and can permanently scar watercolour paper.

**2B** 2B is much softer than HB: the graphite has more of a chalky feel, giving much darker darks, and will not scar watercolour as much. The 2B will however lose its point quite quickly.

**4B** The 4B is a soft lead that gives strong, dark areas but can be washed away when water or paint is applied over the top. The 4B can give an almost dry-brush texture to a sketch, as the lead will not go into the grain of watercolour paper.

Try drawing and painting this window using the pencil and wash technique:

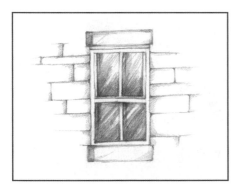

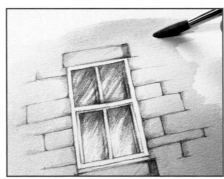

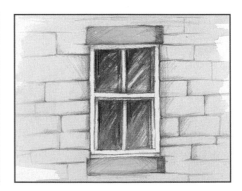

**1** Using a 2B pencil, sketch and outline the window. Add tonal work and details as above. Add some very dark shadows to the panes with a 4B pencil.

**2** Using a size 10 round brush add a pale wash of natural yellow watercolour over the wall area. Notice how the tones and shadows are set by the pencil.

**3** With a size 6 round brush, paint over the window panes to darken them. With pencil, make sure the top-left of every pane is darker than the bottom right – this gives depth to the windows.

# Pen and wash

Similar to pencil and wash, pen and wash is a great technique for artists who love to draw: it is an atmospheric style of watercolour painting. It gives a great mood, using strong, dark tones. It is also very addictive as a technique. The pencil drawing is laid down first, followed by a very free and loose wash of pale watercolour. Then, when the paint is dry, the pen is put to work to add all the shadows, tones, shape, form and detail.

Waterproof – or Indian ink is perfect for watercolour work. The pen I recommend for pen and wash work is a black fibre-tip, fade-proof or waterproof pen. The nibs for these pens come in different sizes: I use either a 'fine' or a 0.5mm tip. A fibre-tip pen allows you to control the angle: if you are working at a right angle, you get a definite clean line; if you are working at a less steep angle, you can almost apply a scribbling effect like dry brush, slightly skimming the paper.

The other good thing about working with waterproof fibre-tip is that it dries quickly: you can apply watercolour over the top so you can jump from paint to pen to paint again. As with pencil and wash, you can work back over the pen details with more paint at any time.

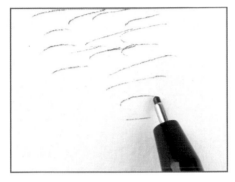
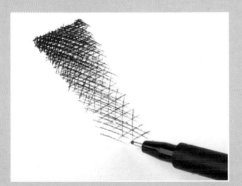

*Top: Hold the fibre-tip pen vertically, to give a strong, dark line.*

*Bottom: Hold the pen diagonally and apply little pressure to give a light shading line.*

## The cross-hatch method

Pen ink cannot be faded in the same way as pencil graphite can, so to 'fade' a pen we use a simple technique called the cross-hatch method. This involves drawing a series of quick diagonal lines, then changing the direction of the lines in order to build up some darker tones.

You can also increase the width of the lines to give the effect of graduation.

Using the side of the fibre tip nib, you can also apply a dry-pen technique – lightly skimming the pen over the paper surface to add light pen pressure.

**1** Draw a series of diagonal lines, spacing them farther apart as you progress.

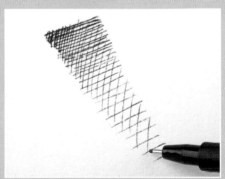

**2** Go back over your lines but change their direction. Begin with lines that are very close together, then widen the gap between the lines as you move downwards.

**3** Build up your cross-hatching by drawing new lines in various directions: this will create a nice graduation, perfect for depicting shadows.

# Pencil and wash in practice

The drawing below was made on location, in a lay-flat, cartridge paper sketchbook, using a 2B pencil.

Using a few pale, transparent colours I applied a wash of watercolour: I painted the sky wet into wet (see page 68) using natural yellow followed by natural blue. I used the same two colours for the water, strengthening the blue towards the foreground to give depth.

Next, I painted the hull of the small boat in the same blue again, with a natural yellow cabin. I applied the same natural yellow to the buildings, with natural orange for the roofs. I laid in the reflections of the buildings on the water in these same two colours. I added natural green into the distant foliage around the buildings.

The water's edge and the foreground were laid in using a pale natural brown with a touch of natural red; I used the same colour on the hull and cabin roof of the nearmost boat.

Finally, I finished the sketch by using a 4B pencil to give a few extra, darker tones and additional detail to the boats and anywhere I felt needed contrast.

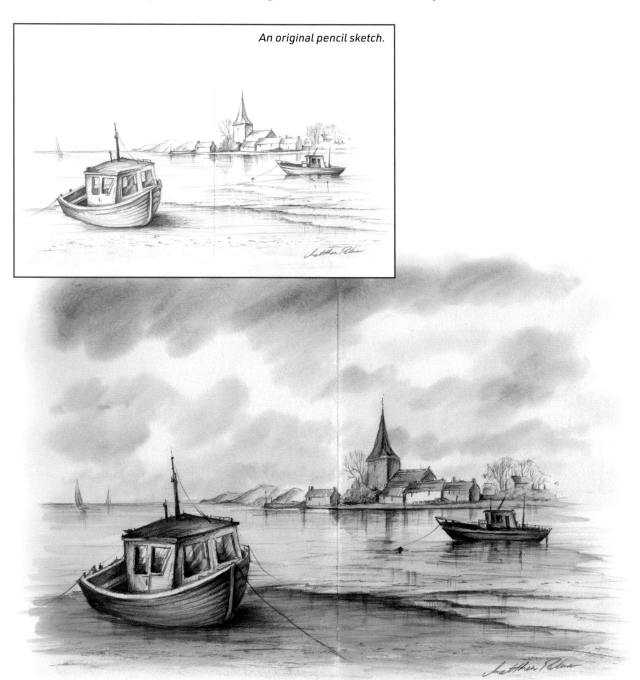

*An original pencil sketch.*

*The finished painting worked in pencil and wash.*

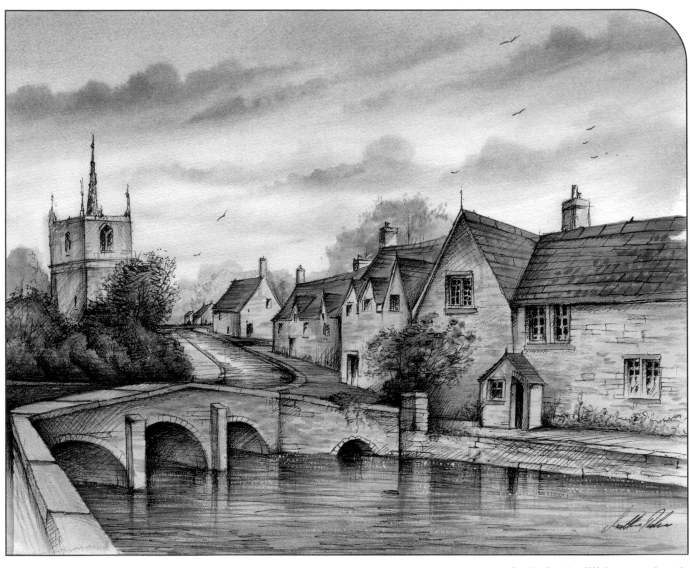

*Castle Combe, UK, in pen and wash.*

# Pen and wash in practice

The pen and wash watercolour above began with a drawing made in 2B pencil, followed by pale washes of natural blue in the sky, with a pale natural yellow base. While the washes were still wet I twisted in some clouds, using a size 10 brush, with natural grey (see pages 64–65 for instructions on creating a similar sky).

The distant trees were also painted while the sky was wet, to give the painting depth and a soft edge. Once dry, I applied the pale washes to the roofs, using a natural brown, and grey shadows in a pale and watery natural grey. I kept building up the green foliage and added a few flowers in natural red.

I used pen to add detail and to darken the shadows, using the cross-hatch method shown on page 23.

## Tip

- *Keep the paint pale and the washes simple. You can always add more paint after you have applied the pen.*

- *In the case of the painting, above, once I had added detail with the pen, I went back in with watercolour to paint some stonework, extra detail on the roofs and anything else I felt the painting needed.*

- *The important lesson to remember with pen and wash is: build up those dark shadows with cross-hatching and just have fun.*

# Working outside

Painting from nature is always a great experience and watercolour really lends itself to working in the field. All you need is a few paints, a handful of brushes, a pad of paper and some water – watercolour travels very easily!

I've spent many an hour painting from life: there is no finer practice for me, and I always find my paintings come out much brighter than they may have done had I worked inside.

## Sketching outside

Sketching outside is a great way of capturing a scene, more so than a photograph. As you spend time on location, you will soak up the view so that it will always stay with you. Ultimately, sketching outdoors is a great way to spend a sunny day.

I use an easel, but this is not essential: a seat and your knee are all you need. I start with a rough sketch, which gives me a chance to see how the composition might

work. It sets the scene and indicates the direction of the sun and the height of the sea (if I am by water) as the tide will turn and the sun will go down. I then transfer the drawing to the watercolour paper in the form of an outline. Then away I go to paint. The sketch, below, of Mundesley in Norfolk, UK (also shown on pages 2–3), was painted in about three hours on a lovely summer's day.

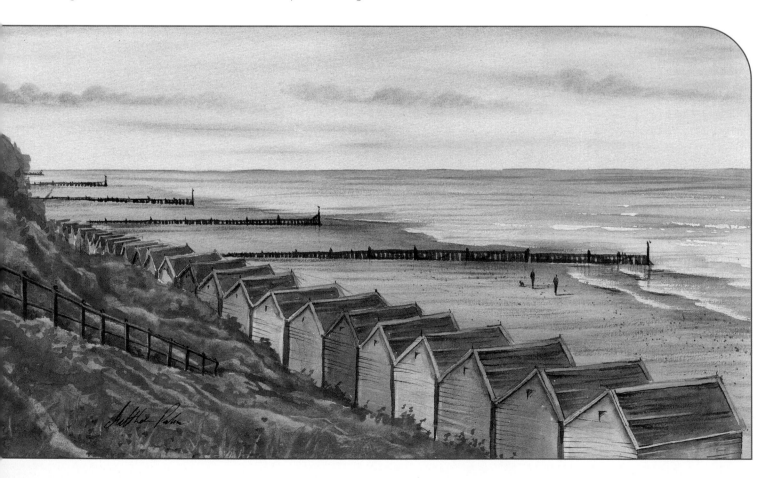

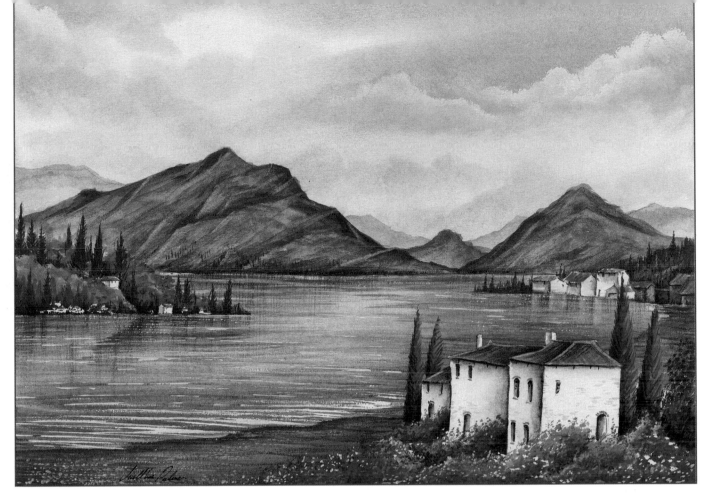

# Painting outside

There are, of course, a few differences between painting outdoors and working from a photograph. The first obvious difference is the scale: a photograph is usually 15 x 10cm (6 x 4in) or 18 x 13cm (7 x 5in) whereas the outdoors is limitless! For me, this makes the process easier. As long as your watercolour paper is in sight, if you stand back and close one eye, you will be able to fit your scene to the paper nicely.

The biggest problem when painting outdoors – apart from the ever-changing weather – is of course the light. The sun will be on the move all day. How do we work around this? I always tell my students on our painting holidays to set the light direction at the time of sketching the scene and to stick with that direction all day. I normally draw an arrow at the top of my paper to indicate the direction of the sun. It is also a good idea to take a photograph of your scene in case the weather turns bad and you have to complete the painting inside.

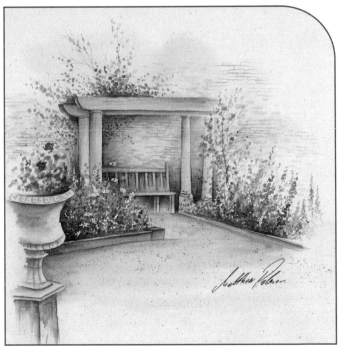

*The two paintings here were painted from nature. I painted the English country garden scene, directly above, in about two hours on location, at Rydal Hall in the Lake District, UK.*

*The top painting is Lake Garda, Italy. This stunning scene began life as a sketch I did on location in a hotel room, then painted back home in the studio. Sketching is a great way to quickly capture a scene. A sketch can take 10 to 30 minutes, so your mind absorbs the view, unlike with a quick photograph.*

# Useful drawings

Here I will walk you through some simple drawings in just a couple of steps. I have chosen elements that you might want to include in a landscape as focal points.

**Tip**

*Most buildings are basically the same shape, just with different features, like windows.*

## House

**1** Start with three vertical lines for the three visible corners of the building. The point of the apex is always central: use a guideline to help you find it. Draw a horizontal line across the gable end, measure and mark its centre and draw a vertical guideline down through the mark.

**2** The sloping lines of the roof must always be parallel, and so must the ridge and eave lines.

## Chimney

**1** Draw a simple arrow pointing up.

**2** Add detail as shown, using more pressure with a sharp pencil.

## Church

**1** Start with a long vertical line, followed by an arrow pointing upwards, then add three further vertical lines.

**2** Add detail as shown, keeping the shadow side to the right to give a three-dimensional feel.

# Bridge

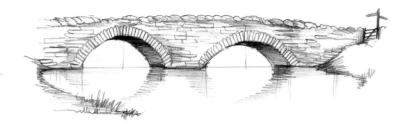

**1** Drawing a perfect arch is difficult, so adding guidelines really helps. Draw a horizontal line for the base. Add three equal dots, to represent the start, middle and end of the arch. The bidding (or top of the arch) is higher and perfectly central. The oval at the top of the middle line helps you draw the arch with ease.

**2** Add detail and shadows as shown and lots of brickwork in the form of outlines.

## Tip
*Remove the guidelines from sketch 1 with an eraser.*

# Pedestrian

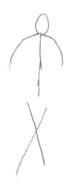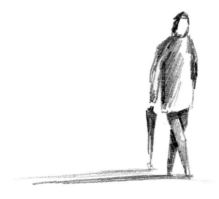

**1** Draw a stick figure. Cross the legs to indicate a walking motion.
**2** Fill out the body and add detail and shadows as shown.

# Dog walker

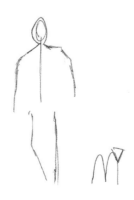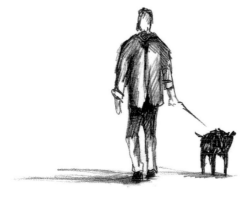

**1** Draw a stick figure. One leg is straight and the other is bent to give the impression of walking. The dog starts off as an 'M' shape with a triangle for the head.

**2** Add detail and shadows as shown.

# Windmill

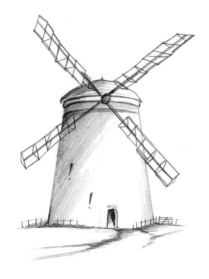

**1** Draw a tall vertical line then add two oval shapes, keeping the distance either side of the line symmetrical. Notice each one is wider as we work down. Hold your pencil about halfway down and apply light pressure when drawing, as these ovals will need to be erased. The sails are drawn with a ruler and are all the same length. They also mirror each other.

**2** Add detail and shadows as shown, adding extra detail to the sails.

# Lighthouse

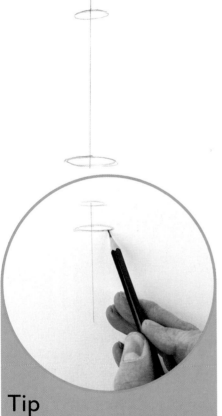

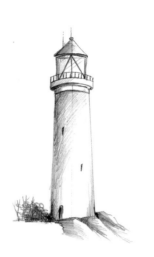

**1** Draw a tall vertical line and add the three oval shapes, keeping the distance either side of the line symmetrical. Notice each one is wider as we work down. These ovals help to give the natural curve of the lighthouse. Hold your pencil about halfway down and apply light pressure when drawing as these ovals will need to be erased.

**2** Add detail and shadows as shown.

### Lighthouse in a scene
*The drawing technique above was used for this lighthouse. Adding the houses to the left side gives extra detail and scale. The houses were added using the drawing technique on page 28.*

## Tip
*Hold the pencil quite low down, at a 45° angle. Make light circular marks. This will give a perfect angle for the curves. Apply light pressure for stage 1 and heavier pressure for stage 2.*

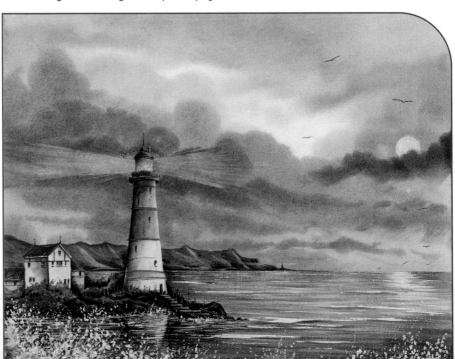

# Circles and ovals

Drawing anything round or oval is difficult, although we can trace round objects for circles. However, ovals are totally different and therefore much harder.

The painting of the *Flying Scotsman* steam train is a great example of working with ovals. The main body of the engine and, of course, the wheels are all sketched using the following technique. Have a try!

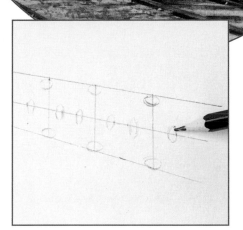

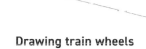

**1** Draw three angled lines, tapering to the left to help give the effect of depth or perspective. The middle line acts as the centre point for the oval and the top and bottom lines give the depth. These angles can be copied from the scene or photograph, using a ruler or straight edge. Hold the ruler matching the angle on the photograph, then slide your ruler over to the paper and apply a faint pencil line.

**2** Draw vertical lines. These are sketched with light pressure so we can easily remove them with an eraser.

**3** Add loose, sketched circles to the top and bottom and loose ovals to the left and right sides. Hold the pencil about halfway down the shaft. This gives a looser grip, allowing the small shapes to form easily.

### Drawing train wheels

*This sketch shows the vertical lines, the loose, sketched circles to the top and bottom and the loose ovals to the left and right sides. The circle and oval sketches make drawing the circles or ovals easier. Lightly sketch around the outline to complete the shape.*

### Finished sketch of train

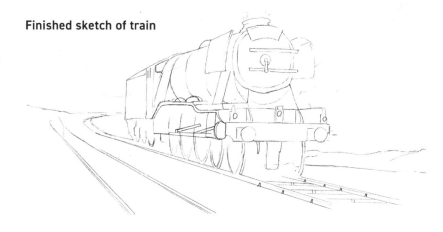

# Easy perspective

A basic knowledge of perspective is very useful. Some of my students struggle to see the angles they need to draw, and learning a few rules of perspective will help you understand the logic behind it.

## Single-point perspective

Linear perspective shows that the lines of three-dimensional objects slope as they get further away from the viewer, and the various lines, if extended, will all meet at a point called the vanishing point. Single-point perspective uses only one vanishing point and is a great way to learn the basics of perspective. Follow this simple exercise.

**Horizon line**

*Horizon line or eye level = an imaginary line that is level with your eye. It depends on your height and whether you are standing or sitting.*

**1** Begin by sketching in the horizon line, or your eye level. In the centre add the vanishing point (the point at which all the receding lines meet).

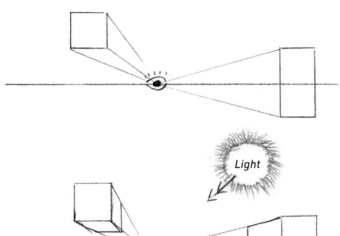

**2** Add two boxes by drawing two simple squares, one above the horizon line and one below. Use a ruler to draw faint guidelines from the corners of the squares to meet at the vanishing point.

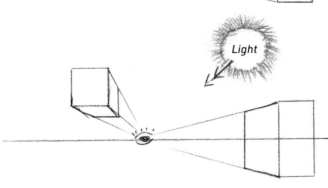

**3** Match the sides of the squares with parallel lines suggesting the further edges of the boxes. These lines should stay within the guidelines. You now have two three-dimensional boxes.

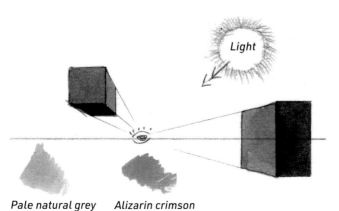

**4** To finish the exercise, paint the boxes. I have added the sun direction to help show which side of the box should be light. Add a pale colour of alizarin crimson over the whole box. Once this is dry, paint the two darker sides using natural grey. Once this is dry, use the same natural grey but darker to paint the darkest face of the box.

*Pale natural grey    Alizarin crimson*

See pages 40–45 for colour mixing.

# A simple house in single-point perspective

Now you have completed a simple exercise in single-point perspective, have a go at drawing a house using the same technique.

**1** Draw the horizon line and vanishing point, then draw a rectangle for the gable end. Add a line down the centre to show you where the roof apex should be and draw this in. Draw in the guidelines to the vanishing point as before.

**2** Add the windows, door and chimney as shown.

*The roof slope must be parallel to the nearer slope.*

*Windows are easy with single-point perspective. Draw the right-hand vertical edge, then draw faint guidelines to the vanishing point as before. All the windows follow these.*

*The chimney is the same as a box: draw the rectangle, add a guideline leading to the vanishing point, then add another vertical.*

*The left-hand wall is just a vertical line.*

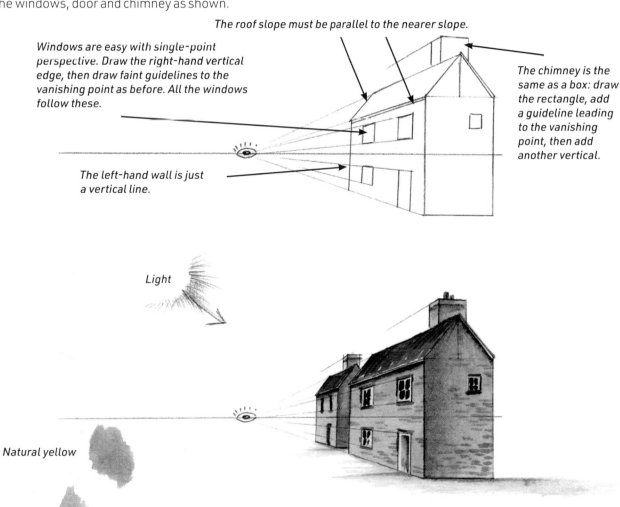

*Light*

*Natural yellow*

*Pale natural grey*

*Natural grey (strong mix)*

*Terracotta*

**3** Paint the house, using the sun arrow to show you where the light and shade should be. Paint a pale base wash of a stone colour such as natural yellow, leaving the windows white. Once this is dry, paint the gable end and the shaded part of the chimney with a transparent layer of natural grey. Add details of stones with the same mix. Use terracotta to paint the roof, window panes, shadow in the doorway and details such as the chimney pot and guttering.

# Two-point perspective

Two-point perspective is a more realistic way of capturing angles, as it gives you the correct angles on both sides of the object. This is the method I use all the time. Once you get to grips with perspective in this way, it starts to come naturally to you as you sketch. It opens your eyes to angles, allowing you to see in which direction the lines should go.

**1** Start with the horizon line as before, but this time add a vanishing point at either end.

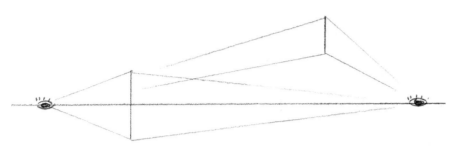

**2** Draw one box above and one below the horizon line. In two-point perspective, you need only to draw the central line of the box, then draw faint guidelines to both vanishing points.

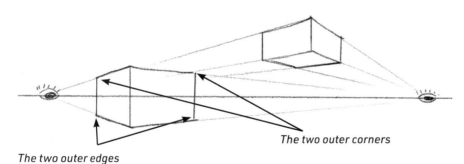

*The two outer corners*

*The two outer edges*

**3** Put in the outer edges of the box by placing two vertical lines within the guidelines leading to each vanishing point. Draw two further guidelines from the outer corners of the box to the vanishing points as shown.

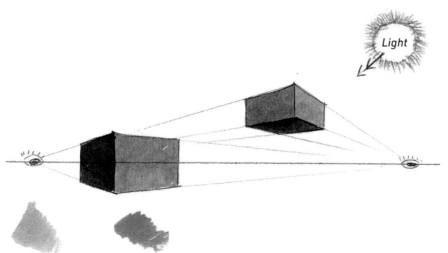

*Light*

*Pale natural grey*    *Alizarin crimson*

**4** Paint the boxes exactly as before, with a base layer of pale alizarin crimson and a transparent layer of natural grey shadow added once this has dried. Finally add the darkest face with a stronger grey mix.

# A simple house in two-point perspective

Now have a go at drawing two houses using two-point perspective.

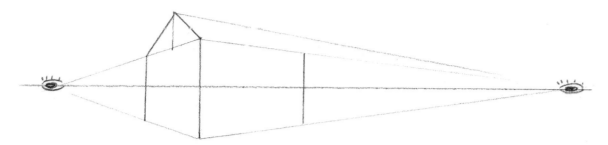

**1** Draw the horizon line and the two vanishing points. Draw the middle line of the house that is nearest the viewer, then add the faint guidelines leading to the vanishing points. You can now use these to draw the outer vertical lines and the apex of the roof.

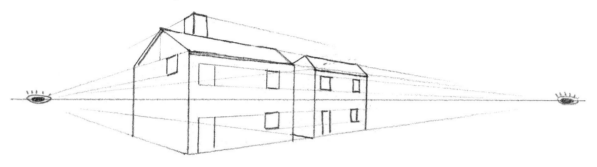

**2** Add details. Draw the first vertical line of a window and add guidelines going to the left-hand vanishing point to help you complete this and the other windows. Add a chimney using guidelines leading to both vanishing points. Draw in a second building.

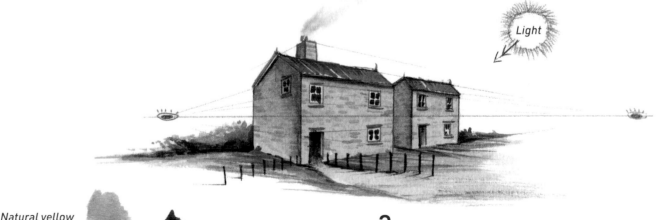

*Light*

*Natural yellow*

*Pale natural grey*

*Natural grey (strong mix)*

*Terracotta*

**3** Paint the houses in the same way as for the single-point perspective house, using natural yellow and two shades of natural grey. Using your knowledge of perspective learnt on these pages, add a rustic fence, made up of posts. Use natural grey and simply make the posts taller as they get closer to the viewer.

# Colour

I have spent years perfecting my colour palette and learning how to achieve the best colour mixes. The most important lesson I have learnt from many years of teaching is that both learners and improvers can struggle to mix colours.

All my common colour mixes – the colours I use on a regular basis – are available to purchase as a stand-alone palette of colours called 'Matthew Palmer's Natural Collection' (see page 9). These are the ones I use all the time in my painting from landscapes to portraits, animal portraits to still life. These paints are designed to make watercolour painting much easier, and all represent colours that readily occur in nature.

You can, of course, replicate any of these colours using the paints you already have. See pages 40–45 for more information on mixing your own colours.

## Colour comparison chart

Here you can easily see which of the colours in my Natural Collection of watercolours can be replaced with generic colours on the market. Use this chart as a quick reference.

| Matthew Palmer's Natural Collection | Alternative generic colour |
| --- | --- |
| Natural blue | French ultramarine |
| Natural yellow | Yellow ochre |
| Natural grey | Mix 60% French ultramarine with 10% alizarin crimson and 30% yellow ochre |
| Natural yellow light | Aureolin or cadmium yellow |
| Natural red | Alizarin crimson or rose madder |
| Natural violet | Intense violet or dioxazine violet |
| Natural turquoise | Mix 80% viridian hue with 20% French ultra ultramarine |
| Natural white | Opaque white or white gouache |
| Natural green | Mix 70% aureolin or cadmium yellow with 30% French ultramarine |
| Natural green light | Mix 70% lemon yellow with 30% French ultramarine |
| Natural brown | Mix 80% burnt sienna with 20% French ultramarine |
| Natural orange | Mix 70% burnt sienna with 30% aureolin |

# The essential three

**Natural blue** The ideal tone for skies and water, this blue contains several blue pigments. Natural blue is more vibrant than French ultramarine blue and crisper than cobalt blue.

**Natural yellow** This clean sandstone yellow, when used pale, is essential to give depth to a sky without turning it green. This shade is also ideal for buildings and sandy beaches.

**Natural grey** Natural grey is pre-mixed from the three primary colours, blue, yellow and red, to give a transparent, 'ready-to-paint' shadow colour that can be applied to any painting.

# Useful colours

As well as the essential three colours discussed, there are also a few useful colours that I use regularly. They mix brighter tones and allow a much wider variation of colours in your painting.

**Natural yellow light** A primary yellow, this transparent, bright shade is great for flowers or sunsets. When mixed with blue it gives a perfect green.

**Natural red** A primary crimson-based red, great for depicting sunsets or flowers in a landscape.

**Natural violet** A transparent purple with a bluish tone that's great for creating florals – especially bluebells – and shadows in snow.

**Natural turquoise** The perfect seascape colour: use it on its own to give a lovely Mediterranean feel to a seascape, or mix with a touch of natural grey to capture a darker sea tone.

**Natural white** This opaque colour, designed to make your water sparkle and your highlights shine, is perfect for over-painting in watercolour and for adding those finishing touches such as a yacht in a seascape, or sheep in a field.

# Foliage colours

What is a landscape without a tree? I struggled in my early painting life to get the perfect mix for foliage. The 'off-the-shelf' greens, browns and oranges simply didn't look right. So here is my ultimate guide to foliage colours. Below you can see my pre-mixed natural colours, ready to replicate nature straight from the tube.

**Natural green** This glorious deep green is perfect for painting trees and creating subtle shadows that can help bring your foliage and summer landscapes to life. It is also ideal for evergreen trees.

**Natural green light** This fresh, light, opaque foliage green tone is perfect for spring landscapes and for adding vibrant touches of stunning highlights to trees and foliage, whatever the season.

**Natural brown** A lovely warm earth tone – perfect for adding depth and drama to your winter foliage or woodland trees. Natural brown is an ideal shade for depicting bark and branches. Mix your own natural brown: 80% burnt sienna, 20% French ultramarine.

**Natural orange** This shade is perfect for giving a warm, golden glow to your florals and sunsets and is the ideal autumnal orange. Mix your own natural orange: 70% burnt sienna, 30% aureolin.

**Foliage colours**
*From left to right: natural green, natural green light, natural brown, natural orange.*

## Mix your own natural greens

**Shadow green** Mix 60% aureolin, 30% French ultramarine and 10% alizarin crimson.

**Average green** Mix 70% aureolin with 30% French ultramarine.

**Bright green** Mix 70% lemon yellow with 30% French ultramarine.

**Natural greens**
*From left to right: shadow green, average green, bright green.*

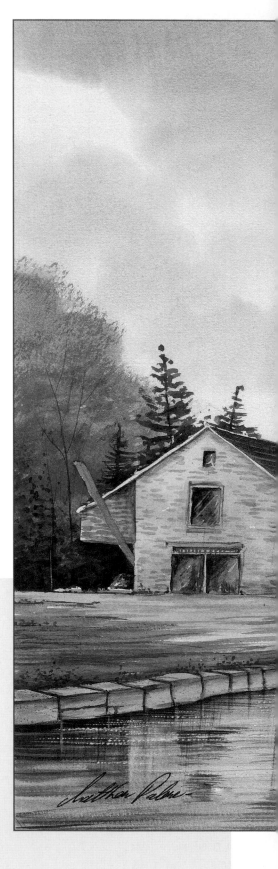

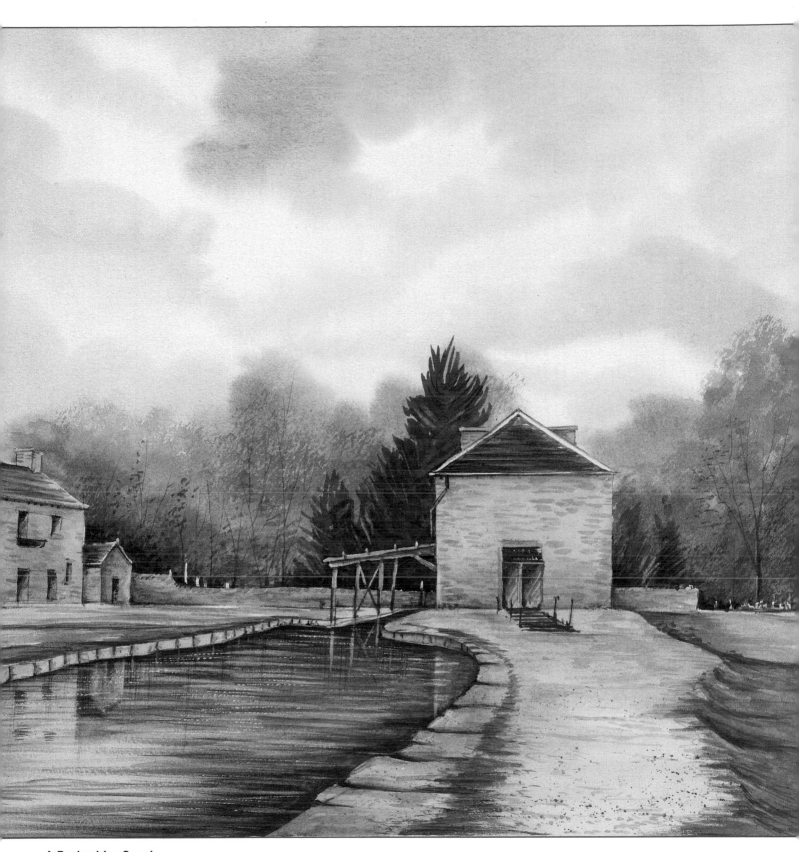

## A Derbyshire Canal

*50.8 x 38cm (20 x 15in) painted on 300gsm (140lb) Not surface watercolour paper. The painting shows great use of the foliage colours – from the bright green used on the tops of the trees to the shadow green at their base. A strong mix of shadow green is also used in the yew trees.*

# Mixing your own colours

When you visit any art store and attempt to buy watercolour you will be blown away by the variety of colours available: it's a minefield. When you start painting, you may want to buy them all; this can, however, make things more complex for you.

It is a good idea to have a sound understanding of primary, secondary and tertiary colours. When I started painting I had just three paint colours: a blue, a yellow and a red (see below), which soon taught me to understand the logic of how colours are mixed.

*French ultramarine blue*

*Aureolin*

*Cadmium red*

## Just add water

Before we move on to discuss colour-mixing, it is worth answering the most commonly asked question in the teaching of watercolour painting: 'How much water should I add to my paint?' My answer is, always keep one brushload of water in your mixing palette and add the colour to this. If you want a paler mix, add more water, and if you want a darker colour, add more paint.

It's always good to keep a scrap of paper alongside your palette so you can test out a mix before you apply it to your painting.

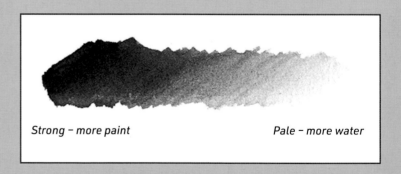

*Strong – more paint*

*Pale – more water*

# Working with primary colours

Primary colours – blue, yellow and red – cannot be mixed from other colours. I paint with my Natural Collection range as these are clean, crisp and pre-mixed from primary colours, but if you are mixing your own colours, you will find it useful to have to hand these two sets of primaries. Both sets can be mixed into an even, natural grey.

### Set 1

### Blue (French ultramarine blue), yellow (aureolin) and red (cadmium red).

This set will mix bright blues, clean yellows, bright greens, vivid reds and oranges. As an alternative to aureolin, you could try cadmium yellow.

There are many different blues, yellows and reds available to the watercolour artist. The pigment choices shown in the first colour wheel on page 42 (top) are the traditional three, which give you the opportunity to mix dozens of colours. It is always worth your time experimenting with mixes of different colours on the colour wheel.

The second colour wheel on page 42 (bottom) shows examples of my second set of primary colours: French ultramarine blue, yellow ochre and alizarin crimson (red). This increases your primary palette to five colours and provides you the opportunity to blend darker tones without adding a black pigment to the mix (see page 43).

### Set 2

### Blue (French ultramarine), yellow (yellow ochre) and red (alizarin crimson).

This set will mix darker tones that are great for landscapes: dark olive greens, rusty reds, peach and sandstone.

# The primary colour wheel

A good starting point for colour-mixing, and a great exercise, is to paint a primary colour wheel. This shows how the three primary colours are mixed. It helped me greatly in the early days to do this. Over the many years I've been teaching watercolour, I still demonstrate this technique.

**The primary colour wheel, set 1**

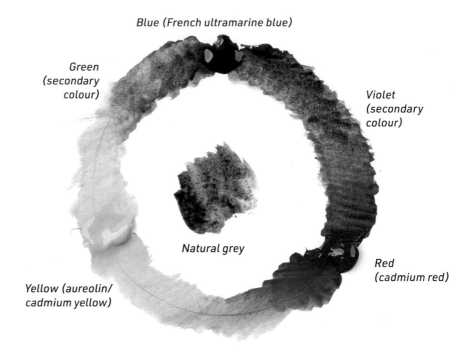

Blue (French ultramarine blue)

Green (secondary colour)

Violet (secondary colour)

Natural grey

Yellow (aureolin/cadmium yellow)

Red (cadmium red)

Orange (secondary colour)

## Creating a primary colour wheel

**1** Draw a circle on a sheet of watercolour paper (try using a roll of masking tape as a template).

**2** Squirt a spot of French ultramarine blue at the top of the circle; aureolin in the lower left arc and cadmium red in the lower right arc.

**3** Use a damp size 6 round brush to blend the paints together – the blue towards the red, the red towards the yellow and the yellow towards the blue.

**4** Where the colours meet, mix them together: this will result in new – secondary – colours: oranges, violets and greens.

**5** Mix your three primary colours in a swatch at the centre of the wheel: this will give you a natural grey. This is the perfect shadow colour and does not contain any black pigment.

**The primary colour wheel, set 2**

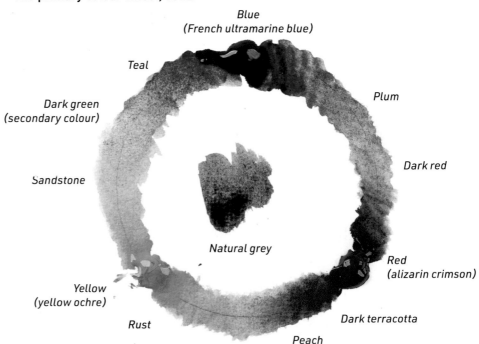

Blue (French ultramarine blue)

Teal

Plum

Dark green (secondary colour)

Dark red

Sandstone

Natural grey

Red (alizarin crimson)

Yellow (yellow ochre)

Dark terracotta

Rust

Peach

## Secondary colours

Secondary colours – oranges, purples and greens – are the result of mixing two primary colours. The colour wheels opposite show the secondary colours that appear when the primary colours mix:

> blue + red = violets and purples
> red + yellow = oranges
> yellow + blue = greens

## Tertiary colours

Tertiary colours are combinations of both primary and secondary colours. The colour wheel below shows the three primary colours, the three secondary colours and the six tertiary colours.

**The primary, secondary and tertiary colour wheel**

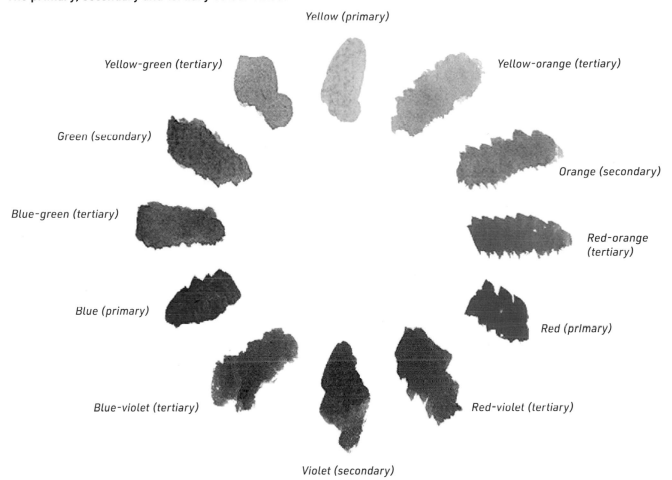

Yellow (primary)

Yellow-green (tertiary)

Yellow-orange (tertiary)

Green (secondary)

Orange (secondary)

Blue-green (tertiary)

Red-orange (tertiary)

Blue (primary)

Red (primary)

Blue-violet (tertiary)

Red-violet (tertiary)

Violet (secondary)

# Black, white and shadows

In watercolour painting, you will typically use the colour of the paper for white areas, unless you decide at a later stage in your painting to add a light detail, such as the moon (see page 142), or waves on the sea (see page 72) in natural white or gouache.

Black or grey – such as Payne's gray – can be too dark and overpower a painting. Natural grey – such as the shade found in my Natural Collection, mixed from the three primary colours – is more of a subtle, transparent shadow colour that recedes, allowing you to lay over any other colour and create perfect shadow tones.

*Payne's gray versus natural grey.*

# Colour mix percentages

Here are some useful colour mixes for your watercolour painting, all mixed from the two sets of primary colours. French ultramarine blue, aureolin (or cadmium yellow), cadmium red, yellow ochre and alizarin crimson.

### Autumn tree and sunset orange

*Mixed with lots of water, this is an ideal blend for autumn trees or sunsets.*

70% aureolin + 30% cadmium red

### Rustic brown

*For fields, fences and paths.*

50% yellow ochre + 30% alizarin crimson + 20% French ultramarine blue

### Vivid orange

*A good blend for sunset clouds and certain flowers.*

70% aureolin + 30% alizarin crimson

### Average green

*For summer foliage or grass, when mixed with lots of water.*

70% aureolin + 30% French ultramarine blue

### Terracotta

*For roofs and flowerpots.*

60% yellow ochre + 40% alizarin crimson

### Distant green

*For distant hills and woodlands.*

60% aureolin + 40% French ultramarine blue

### Brick red

*For house bricks or old railings.*

50% yellow ochre + 30% alizarin crimson + 20% French ultramarine blue

### Shadow green
### *(same as natural green)*

*For dark trees and the shadow areas on trees. Also good for pine trees.*

60% aureolin + 30% French ultramarine blue + 10% alizarin crimson

### Sand and sandstone
### *(same as natural yellow)*

*For beaches, and sandstone buildings when mixed with lots of water.*

80% yellow ochre + 10% alizarin crimson + 10% French ultramarine blue

### Snow shadow colour

*For dark skies, and snow shadows when mixed with lots of water.*

70% French ultramarine blue + 30% alizarin crimson

### Shadow colour
### *(same as natural grey)*

*For shadows, when mixed with lots of water, and skies.*

60% French ultramarine blue + 10% alizarin crimson + 30% yellow ochre

## Tip

*For most of these pigments as they appear in the step-by-step projects, I have used the following colours from my Natural Collection: for French ultramarine blue, use natural blue; for aureolin or cadmium yellow, use natural yellow light; for yellow ochre, use natural yellow; for alizarin crimson, try natural red. See the colour comparison chart on page 36.*

# Additional colours

While the three primary colours will mix most of the shades needed for painting naturalistic watercolours, there are some that cannot be obtained, so it's good to keep a few additional colours in your palette.

**Burnt sienna**

*Great for mixing autumn tones and rusty colours.*

**Viridian hue**

*A vibrant green. Use this in tiny amounts to lift another colour. Do not use it on its own.*

**Intense, or dioxazine, violet**

*Great for bluebell shades and dusky skies.*

**Lemon yellow**

*An opaque yellow that, when mixed with French ultramarine blue, will give a vivid, opaque green.*

**Permanent rose**

*Used on its own, permanent rose is ideal for vibrant flowers in a landscape, or vivid sunset skies.*

---

**Autumn foliage**
*(same as natural orange)*

*For autumn foliage and terracotta.*

*70% burnt sienna + 30% aureolin*

---

**Sea turquoise**
*(same as natural turquoise)*

*For seascapes, when mixed with lots of water, and coastal shades.*

*60% French ultramarine blue + 40% viridian hue*

---

**Bluebell colour**
*(same as natural violet)*

*For woodlands and lavender fields.*

*80% intense violet + 20% French ultramarine blue*

---

**Bright green**
*(same as natural green light)*

*For spring foliage and sunlit meadows.*

*70% lemon yellow + 30% French ultramarine blue*

---

**Slate grey**

*For railings or slate roofs.*

*70% viridian hue + 30% alizarin crimson*

---

**Deep grey**

*For lampposts or foreground details; not suitable for shadows.*

*70% French ultramarine blue + 30% burnt sienna*

---

**Tree branch brown**
*(same as natural brown)*

*For realistic tree branches and fence posts.*

*80% burnt sienna + 20% French ultramarine blue*

# Building a scene

A great way to learn watercolour techniques is to build up a painting, bit by bit. By following the steps over the next few pages, not only will you learn some of the essential watercolour techniques but you will also produce a complete watercolour painting.

### You will need:

Watercolour paper: 300gsm (140lb) 100% cotton Not surface

Colours: natural orange; natural violet; natural grey; natural brown

Brushes: sizes 20, 10 and 6 round; lift-out or flat brushes

Other: kitchen paper; masking tape; hairdryer (optional)

*STAGE ONE: Laying a graduated sky*

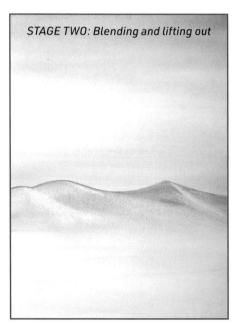

*STAGE TWO: Blending and lifting out*

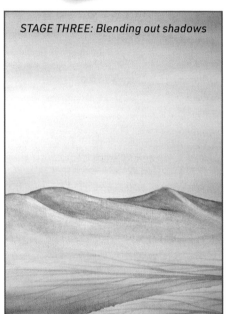

*STAGE THREE: Blending out shadows*

*STAGE FOUR: Dry-brush technique*

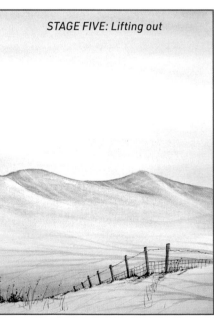

*STAGE FIVE: Lifting out*

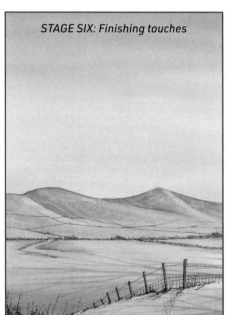

*STAGE SIX: Finishing touches*

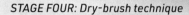

# Stage 1: Laying a graduated sky

All watercolour landscapes start with a sky (see pages 64–67). The basic rule I've always worked with is to start at the back and work forwards.

**1** Wet the paper with the size 20 round brush, keeping the board slightly tilted. Make sure the whole paper is shiny, with no puddles. Begin by laying the lightest colour for a graduated sky – a pale natural orange with water, mixed in the palette. Start the wash halfway down the paper in perfect horizontal strokes, and moving upwards. Keep reloading the brush with colour.

**2** Move your brush down the paper as well as up the page, so the paint fades up and down. The paint should fade off to nothing at the bottom.

## Wetting the paper
*Spend time applying water to your paper; wet the paper several times, and check that the paper is wet. Work with your board on a tilted surface so you can see the water shine. Brush away any puddles before applying the paint.*

## Note
*When you wet the paper at step 1, it may cockle, but don't worry – it will dry flat (see page 85). If you want to avoid cockling, stretch your paper as explained on page 13.*

**3** Clean your brush, wipe off any excess moisture, then choose your second colour – natural violet – to create an evening-time atmosphere. Start right at the top of the paper, and move downwards on a slight diagonal cross.

**4** Keep loading your brush and moving towards the orange area. Allow the two colours to meet in the middle of the paper, but keep the brushstrokes moving so that the violet blends in with the orange. Keep going back up and down the paper with your brushstrokes to soften any hard lines.

**5** Clean your brush and squeeze out the water to flatten the bristles. Then make horizontal soft strokes across the sky area. Allow to dry (feel free to use a hairdryer).

# Stage 2: Blending and lifting out

Blending is the most widely used technique in watercolour, and can help you move seamlessly from one colour into white or into a background colour, for instance, to depict distant hills or mountains that appear to fade into the colour of the foreground.

Here we use a blending technique to lay in some distant mountains, and a lifting-out technique to reintroduce light to the mountainsides.

## Wet on dry

*The wet on dry technique is the opposite of wet into wet, which is explained further on page 68. Wet on dry is the practice of applying wet paint to dry paper. Wet on dry is used in all watercolour painting, and allows for clean, crisp washes of colour.*

1

2

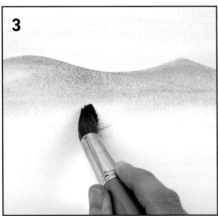

3

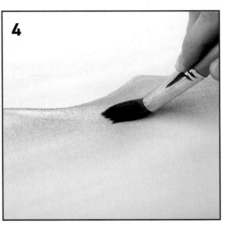

4

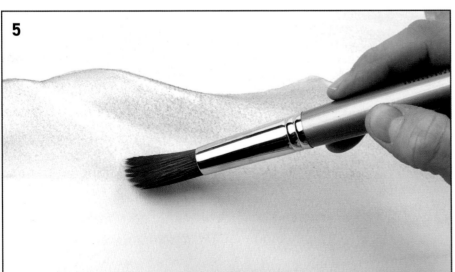

5

**1** Working wet on dry to create sharp edges, load pale natural grey on the size 20 brush and paint in the topmost edges of distant mountains on the horizon. As you paint, think about the shapes of the mountains, and add some character. Work the grey over the orange colour of the sky.

**2** Work a little way down the paper with the grey, then clean your brush well and wipe off any excess moisture.

**3** Make a puddle of water below the colour line. With the brush, move the water up towards the mountains, before dragging the paint into the moisture in a criss-cross motion. Keep smoothing the colour down: sometimes a little scrubbing is required to reactivate the grey pigment. Clean your brush, wipe off any excess moisture, then soften off any hard lines.

**4** Clean your brush again and squeeze it out to make it flat. Use the flat edge of the bristles to wipe away some areas of light that are coming down on the right-hand sides of the mountains.

**5** Use the brush to lift out, or wipe away, as many streaks of light as you see fit. Sometimes it helps to apply a scrubbing motion to loosen the colour. The flat brush will also soften any hard lines. Allow to dry.

# Stage 3: Blending out shadows

Shadows make a scene come alive and add dimensionality to a painting. Adding cast shadows – where light is blocked by an object such as a building – can help to create a sense of solidity and structure in a painting. Shadows can also be used to prevent large areas from appearing flat, as demonstrated below, on the vast foreground area.

## Note

*Before applying masking tape at step 5, remove some of the adhesive by running the tape through your fingers. This will prevent the tape from ripping the paper – if this happens, see page 84 for advice on how to fix it.*

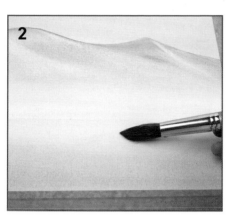
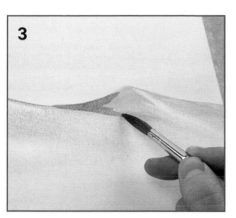
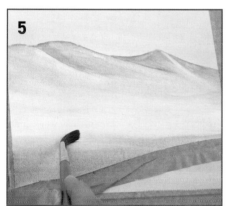
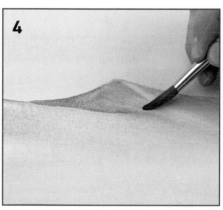
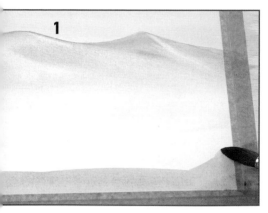
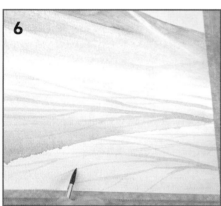

**1** Using the size 20 brush loaded with pale natural violet, and working wet on dry (see opposite page), lay a broad brushstroke of violet across the bottom of the paper. Make the 'corners' of the stroke slightly higher than the base.

**2** Clean your brush, wipe off the excess water on the side of your pot, then lay in a puddle of clean water just above the violet area, and begin to blend the violet into the water with diagonal brushstrokes. Wipe off your brush and tap it onto kitchen paper to dry it, then blend in the violet shadow area into the mountain area at the top of the painting. This completes the first of the shadows. Allow to dry.

**3** Change to the size 10 round brush. Take up a pale grey and add a few shadows between the different mountain shapes to create separations. As watercolour is transparent, apply these shadows using multiple layers. Start off with the dip between the two largest mountains: paint in a 'V' shape.

**4** Blend out the 'V' shape towards the right of the paper. Repeat steps 3 and 4 in any other areas where you feel a darker, shadowy area needs to be painted, such as between the mountains on the left.

**5** Return to the foreground: stick a strip of masking tape irregularly, roughly and horizontally across the paper. Use natural violet on the size 10 brush to paint across the top edge of the tape, blending quickly so the pigment does not stain the paper. Blend water into the violet and sweep up into the mountains until the violet disappears. Remove the tape and allow the paint to dry.

**6** Use a size 6 brush and the same violet to add cast shadows from unseen trees on the right of the paper. Alter the angle of the shadows in the very foreground.

# Stage 4: Dry-brush technique

One of the best-kept secrets of watercolour painting is the dry-brush technique. Most watercolour paper has a texture, which is great for creating this effect. Used in almost all of my paintings, dry-brush is great for depicting walls, grass, water and trees.

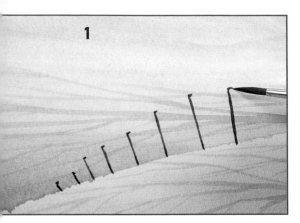

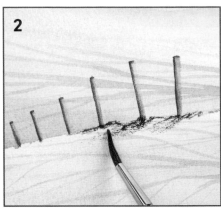

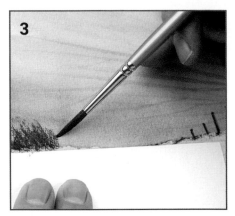

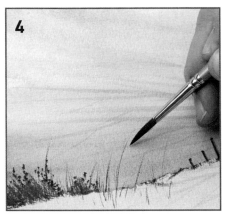

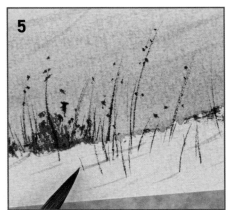

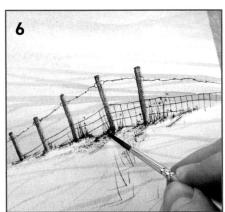

**1** With a fairly strong mix of natural grey and natural brown on a size 6 round brush, paint some fence posts into the scene, allowing them to 'disappear' over the hillside by decreasing them in size as you move to the left of your paper. Paint a tiny curve on the top of these posts.

**2** Clean your brush and wipe off any excess, then blend the posts upwards and to the right to define the three-dimensional shape of the posts. Allow to dry, then wipe off the majority of the colour at the base of each post with the side of the brush, in order to capture the texture of the Not paper. This dry-brush effect can also go up the posts to give them more texture.

**3** Create the impression of foliage coming from the left of the paper, using a straight edge such as a plastic card to mask the area below. Add a couple of spots and dots above this area to give some good foreground detail.

**4** Using the point of the brush and keeping it very dry, add some fine grasses poking out of the snow. Painting tall grasses with a dry brush is much easier than with a loaded brush: you can really make use of the fine point, as if you are writing with a pen. Add a few grasses anywhere in the foreground and make a few little spots on the tops of the new foliage.

**5** Using the violet, add some more cast shadows from the tall blades of grass, depicting these as fine flicks. Rotate your board if you need to.

**6** Wipe off excess colour by rotating your brush through kitchen paper to achieve a super-fine tip. Fill in, in fine lines, the wire fencing between the post using natural grey mixed with natural brown. Add barbed-wire detail with tiny round marks around the fence posts and join up the marks with uneven lines.

# Stage 5: Lifting out

Lifting out, or lift-out, is a technique not widely used by many artists, but which for me adds life, light and contrast to a painting. Rather than applying paint, lift-out is the process of removing the pigment. In this instance with a damp, sharp-edged flat brush.

I have created my own range of lift-out brushes: small (S), large (L) and extra-large (XL) (see page 10). The extra-large brush will add additional light to the distant hills in this scene. The small brush has a width of 3mm (⅛in), the large, 6mm (¼in) and the extra-large, 12mm (½in).

*My own range of lift-out brushes.*

**1** Use the flat edge of a damp extra-large lift-out brush (or any clean flat brush) to add some light into the hills in a sweeping motion. Scrub over the area several times with the sharp end of the brush, then wipe the area with kitchen paper (see inset). Add as many highlights as you need to.

**2** Lift out areas of the foreground around the fence posts to add extra light, especially at the bottoms. Use the technique to add in a few light grasses in the foreground.

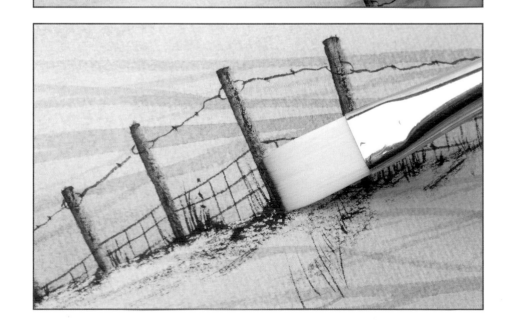

# Stage 6: Finishing touches

The finishing touches really 'make' the scene, in my opinion. It's always worth sticking a painting out to the end even if you feel your piece is not working, as these last few strokes make all the difference.

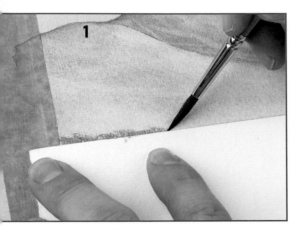

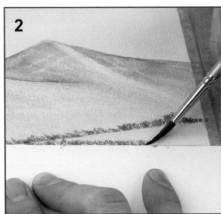

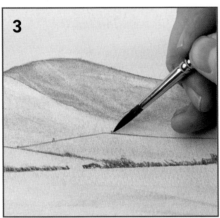

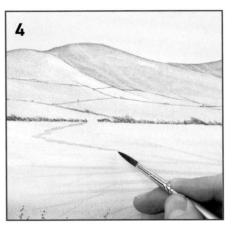

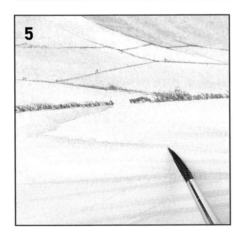

**1** With a medium to pale natural grey mixed with a tiny bit of natural brown on a size 6 brush, paint along a straight-edged piece of card, using the dry-brush technique, to create a distant line of hedgerow coming in from the left of the paper. Leave a tiny gap to represent a gateway.

**2** Angle the piece of card and add various hedges at different angles in the midground.

**3** Use the point of the size 6 to sharpen the bottom edges of the hedgerows and to put in a few finer distant hedgerows, into the hillsides. Drop in a few spots to represent distant trees and bushes. As the fields recede, use a diluted version of the same colour but still use a dry brush. Flick the hedgerows into the hills so they fade.

**4** Use a pale, watery, natural violet and the size 6 brush to blend in a footpath through the snow leading from the gateway in the hedgerow (see step 1). Use a zigzag motion from left to right. Clean your brush, wipe it on kitchen paper to remove excess water, then fade the left side of the path into a snow bank. Do the same on the right edge of the path. Use the same watery natural violet to add a couple of shadows to the left of the large hedgerows: lay them in with horizontal sweeps. Allow to dry.

**5** With a medium-to-strong mix of natural grey and natural brown, suggest the earth below the snow with the side of the brush along the path to give the impression of the perspective receding into the distance. Use the very tip of your brush and the dry-brush technique to fill in a gate in the hedgerow. This completes the painting.

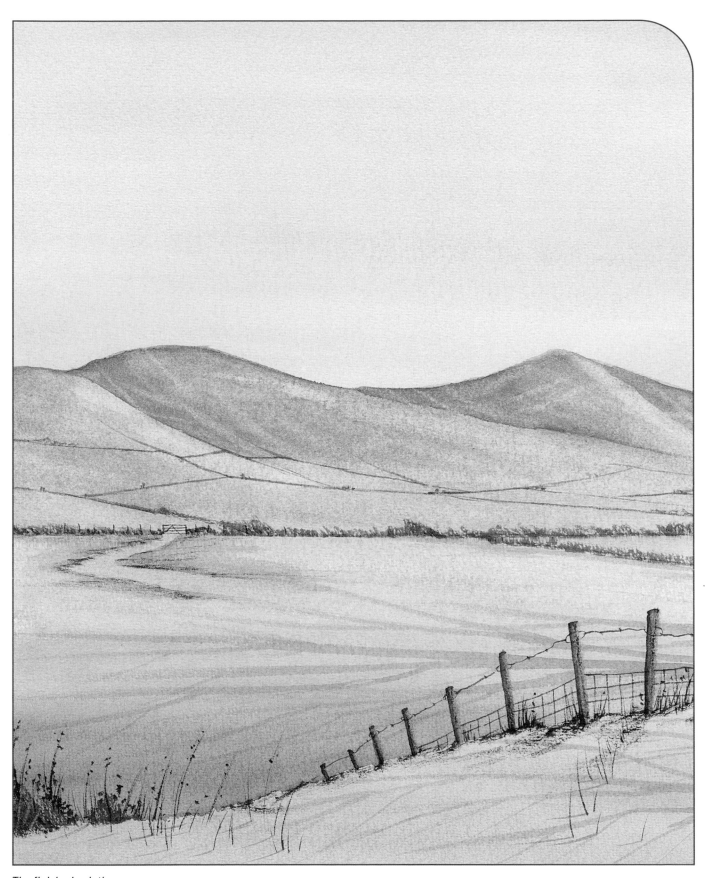

*The finished painting.*

# Top techniques

It's amazing how versatile watercolour is and how simply you can achieve amazing effects, from using masking fluid to scratching out highlights with a plastic card. It's time to have fun: try these techniques, learn the tricks of the trade and apply them to your own watercolour paintings.

Later in the book you will learn how to paint skies, water, trees and much more.

## ■ Using masking fluid

Masking fluid is, for me, an essential part of the watercolour medium and it is best left to dry naturally. If hairdryers are used, the fluid can go sticky and be hard to remove.

Masking fluid can ruin brushes. Use older brushes, or protect a normal paintbrush with household soap. First clean the brush in water, then coat it in the soap – the soap puts a protective barrier on the brush, allowing you to apply the masking fluid and paint freely with it for two or three minutes.

If you are not using soap, dampen your brush before applying the fluid, and paint for no more than sixty seconds. Then clean the brush, pick off any dry bits of fluid and carry on painting. Where possible, use a coloured masking fluid: the cream and the clear fluids can be quite hard to see when applied.

Masking fluid is the first thing that is applied to a picture and should always be applied before paint. In this example we are painting a rustic gate with settled snow.

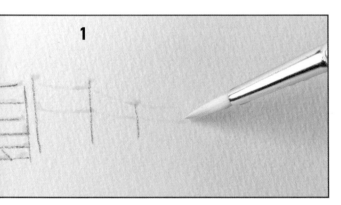

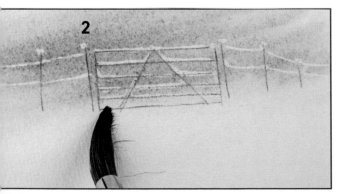

**1** Using pencil, sketch the gate, the surrounding fence lines and the suggestion of a barbed-wire fence on either side of the gate. Dip your masking brush into the fluid, wipe off any excess, then apply the fluid in the same way you would use paint – apply it just above the pencil line to represent snow, then put little dots of fluid on the tops of the fence posts. Paint in very fine lines to represent snow that has settled on the wire fence. Build up the fluid in the visible corners of the fence (on either side) to achieve a greater sense of the settled snow. Leave the fluid to dry.

**2** Paint in the background. The darker the background, the more the masking fluid will shine forth. Using a size 10 round brush, wet the area surrounding the gate and the fence, being careful not to scrub too hard over the masked area. Just a gentle glaze of water will do. Paint a dark, wintry sky starting with medium-strength natural yellow. Start at the bottom of the sky area and paint in a diagonal slant from left to right. Clean your brush, then take up natural violet, at medium strength, to paint the top of the sky. Begin with horizontal strokes, then work your way down in diagonal strokes until the violet meets the yellow. Bring the violet up over the top of the masking fluid area to give the impression of

darkness beyond the gate. Blend the colour down: clean your brush, wipe it on kitchen paper until it is almost dry, then soften any hard areas of paint and smooth the colour into the ground area.

**3** Take a size 6 round brush; use a medium to strong natural grey to paint in some pine trees in the background. These should start as vertical lines – take the lines right down to the bottom of the gate, then make diagonal flicks up from either side of the vertical trunk. Spend time building up the forest of pines around the gate. As the background will still be damp this will result in a nice out-of-focus impression. Add a few extra pointed tops to the trees, then allow them to dry. Use the same brush with pale natural violet to add some shadows from the trees, on a diagonal pointing down to about 'four o'clock'. Taper the shadows away, and leave them to dry.

**4** Mix a strong natural brown with natural grey and paint in the fence posts and the gate itself. Use natural violet to paint in some shadows from the fence posts in the same direction as the shadows of the pine trees (towards 'four o'clock').

**5** Once dry, remove the masking fluid with your finger. The white of the paper beneath will make the snow look bright and crisp.

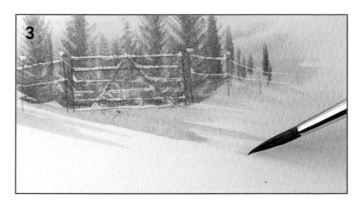

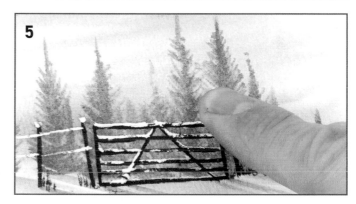

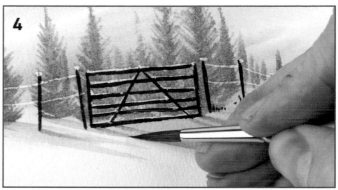

*The finished painting.*

## Tips

- *Use an older brush, or a specialist masking fluid brush, and coat the brush in ordinary household soap before using it.*

- *If you are masking a large area, clean your masking brushes every two to three minutes to stop the fluid sticking to, and destroying, the brushes.*

- *Smaller brushes work better for masking: it is much easier to control the detail if there is less fluid on your brush.*

- *Masking fluid should be left to dry naturally; hairdryers can turn the fluid to rubber.*

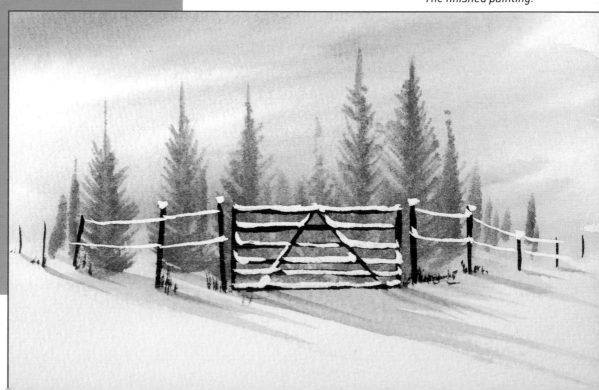

# Using masking tape

Tape can be used to protect larger areas of a painting, especially for creating a clean edge where the sky meets the land or sea. Masking tape is also useful for masking off the shapes of buildings or dry-stone walls in the foreground of a painting.

It is important to remove much of the adhesive from the reverse of the tape before you apply the tape to your paper: stick the tape to a low- or non-tack surface (fabric, for instance) and peel it off quickly to remove excess glue.

Once the tape is stuck to the watercolour paper, ensure that the top edge is stuck down firmly as paint can sometimes seep behind the tape – although seeped paint can be blended into the painting as a reflection, for instance, or it can be covered over with a dry-brush technique. To remove the tape from your paper, use a hairdryer as the heat will loosen the glue, which reduces the risk of the tape ripping the paper.

In this exercise, masking tape is used to define the horizon line between the sky and the tree line, and the foreground.

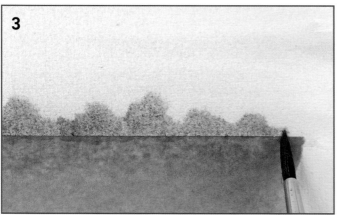

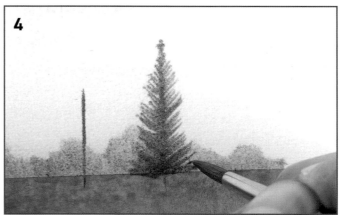

**1** After removing the glue from the reverse of the tape, apply it to your paper, ensuring that the top edge is securely stuck down. Use a size 10 round brush to wet the area leading down to the top edge of the tape, then paint in the first layer of sky in natural yellow. Make horizontal strokes from the tape line up to the middle of the sky area.

**2** Paint in some natural blue coming down from the top of your paper in horizontal strokes. Paint over the yellow area until the colours blend on the page.

**3** Pick up a size 6 round brush, then mix natural green and natural green light to a medium strength. While the sky area is still damp, work along the top tape edge in a twisting motion to create a slightly out-of-focus line of trees.

**4** Use natural green quite thickly, with just a touch of water, to paint in a trio of pine trees on the right of the scene. Begin the trees as thin lines leading up from the tape, then starting from the bottom of each tree, flick the brush outwards from the trunks to create the branches. Work on one side at a time, up to the fine point of each tree. Allow to dry.

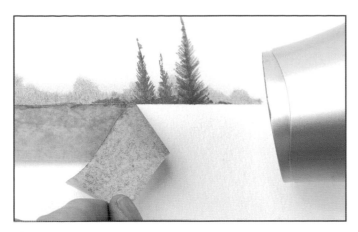

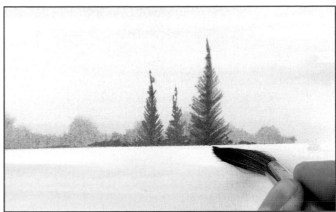

**5** Remove the masking tape, using a hairdryer to soften the remaining adhesive on the back of the tape thus preventing rips and tears. (See page 84 for guidance on fixing any accidental tears.)

**6** Now paint below the masked tree line: in this example I have painted in a grassy field. Leave a thin area of white between the tree line and the field, then block in the field in horizontal lines, working wet on dry (see page 48) with natural green light on a size 10 round brush. Then blend the light green back towards the tree line.

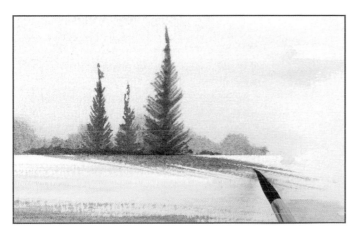

**7** While the light green is still damp, pick up a strong natural green on the brush. Along the left-hand side of the scene, add some horizontal lines in the foreground to represent shadow cast across the area. Drag the lines across, making them wider as you move into the foreground. Soften any hard lines with the damp size 10 brush. Switch back to the size 6 brush. With the same strong natural green, add some shadows, cast from the left, from the bases of the pine trees to finish.

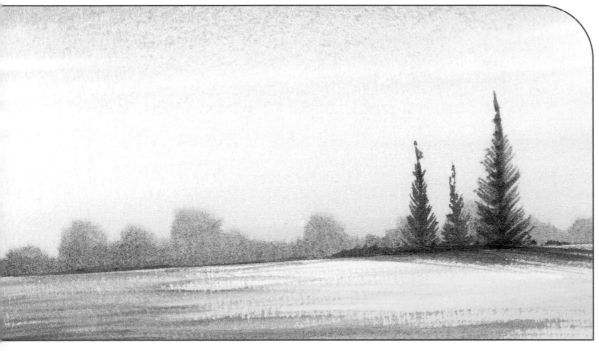

*The finished painting.*

# Using a plastic card

A flexible plastic card, such as a store card, is great for scraping off the surface of paint, leaving behind a textured effect. This works best with strong watercolour as the process reveals a lighter, textured area. In the *Hawaiian Sunset* project on pages 114–131, a plastic card is used to give definition to the rocks.

This exercise begins with a graduated-wash sky – graduating is simply the blending of more than one colour on a painting from a strong to a pale wash.

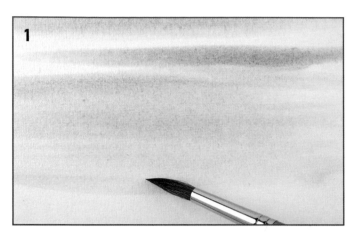

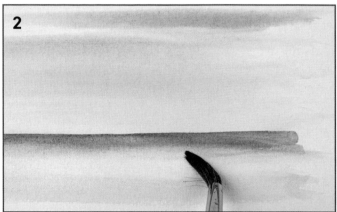

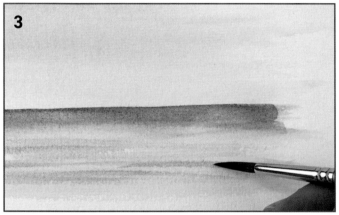

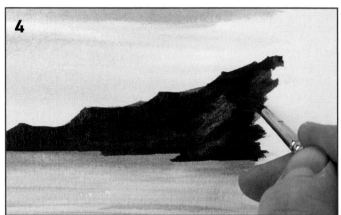

**1** Wet the sky area with a size 10 round brush. Using a pale natural red, lay in some horizontal strokes at the bottom of the sky area to represent the light. Fade this colour down to nothing. Use natural blue along the top of the sky area, working down. Leave a few white patches to represent areas of wispy cloud. Blend the blue into the red until the blue graduates and disappears. Allow to dry.

**2** Paint the sea in pale natural blue mixed with a tiny touch of natural grey. Overlap the base of the sky slightly, and paint in a straight horizon line. (You may wish to sketch this in before you start to paint.) Clean your brush. Wipe off any excess moisture, then use a transparent blend of natural turquoise to paint in the area just below the blue-grey.

**3** Change to a size 6 round brush. Return to your blue-grey mix and add some horizontal wet into wet ripples (see page 68) over the top of the water. Keep these quite straight. Allow to dry.

**4** Mix up a strong natural grey with natural brown and, still using the size 6 brush, paint in a distant cliff area, starting from the very edge of the horizon line, and stepping higher as you move around to the right of the painting. Then fill in the cliff area, stepping slightly downwards this time with a series of horizontal lines. This will give you a block of cliffs that will need to be separated with the plastic card.

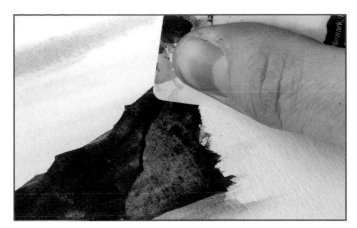

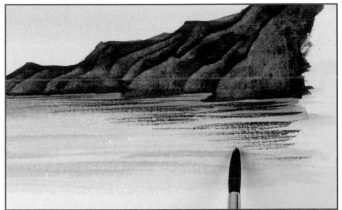

**5** Clean your brush, wipe off any excess moisture, then glaze over the top of the cliff area to reactivate any dried paint – the paint needs to be damp to allow you to scrape it off with the plastic card. Using the short edge of the card – not the corner – bend and drag the edge up towards the tops of the cliffs. Repeat this from the right edge to the very left-hand cliffs on the horizon line. This technique is worth practising before you apply it to your work as the results are both effective and addictive!

**6** To finish the painting, use the same brown-grey mix used for the cliffs. Using the size 6 round brush, add a few horizontal ripples on the water below the cliffs to make them appear to reflect into the water. A dry-brush effect will give a speckled stroke, making use of the grain of the paper and suggesting texture – the drier the brush, the better!

## Tips

- *You should ideally only scrape out with the card while your paint is still wet. If the paint is too dry, use a damp brush to glaze over the painted area and reactivate the paint before attempting to scrape again.*

- *When scraping, you may find that flecks of paint land on other areas of your painting. These can be easily washed off with a lift-out brush, or covered with a reflection.*

*The finished painting.*

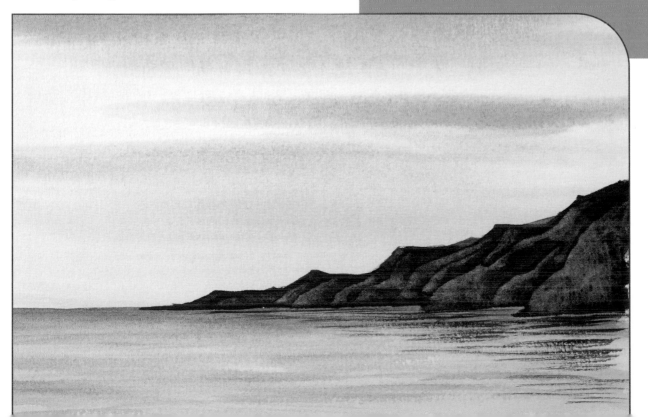

# Using salt

When salt is sprinkled on a damp watercolour, it will absorb a tiny amount of paint, leaving a star shape or snowflake effect. This can be used for a snowy sky, flowers in a summer meadow or texture on a dry-stone wall.

Experiment and practise with the technique, but remember that the paint must be damp: not soaking and not dry. Certain colours are absorbed better than others by the salt.

In this exercise, we use salt to depict snowfall.

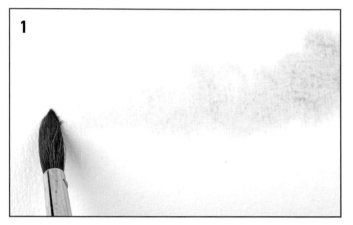

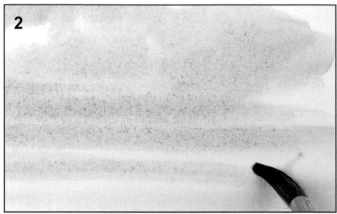

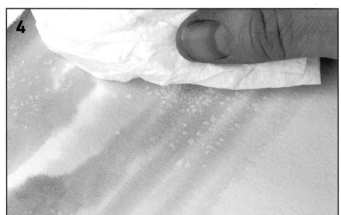

**1** Using a size 10 round brush, wet the sky area. Starting with a pale to medium natural orange, twist in some clouds in the middle of the sky. Paint in horizontal lines below to give the impression of distant clouds.

**2** Clean your brush, then work horizontally across the top of the sky using natural violet. Work down towards the orange part of the sky, then begin to twist the brush again. Work over the orange to create the effect of a wintry sky. Finish by laying in more horizontal lines below the twists.

**3** At this point, before the paint dries, apply a loose sprinkling of salt. One grain of salt equates to one snowflake so apply it carefully and sparsely. Allow the paint to dry naturally to allow the salt effect to work; only use a hairdryer to finish the process once your snowflakes have reached your desired size.

**4** Once the paint is completely dry, brush away the salt with some clean kitchen paper.

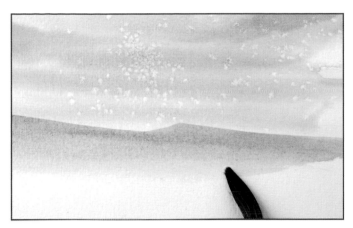

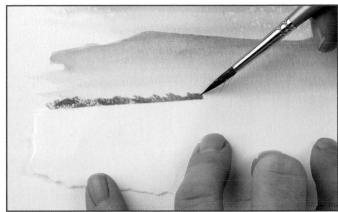

**5** Using the size 10 round brush, paint an uneven line of pale natural violet along the base of the sky to represent distant hills. Clean your brush – but do not dry it – then soften the hilltops. Allow the paint to dry.

**6** Using a piece of scrap card with a straight edge to help guide you, apply a dry-brush technique to add in a hedgerow beneath the base of the hills on a size 6 round brush loaded with a natural brown–natural grey mix. Leave a gap for a gate. Add in a few spots along the top of the hedgerow to suggest larger areas of foliage.

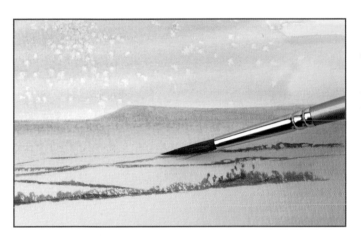

**7** Use the same colour in a dry-brush effect to paint in a few diagonal hedgerows in the fields. Twist your brush every so often to create the impression of larger bushes and trees. Paint much finer lines towards the rear of the field area. Finish this miniature snow scene with a small gate in the foreground. Use a rigger brush if you find it more comfortable for the finer details. A little bit of dry-brushing coming away from the gate will give the impression of a footpath, and an extra level of perspective.

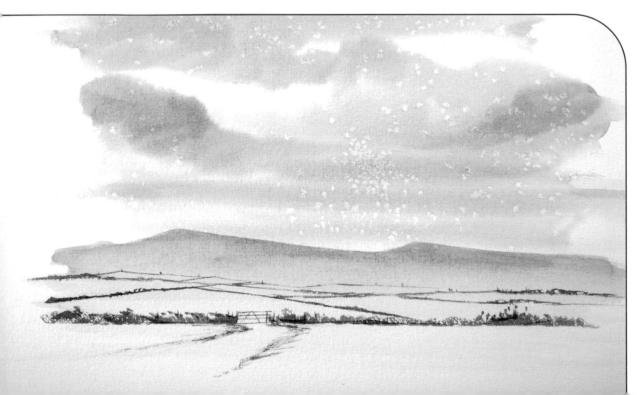

*The finished painting.*

# Splattering

Splattering gives a random speckled effect in your watercolour paintings. This is a very common technique in landscapes, great for pebbles on a path, splashes in a waterfall and scattered flowers on a meadow. In the *Northern Lights* project on pages 90–99, splattering is used to suggest stars.

For this exercise we are painting a dry-stone wall.

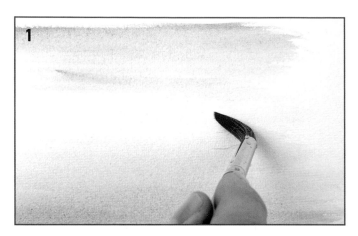

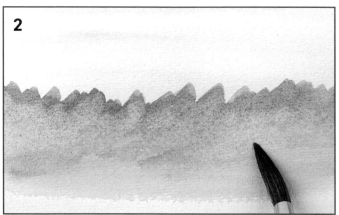

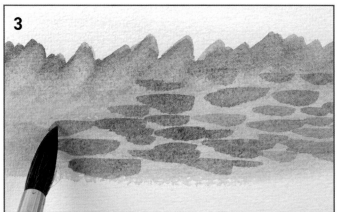

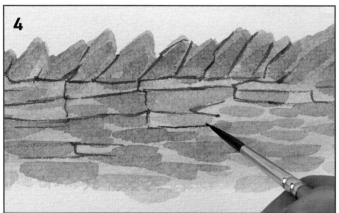

**1** Begin by wetting the sky area with a size 10 round brush. Clean the brush, wipe off any excess moisture, then paint in a medium natural yellow at the bottom of the sky area. Work it up so that it fades into the distance. Clean your brush again, then use natural blue to work down from the top of the sky until the blue fades into the yellow.

**2** Mix natural yellow with natural grey. Paint in a loose line across your paper in diagonal brushstrokes to create the top (coping) stones of the dry-stone wall. Clean your brush, tap off any excess, then soften the base of the wall until it disappears into the natural yellow at the bottom of the painting. Allow to dry.

**3** Use the same grey and yellow mix to paint in some of the stones sitting within the wall, using horizontal strokes in the area just below the coping stones. Add a few diagonal lines back over the coping stones once the paint has dried.

**4** Add a few cracks between the stones using a size 2 rigger and a strong natural grey. Make use of the fine point of the brush and use the rigger like a pen: rest it on the paper. Start by defining the coping stones; you do not need to separate all of them; just some here and there as you work across the wall. Start to define the cracks between the horizontal stones on the lower part of the wall – again, do not separate all of them; suggest the separations between the stones here and there. Allow to dry.

**5a**

**5b**

**5** Rotate your board in the orientation of the object you want to splatter and use scrap paper to protect any areas you do not want to cover, such as the sky. Any stray splatters can be washed out with a lift-out or flat brush, or turned into the shape of a distant bird. There are two ways in which you can apply splatter:

**a** Hold out the index finger on your non-dominant hand; hold your brush at one end with the other hand, and tap the brush firmly over your finger. A size 6 round brush is good for this method, which is more directional than option b.

**b** Hold the brush firmly with your dominant hand, and tap it with your fingers from above. This will result in a more random scattered effect.

## Tips

- *Before applying splattering to a painting, practise on scrap paper so that you know how much water to add to the paint and how much paint you need on the brush to make your splatters.*

- *The paint splatters will land in whichever direction your brush is pointing.*

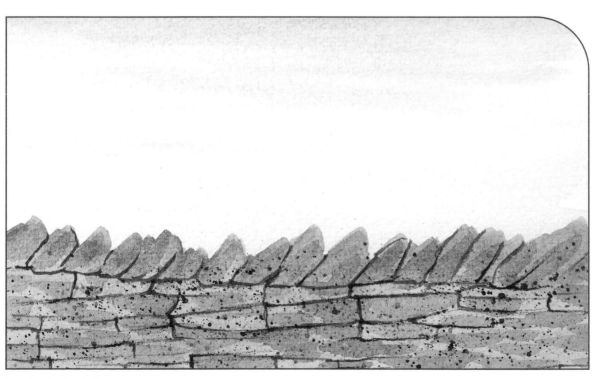

*The finished painting.*

# Painting skies

Skies are the first thing you paint on a landscape or seascape. Here I'll show you in step-by-step detail how to paint my three favourite styles of sky: daytime, night sky and a sunset.

## Daytime sky

A good everyday sky to add to your watercolour paintings.

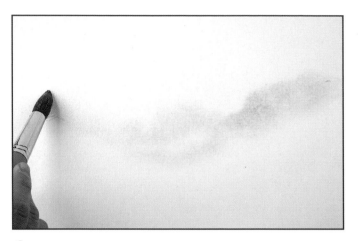 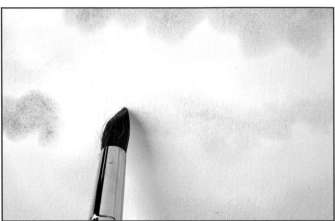

**1** Wet the entire sheet of paper with clean water, moving the board around to ensure that you do not end up with any dry areas. Work with your board on a downward tilt, and go over all areas twice. Brush off any excess water. Mix a pale natural yellow. In the centre of the paper and around the bottom, make some twisting motions, pointing the brush upwards, to give a cloudy effect.

**2** Take up pale natural blue on a size 20 brush. Use the same twisting action across the top of the paper, leaving some areas clear to suggest white clouds. As you move towards the centre of the sheet, the blue will mix with the pale natural yellow to give a nice, cloudy daytime feel.

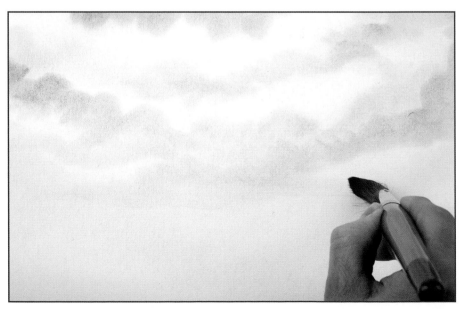

**3** Keep picking up new colour, wiping off any excess on the palette, and continuing the twisting action. Avoid going back over areas you have painted too much – once the paint is dry you will lose its softness. Move to a horizontal stroke as you reach the bottom of the paper, as the clouds should appear thinner, smaller and more distant.

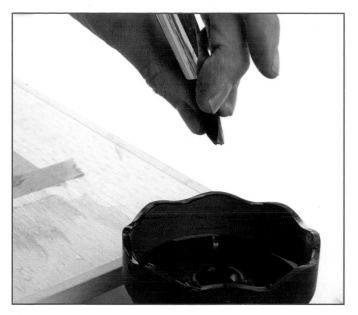

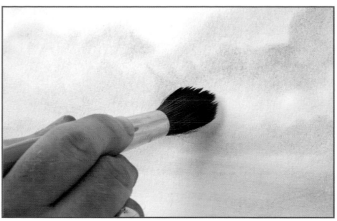

**4** Clean your brush, and squeeze out all the water. Pinch the brush flat so the bristles form a paddle shape.

**5** Use the dry, squeezed-out brush to soften away any hard lines at the bottoms of your clouds. When softening the clouds, it is important that the bottom of the sky blends away to nothing.

## Tip

*The best skies are the ones you complete and leave alone. Going back into a sky when it is almost dry can cause marks and cauliflowers (see page 82 on how to correct cauliflowers).*

*The finished painting.*

# Night sky

Using violets or purples gives a wonderful night feeling and a moon is the icing on the cake.

**1** With a size 20 round brush, wet the whole sky area. Next, lay a pale natural orange, wet into wet (see page 68), in the bottom half of the sky using a slightly diagonal brushstroke. Paint to the bottom of the paper for a smooth graduation.

**2** Go for a medium-consistency natural violet: this colour is great for evoking a night-time atmosphere. Work across the top to fill the paper, keeping your strokes horizontal. As you approach the orange area, start to work diagonally.

**3** Wrap a small coin in a sheet of kitchen paper. Where the violet and the orange strokes meet, make a firm impression with the coin to create a moon.

**4** Switch to a size 10 round brush, and mix a medium strength grey. Wipe off the excess paint until you have a dry brush. Starting from the right of the moon, twist in some grey clouds. Keep your brush pointing upwards, and overlap the moon to give your night sky an atmospheric feel. Taper the cloud over the moon to a neat point.

**5** Add as many clouds as you see fit, making the clouds smaller lower down the paper – make horizontal strokes with a very dry brush, barely hitting the paper. Twist over the tops of these small clouds to suggest even tinier clouds.

**6** Finish by softening the bottoms of the clouds with an almost dry brush to drag away any harsh lines. Make horizontal or diagonal wiping motions to keep the clouds looking soft.

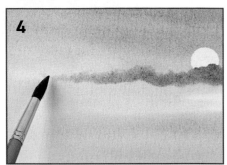

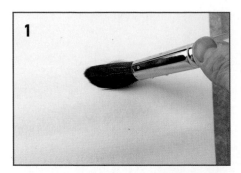

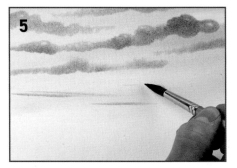

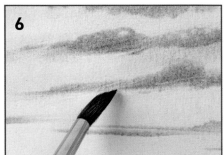

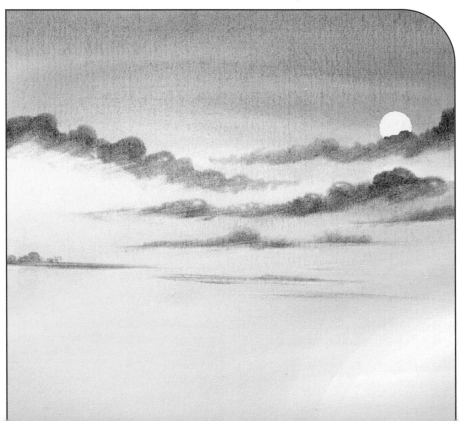

*The finished painting.*

# Sunset sky

Using yellows, reds and oranges, you can paint some stunning sunsets.

**1** Wet the whole paper with a size 20 round brush. Starting with a fairly strong natural yellow light, lay the wash across the bottom of the sky, working up and down so the colour fades in both directions.

**2** Start just above the yellow with medium-strength natural orange: bring the colour down the paper in a loose criss-cross movement to allow the orange and yellow to blend. Keep replenishing the brush with colour.

**3** Load the brush with medium-strength natural violet, and bring the colour down from the top of the paper to mix with the orange, again using loose criss-cross motions. Move quickly so all the colours blend.

**4** Pick up a tiny bit of natural red on a size 10 round brush. Make sure the colour is not too strong and the brush is fairly dry, then lay in a few strokes of red towards the bottom of the sky where the yellow and the orange meet.

**5** Stamp away the sun with a coin wrapped in kitchen paper, placing the stamp over the natural red strokes.

**6** Load the size 10 brush with some natural brown and natural orange for a rusty shade. Add some nice, silhouetted clouds around the orange sky area in the same way as for the night sky, opposite, using twisting motions. Add some natural grey into the mix to darken the clouds, then with a very dry brush, lay in one or two weak horizontal cloud lines lower down. Finally, soften the bottoms of the clouds with a dry brush.

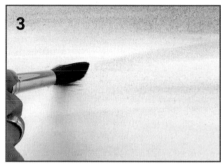

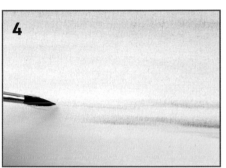

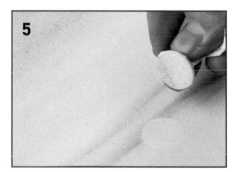

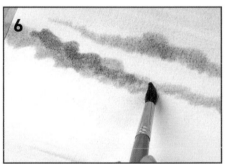

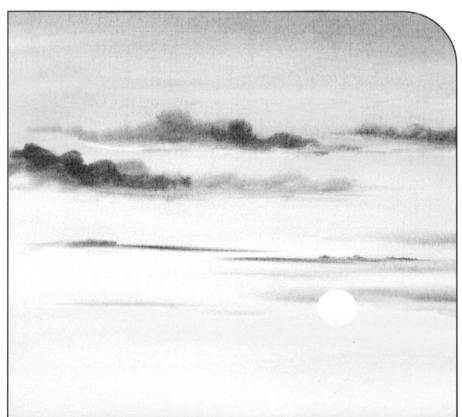

*The finished painting.*

# Painting water

## Reflections

The best reflections are painted wet into wet. This gives the reflections a soft, slightly out-of-focus look that is particularly well suited to a depiction of water. Reflections can be laid in as downward or vertical lines with horizontal ripples but should always mirror the direction of the objects reflected.

### Tips

- *Use the very point of the brush and hold the brush close to the tip (like a pen) when laying in reflections.*
- *When laying in reflections on still water, think of a mirror and use the same colours you have used in the sky.*

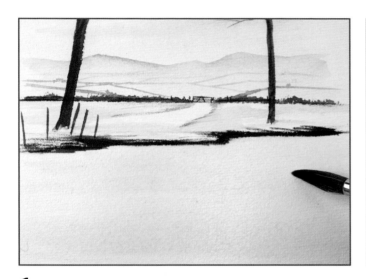

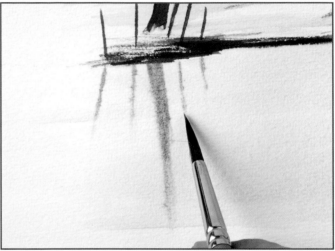

**1** We are beginning this exercise with a partly-completed landscape. With a size 10 round brush, wet the area below the riverbank and lay in horizontal brushstrokes of natural orange at the top of the water area to reflect the lower sky, then take up the natural blue from the sky and lay in the brushstrokes at the bottom of the water area.

**2** Switch to a size 6 round brush, and use a dark mix of natural grey and natural brown to lay in the reflections of the trees. Paint downwards from the base of the tree, and move in the same direction as each tree. Use a very dry brush to lay in the reflections of the fence posts in the same way.

**3** Use the size 6 brush and a transparent, watery natural grey to make loose horizontal brushstrokes over the surface of the water to suggest movement of the water.

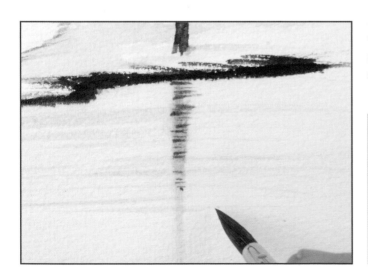

### Wet into wet

*Wet into wet, or wet on wet, is how I paint most of my watercolour skies and any areas in which I want the paint to mix and blend on the paper. The technique begins with wetting the area first, often with clean water, then applying paint. The watercolour reacts like ink on wet paper: it spreads or bleeds, giving a soft effect that is particularly ideal for depicting clouds, skies or water.*

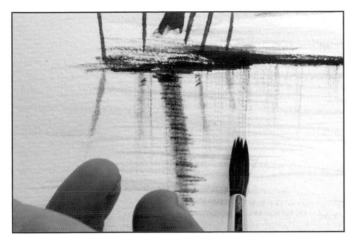

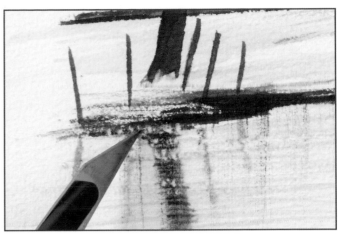

**4** Pinch the bristles of a size 10 round brush to splay them. Take up a small amount of the dark brown-grey mix from step 2, but keep the brush fairly dry: draw in some texture on the water from the bank of the water downwards.

**5** Finally, with the point of a sharp craft knife, scratch in some horizontal highlights over the darker areas on the edge of the bank and within the darker areas of the tree trunks.

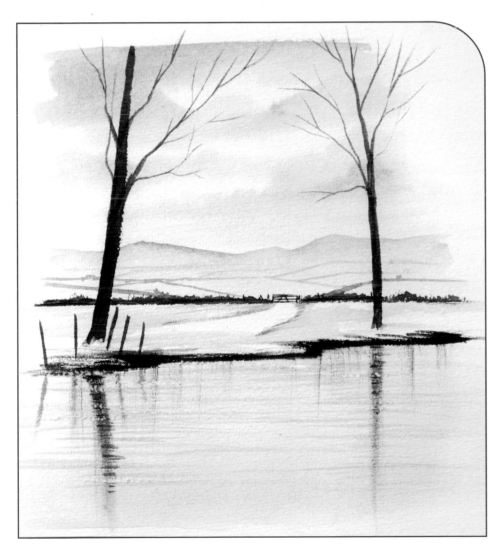

*The finished painting.*

# Waterfalls

I love painting waterfalls and flowing water; it's a very straightforward technique to learn. The key to depicting moving inland water is that it's all about the direction of the brushstroke.

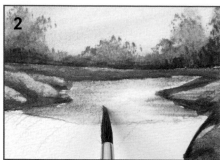
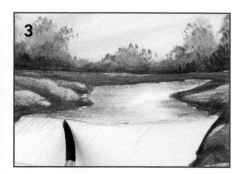

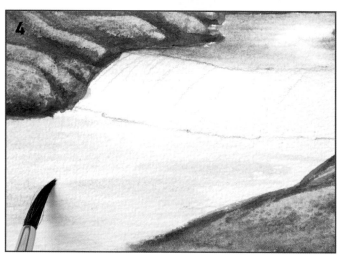
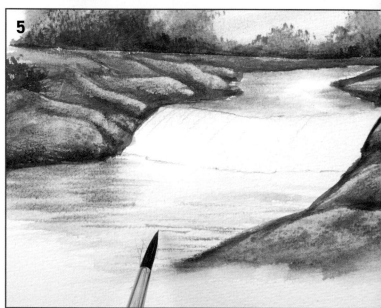

**1** Wth a size 6 round brush, wet the top water area then add the colours used in the sky. Start by laying in pale natural yellow in horizontal brushstrokes. Clean your brush, then lay in pale natural blue in the same area.

**2** To reflect the trees around the banks of the stream, mix natural green and natural green light, and add a few horizontal lines – wet into wet (see page 68) – just below the banks on either side of the stream above the waterfall.

**3** To create the line of the stream that meets the fall, soften the edge with a clean, damp brush, so the line disappears over the waterfall.

**4** Wet the bottom section of the waterfall, then put in horizontal brushstrokes in natural yellow. Space the strokes out a little more here to create the movement in the water. Repeat with natural blue, but do not lay in colour too near the bottom of the fall itself as the water will be very mobile here.

**5** Take up a mix of natural green light and natural green, and fill in the edges of the bottom section of water. Darken the edge of the water where it meets the bank on the left-hand side to suggest reflection. Put in a few horizontal lines coming from the right-hand bank. Allow to dry.

**6** Rotate your board. To portray the flowing water use a medium Tree & Texture brush with a pale natural blue. Stipple the brush in the paint, tap off any excess on kitchen paper, then apply very light pressure down over the middle section of the waterfall, following the movement of the water. Add natural grey to the blue, then add more movement lines over the middle section.

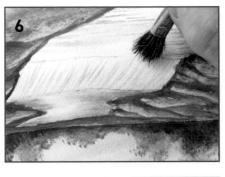

## Tip

*If you don't have a Tree & Texture brush with which to paint the waterfall, try pinching open the hairs of a size 6 round brush to create a similar effect.*

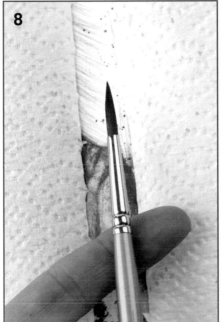

**7** With your board the right way up again, and working from the top section to the bottom, add horizontal ripples to the surface of the water with a size 6 round brush or a fine rigger. Lead the ripples in the direction of the flow of water.

**8** Use kitchen paper to mask out the top and bottom sections of the waterfall. Splatter the blue-grey mix from step 6 from a size 6 round brush.

**9** Make a fairly strong mix of natural green and grey, splay the bristles of your size 6 brush (see page 142), then, with your board rotated by 90°, make downward strokes from the edges of the bank to give depth to the water.

**10** Add some sparkle by scratching into the surface with the point of a sharp craft knife in the top and bottom sections of the waterfall. These may not be entirely visible but will lighten the area.

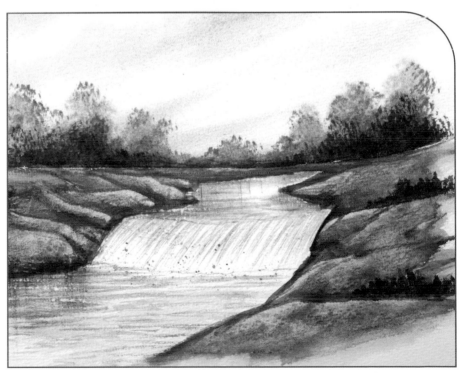

*The finished painting.*

# Ripples and highlights on the sea

The sea behaves very differently from lakes and rivers; it has more movement and very little reflection. To paint successful seas, we add ripples and rolling waves.

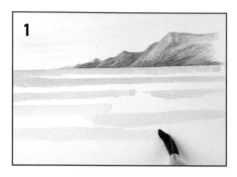

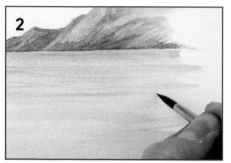

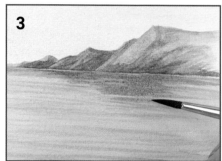

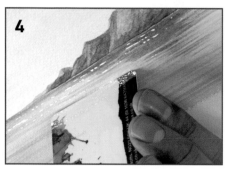

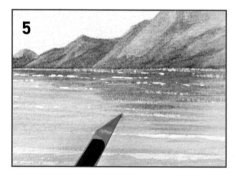

## Tip

*At step 4, add the white paint from a scrap of paper rather than from the palette as white can get forgotten and mixed in with other paint colours. Mix some water in with the white but do not dilute the colour as the white will disappear.*

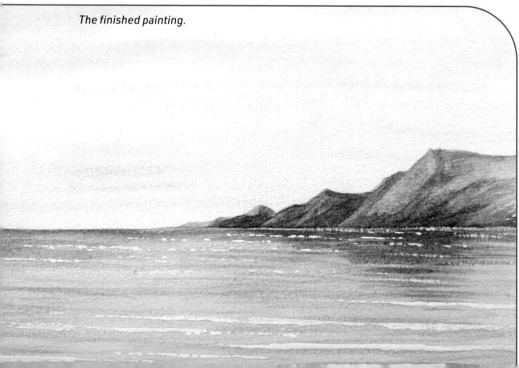

*The finished painting.*

**1** Working wet on dry (see page 48), with the point of a size 10 round brush, paint a clean horizon line in pale natural blue with a hint of natural grey for a distant sea colour. Move down the paper in horizontal strokes, leaving white spaces between the waves. Halfway down the sea area, lay in natural turquoise and continue in horizontal strokes down the paper. With a damp, clean brush, soften the turquoise in the foreground back into the greyer waters towards the horizon.

**2** Change to a size 6 round brush and, working wet into wet (see page 68) with the blue-grey mix, add horizontal lines for ripples all over the water area. Allow to dry.

**3** Add a few ripples beneath any cliff areas to suggest reflection, using a mix that matches the colour of the cliffs – for example, natural grey with brown. Catch the paper in horizontal strokes. Allow to dry.

**4** Apply natural white with a plastic card to create the effect of foam and enhance the ripples. Paint the white onto the edge of the card, and press the card straight down on the paper to suggest distant 'white horses'. To add large waves in the foreground, use the card at a less steep angle and pull it downwards as you apply it to the paper.

**5** For extra sparkle and light, make horizontal scrapes across the water with the point of a sharp craft knife. This works especially well along the bases of the cliffs, and can allow you to extend some of the white waves painted with the card.

# Painting trees

Trees are one of my favourite subjects. When I was learning watercolour as a child, I spent hours out and about with sketchbooks, simply painting trees. This is where the idea for my Tree & Texture brushes came from, and of course how I developed these realistic tree effects.

In this chapter, I will show you how to draw a winter tree, a summer tree and a cherry blossom tree.

## Note

*To paint an autumn tree, the technique is the same as for a summer tree, but you will use different colours (see page 45 for autumn foliage colour). The main difference is that an autumn tree has a softness and a warm glow about it that we associate with the season.*

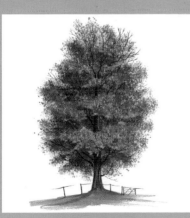

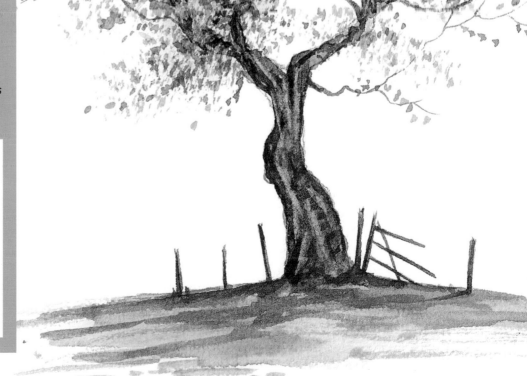

# Winter tree

Snowy winter scenes are among my favourite subjects. I love the way in which the use of shadows can tranform a white sheet of paper into a three-dimensional painting. Good winter trees are therefore essential. For instructions on how to draw pine trees, see the *Northern Lights* project on pages 90–99.

- The first thing to practise is the shape and structure of a winter tree. Remember the 'thick to thin rule': a winter tree goes from thick at its base to thin at its top and outer edges. It helps if you paint the tree in the direction in which it grows: from the ground up.

- Mix your colours.

- Paint the trunk, working in thirds.

### Colours

*From left to right: bark shadow, bark colour, light bark colour.*

- Bark shadow: 80% natural brown + 20% natural grey (or burnt umber and Payne's gray)

- Bark colour: natural brown

- Light bark colour: 80% natural yellow + 20% natural brown (or yellow ochre and burnt umber).

## Tips

- *It is important to taper the branches at the end and having less paint on your brush gives you more control over the taper. Wipe off the excess paint on kitchen paper before applying to the painting.*

- *Use the bark shadow colour to give the impression of branches growing from the front of the tree, and the paler colour for branches growing from the far side of the tree.*

- *To paint the fine ends of twigs, gradually lift and flick the rigger off the paper, or gently rub your finger over the tips to fade them.*

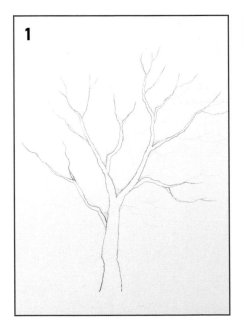

**1**

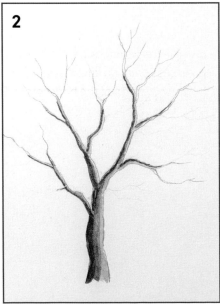

**2**

## Painting the tree

**1** Sketch a winter tree. Apply masking fluid to the tops of the branches where snow would settle. Also use it to paint some new branches.

**2** Work out from the centre as far as the width of your brush allows. Using your bark colour, blend the darker colour on the left with the bark colour in the centre. Use the light bark colour to paint the right-hand side of the tree branches.

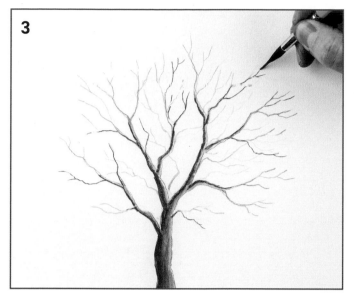

**3** Use either a size 1 rigger or a branching detail brush. Start with the light bark colour and work out from the main branches of the tree, painting some branches that are behind the tree. These can be ones you have sketched in or ones you paint fresh. Using the bark colour, start to expand from the main broad branches, working finely towards the tips. Repeat this on any final branches using the bark shadow colour.

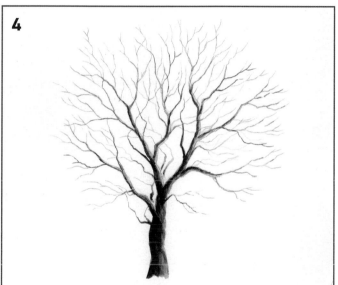

**4** To bring life to the winter tree, paint many fine branches and add a few shadows, creating a darker side. I've used a size 6 round brush to paint a shadow side on the left. With a damp brush (tap off excess water on kitchen paper) and natural shadow grey, blend this to the right. Try to use this shadow to bring branches in from the centre of the tree. Notice how I painted the shadow following the core trunk and 'branched off' to the large left branch. I left a small space and continued up the left side. These can be intensified later with the lift-out technique (see page 51). Use all three colours for the finer branches: natural shadow grey and bark colour for closer branches and and light bark colour for more distant branches. This helps to give a three-dimensional effect to the tree. Paint these fine branches using a rigger, tapping off excess paint on kitchen paper first. This allows the brush to paint extremely fine detail. Try to use just the tip of the rigger and hold it like a pencil, resting on the paper to give stability. Paint in the direction the branches grow, trying to 'flick' or taper away at the ends. The drier the brush the finer the branch.

**5** Winter trees always have a few leftover leaves and branches that seem too fine to paint. The secret to fine branches is to be very dry with the paint, by tapping off excess paint on kitchen paper and using a paler, watered down version of the bark colour. Practise the technique first and gently stroke the fan brush or a 'splayed bristle' size 6 brush inwards (see page 142). The drier the paint on the brush the better. You can build this up around the masking fluid to help the snow pop! Use the tip of a size 6 brush to 'spot' the odd leftover leaves.

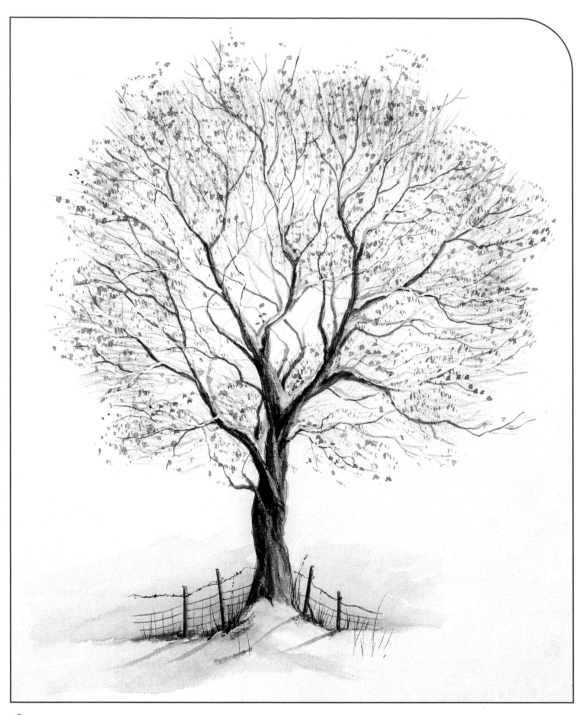

**6** The next stage is to paint some snowy branches. Remove the masking fluid and use a pale natural violet (or mix 80% intense or dioxazine violet with 20% French ultramarine blue). This is a pale colour for where the snow has settled and for some fine branches, going over the areas where the masking fluid was. This colour can be used to paint a snow base and shadows for the fence at the base. Use water to blend this away into the background.

Adding highlights to the trunk and branches with a small lift-out brush or a 6mm flat brush gives a wonderful three-dimensional effect. Pick up water, tap off the excess on kitchen paper. Using the tip, scrub away the paint. Firmly dab off with dry kitchen paper. Try to bring branches into the centre of the wide trunk by lifting out lighter lines that follow the tops of a branch and lead into the central part. This is the opposite side to the shadows you added in the previous step. A few twists and knots can be created here too.

Add a rustic fence and a few grasses and you have a lovely winter tree.

# Summer tree

When I started painting in watercolour, I really struggled with summer trees, so I went through a stage of painting nothing but summer scenes, and developed my own technique. Over the years, this has evolved. For how to draw palm trees, see the *Hawaiian Sunset* project on pages 114–131.

Look at summer trees and note the shadow areas, and the way the darkest parts almost form bands across the tree. These are the 'in' parts of the tree. Note also that you can see the branches over these areas.

## Shape

The first thing to practise is the shape. A good summer tree shape to aim for is almost oval, with a few lumps on the side.

I always start with a basic sketch of the height and shape, which I draw in a zigzag style to create the 'ins' and 'outs' of the tree.

## Greens

Mix your greens (see page 38). I have my own greens in my Natural Collection, including average green. You will also need a bright green. For the darkest shades of the tree, use a shadow green.

*Avoid lollipops or triangular Christmas tree shapes.*

*Aim for an almost oval shape. Start with a zigzag-style tree.*

### Colours
*From left to right: shadow green, average green, bright green.*

- *Shadow green: 70% aureolin + 30% natural grey*

- *Average green: 70% aureolin + 30% French ultramarine*

- *Bright green: 70% lemon yellow + 30% French ultramarine.*

## Stippling

Practise the stippling technique to achieve a leafy effect. Gently stipple a size 6 brush in the palette to splay the bristles a little, allowing you to paint several leaves in one go. I use my Tree & Texture brushes which are specifically made for this purpose. Pick up only a little paint on the brush and stipple on to the paper with light pressure.

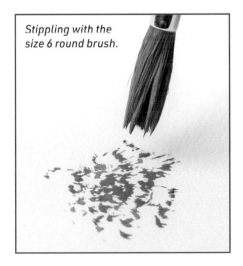

*Stippling with the size 6 round brush.*

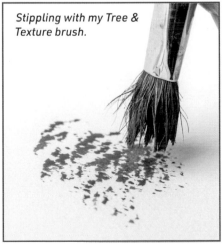

*Stippling with my Tree & Texture brush.*

## Painting the tree

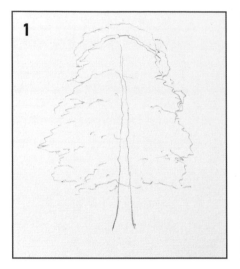

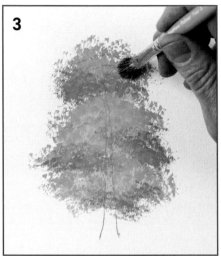

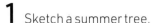

## Tips

- *Don't rinse your brush between using the greens, just tap off the excess on kitchen paper.*
- *When using the rigger brush to paint the finer branches, use only the tip of the rigger and hold it like a pencil, resting on the paper to give stability.*

**1** Sketch a summer tree.

**2** Use either a medium Tree & Texture brush or a size 10 round brush (see page 77 on stippling with brushes). Start with the bright green and loosely fill in the shape of the tree using a zigzag pattern. Pick up the average green and start to stipple the brush in the palette to separate the individual hairs and stipple around the edge of the tree, applying gentle pressure to create individual leaves.

**3** Introduce the shadow green. Work out where the shadow areas of the tree will be – look for where the tree is slimmer. Add stippling to the underneath of the large branches to make the tree look three-dimensional. Wash your brush thoroughly and remove the excess water on kitchen paper. Use the damp brush to stipple over the edge of the shadow green areas on the inside of the tree to soften and blend them.

**4** Weave the trunk and branches through the foliage. The darker areas are the inside of the tree and lighter areas indicate the outer foliage. Following this shadow versus light rule, paint the main trunk first. Gradually taper the central trunk towards the top of the tree. As you reach the top, literally 'branch out', painting in the direction the tree grows. Use a size 6 round brush for the main trunk and then move to a rigger for the finer branches. Tap off the excess paint on kitchen paper to allow the brush to paint very fine branches. Alternate between a strong natural grey and the bark colour, trying to add the grey at the point where the trunk goes in to the foliage.

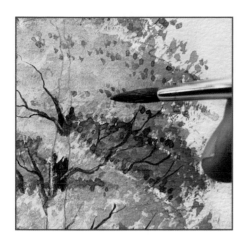

**5** This is where the tree comes alive. Using a size 6 round brush and a dark green or shadow green, 'spot' extra shadows and foliage onto dark areas to give more depth to the trees. This pushes the foliage back and gives a strong three-dimensional feel. Place these dark spots on the tops and bottoms of the dark areas and use the average green to blend or spot into the centres of the shadows. Average green is also great for painting random, extra leaves anywhere around the tree, from the inside of the light areas to the outside edges. This adds extra texture to the tree.

To add definition to the trunk and branches, use the lift-out technique (see page 51) using a small lift-out brush or a 6mm flat brush. Pick up water, tap off the excess on kitchen paper, then using the tip scrub away the paint. Firmly dab off with dry kitchen paper. It's amazing what a difference this makes. Try adding this detail to the finer branches as well as the bark.

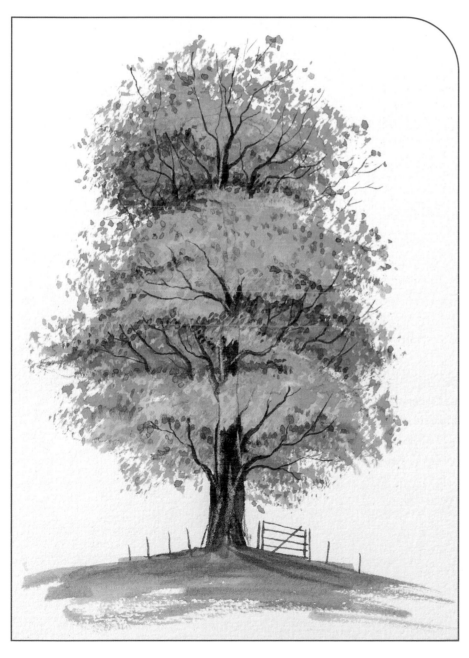

**6** To finish the tree and add scale, paint a grassy base and a rustic fence and gate using the grey and the rigger.

# Cherry blossom tree

There's nothing more eye-catching than a flowering cherry blossom tree and this step-by-step exercise will teach you how to capture this beautiful spring tree.

### Colours

- *Watery mixes, from left to right: shadow blossom mix, rose madder*

- *Shadow blossom mix: 80% rose madder + 20% French ultramarine blue.*

## Painting the tree

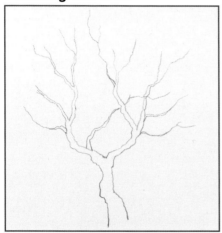

**1** Sketch a cherry blossom tree.

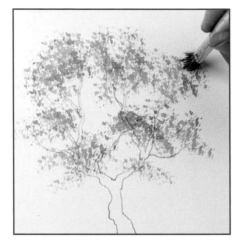

**2** Use either a medium Tree & Texture brush or a size 10 round brush. Start with the rose madder and gently stipple around the shape of the tree to represent the blossom.

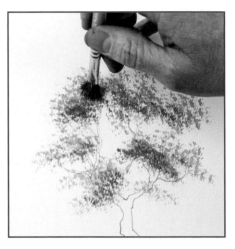

**3** Use the shadow blossom colour mix. Gently stipple at the base of the bunches of blossom. Clean the brush, wipe it almost dry, then blend the shadows into the light blossom.

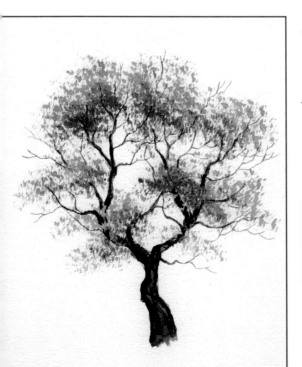

**4** To weave the branches through the blossom, use a size 6 round brush for the larger trunk and a rigger for the finer branches. Notice how these gradually taper from a thick trunk to a fine branch. Tap off the excess paint on kitchen paper before painting the fine branches – this allows the brush to paint super fine detail. Then paint in the direction the branches grow. Simply alternate between a strong natural grey and the bark colour. Adding a few areas of the light bark colour helps too. Once this area is dry, use the size 6 brush and the natural grey to add a darker side. On this example, I've painted the right side of the tree darker.

## Tip

*When using the rigger brush to paint the finer branches, use only the tip of the rigger and hold it like a pencil, resting on the paper to give stability.*

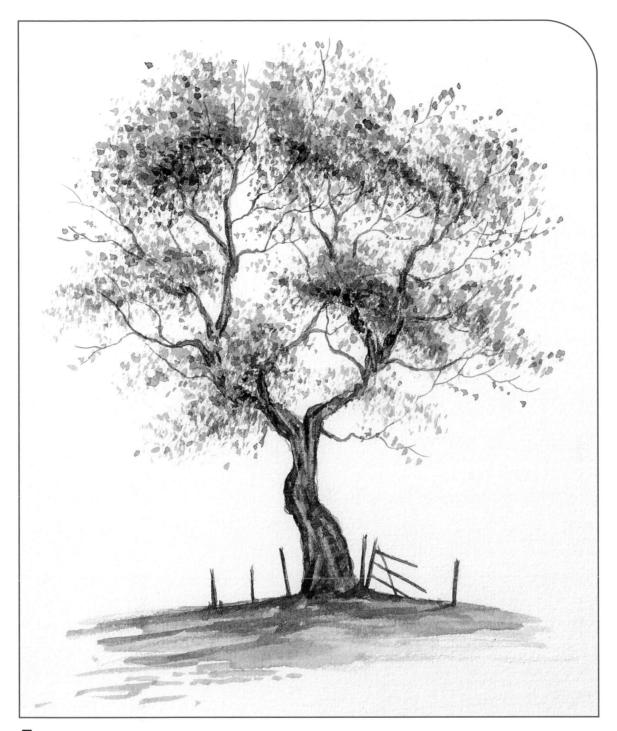

**5** Adding highlights to the trunk and branches with a small lift-out brush or a 6mm flat brush gives a three-dimensional feel. Pick up water, tap off the excess on kitchen paper then, using the tip, scrub away the paint. Firmly dab off with dry kitchen paper. Try to bring branches into the centre of the main trunk by lifting out lighter lines that follow a branch and lead into the core part of the trunk.

Using the rose madder, paint extra spots with the tip of your size 6 brush. Simply spot around randomly. Then use the blossom shadow mix to intensify the shadow area. A few spots using average green will help to bring extra life to the tree. Finally, paint a grassy base with a touch of the rose madder and an old rustic fence.

# Troubleshooting

After years of painting and teaching watercolour to groups, one lesson I've learnt is that we all make mistakes. Here are some common problems that occur and how to fix them. Learning how to correct mistakes is as important in the study of watercolour painting as the painting itself.

After a long painting session, it is important to walk away and come back at a later stage to critique your work. Looking over a painting with a fresh eye is essential, in order to iron out any problems, add a few extra details here and there and generally improve the final result.

## ◼ Correcting cauliflowers

'Cauliflowers' happen when water is added to an area of pigment that is almost dry – such as a wash for a sky. The dispersal of pigment causes a white mark with rippled edges to appear. This mark looks like the head of a cauliflower, hence the name. This is a very common problem especially for beginners, but don't panic! Simply allow the water to dry, then fix the issue as follows.

### Method 1

Using the same brush you used to lay down the paint in the area affected, wet the whole area, spending time going over the cauliflower itself. Focus your brushstrokes over the cauliflower to blend it into the wash and remove it. This will work in most instances.

### Method 2

You may find that some papers hold the stain more than others; and some colours will stain more than others. If the cauliflower proves harder to remove using the first method, try wetting the whole affected area, then add some more of the original wash colour to cover up the mistake. Lay a smooth wash over the cauliflowers so that they 'disappear' into the wash.

### Tip

*Having problems removing a cauliflower? You can always cover it with a grey, silhouetted cloud. Dampen the area with clean water using a large brush, then use a smaller brush to lightly 'twist in' some rolling clouds. Use a medium-strength natural grey and tap off any excess paint on kitchen paper before you apply the paint.*

# Removing a bristle from the wash and repairing a scar

A common problem for watercolour painters is that stray bristles can sometimes detach from the paintbrush. If this happens, the best thing to do is to leave the bristle on the paper until the paint has dried. You can then blow the bristle away.

If you pick at the paper to try to remove the bristle, you are likely to scratch the paper with your fingernail (as shown here). The same can happen if you use a palette knife, as the blade can scar the paper. The best option is to forget the bristle is there and it will blow away in the wind once dry. If you do get a scar on the paper, you may be able to hide the scar by reactivating the paint around it and covering the blemish with pigment. If you are left with a tiny mark in a sky area, you could paint a flying bird over it, or even a cloud in natural grey.

Sandpaper can also be used to sand out a white cloud; or use an opaque white watercolour – such as natural white – to paint in a white cloud over the scar in the paper. However, this should only be used as a last resort.

*Paper scratched by a fingernail when removing a bristle.*

# Fixing water spots in stippled areas

If you accidentally drip water from your brush into an area of foliage, washing away the colour, it can be easily fixed!

Let the paint dry completely, then take up a small brush – in this instance, the small Tree & Texture brush – to soften the tree tops. Mix the same foliage colours from your palette, then stipple directly over the water spot. Clean your brush, wipe it almost dry, then stipple around the area to work the new paint into the old.

If you need to use a palette knife to reintroduce branch details, you can do so at this stage.

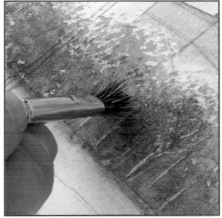

# Repairing torn paper

Watercolour paper can sometimes get ripped or lose its surface. If old masking fluid has been left on the paper for too long, removing it with your finger can tear the surface of the paper. Rips in the paper surface can also be caused if you do not remove enough adhesive from masking tape, or you remove the tape too quickly after masking.

There is no need to panic if you do rip the paper, however – sandpaper is a great remedy for smoothing out the paper.

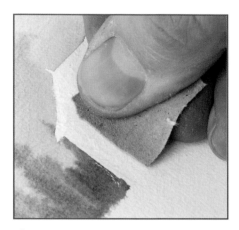

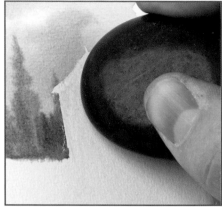

## Tip

*Avoid painting straight over an area of ripped paper. If you do so, a scar will appear on the damaged surface in a similar way to when you try to remove a bristle from a wash (see page 83).*

**1** Brush away any excess damaged paper with your hand, then use a fine-grain sandpaper to sand the paper smooth again.

**2** Once smoothed out, use a polished object such as a smooth pebble or your fingernail to flatten the surface. A gentle rub over will smooth and flatten the paper, and make it suitable enough for painting.

*The rip on the paper is caused by removing masking tape too quickly.*

Masking tape is used to mask off an area, for example when painting a sky the tape is used to protect the landscape below. If the tape is too sticky or you remove it from the paper too quickly, the paper can rip. To prevent this happening, remove the stickiness from the tape by running your hand over the masking tape several times. When removing the tape from your paper, use a hairdryer to loosen the adhesive. The heat will soften the glue and allow it to be removed more easily.

## Flattening cockled paper

If your watercolour paper cockles when you apply a wash, don't worry – it is more than likely to flatten once it is dry. Otherwise, you can dry the paper with a hairdryer, while flattening it with a clean hand.

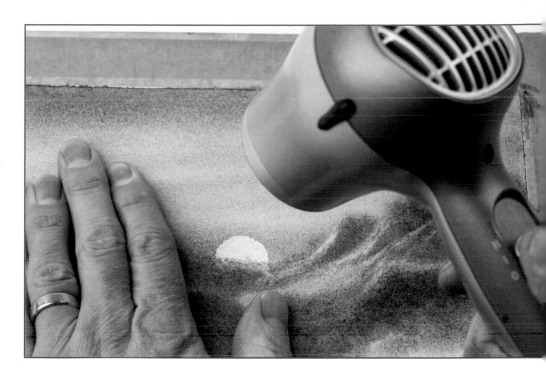

## Repairing a damaged masking brush

If you don't wash your masking brushes regularly, the masking fluid can dry onto the bristles and turn them to solid rubber, making the brush useless (**a**).

The best way to prevent this happening is to dampen the brush and coat it in soap before you paint. However, if you have not done this, you can use rubbing alcohol as a cure, or white spirit, which will crystallize the fluid. Leave the brush immersed in a saucer of alcohol for several hours (**b**). Wash off the alcohol with soapy water and see how the fluid crystallizes. This method will not remove all of the fluid but will remove most of it.

**a**

**b**

# The Projects

Now you have learned the essential watercolour techniques, you can have some fun and work along with me to create these six step-by-step projects. Every brushstroke is detailed for you, every colour mix is given so you can achieve six wonderful watercolours – a sunset, a night-time snow scene, a summer waterfall, gondolas in Venice, the aurora borealis and a poppy meadow.

I use my own collection of paint, 'Matthew Palmer's Natural Collection' (see pages 9 and 36–38). You can, of course, replicate any of these mixes using the paints you already have (see pages 40–45 for more information on colour-mixing).

Each painting uses techniques that you have already begun to master, whether you are capturing dark skies or flowing water, portraying reflections or depicting realistic-looking trees.

## Using the outlines

In the centre of this book you will find fold-out pages that feature the outlines of these six projects. These are reproduced at full-size and are designed to fit a standard sheet of quarter imperial or A3 – 42 x 29.7cm (16½ x 11¾in) – watercolour paper.

Carefully remove the outlines from the book along the perforations. See pages 88–89 for how to transfer the outline to your watercolour paper.

As well as being provided in the book, the outlines for the six projects are available to download from the Bookmarked Hub: www.bookmarkedhub.com – search for this book by title or ISBN: the files can be found under 'Book Extras'.

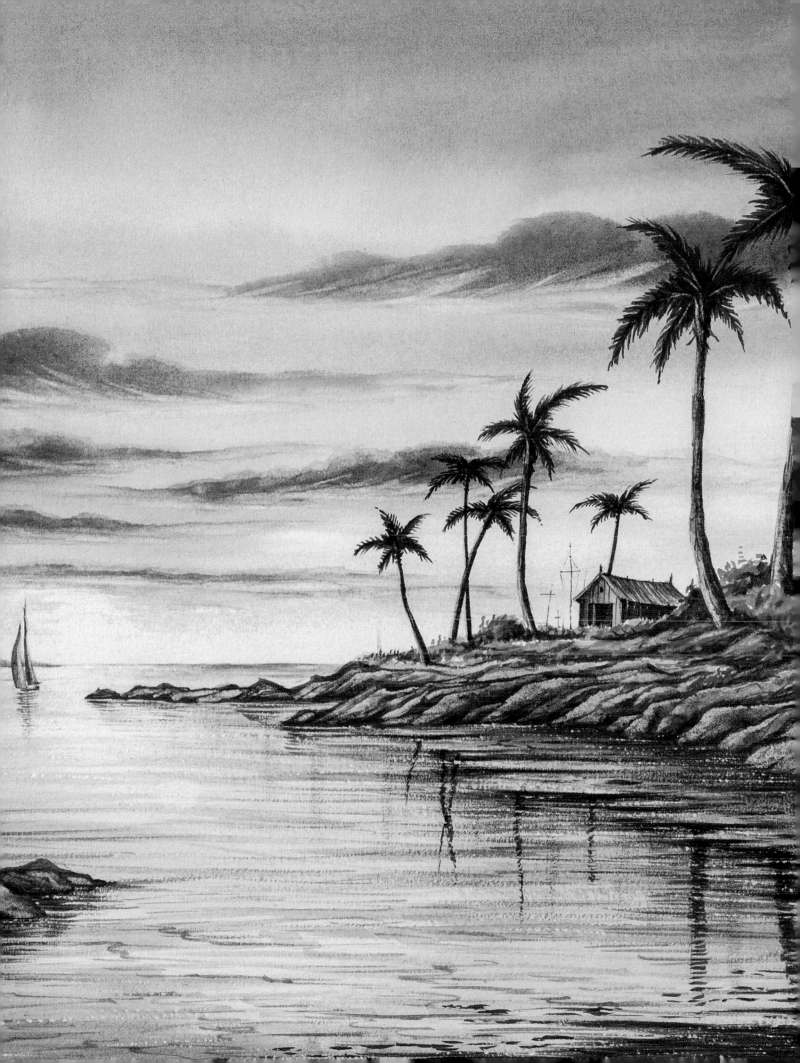

# Transferring the outline

When you are drawing for a painting, only the basic outline is required. The outline drawings for all the step-by-step projects in this book are provided. You can transfer the outline to your watercolour paper by using a soft pencil to scribble over the back of the outline. Then trace onto your watercolour paper. It is also a good idea to reinforce the outline once it is on your watercolour paper, as your brush may wash off some of the pencil when you begin to paint.

## Tracing the design

**1** Scribble over the back of the outline paper with a soft 2B pencil. Turn the paper over and tape it down over your watercolour paper. Draw over all the lines with a sharp pencil.

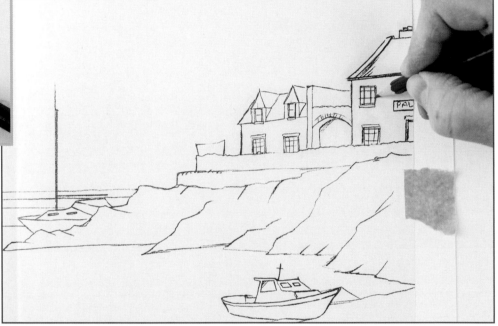

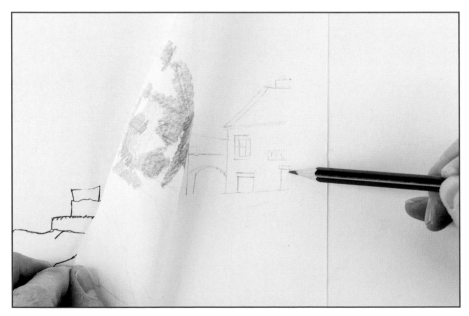

**2** Lift up the outline to reveal the drawing transferred on to the watercolour paper ready for painting. You may need to reinforce some of the lines with a pencil directly on the watercolour paper.

## Using a window

A simple and traditional way to trace is to use a brightly lit window, working from the inside looking out. The window acts almost like a light box. This technique works best on bright days.

**1** Place the outline from the centre of this book behind a sheet of watercolour paper and tape to a window where the source of light is behind your paper. Turning off any inside lights will make it clearer to copy.

**2** Use a pencil to trace the outline onto your watercolour paper.

# Northern Lights

I love it when it snows and snow is one of my favourite subjects to paint. I like the contrast between a dark sky and the snow. This painting of the northern lights has mood, atmosphere and high contrast which makes it such an interesting scene to paint. The bold shadows and the varied direction on the sky make for a really fun project.

## You will need:

Outline 1

Watercolour paper: 300gsm (140lb) 100% cotton Not surface

Colours: natural yellow light; natural red; natural turquoise; natural grey; opaque white; natural violet; natural green; natural brown

Brushes: sizes 6 and 20 round; extra-large lift-out brush or 12mm (½in) flat; rigger or branch and detail brush

Other: pencil; masking tape; kitchen paper; craft knife

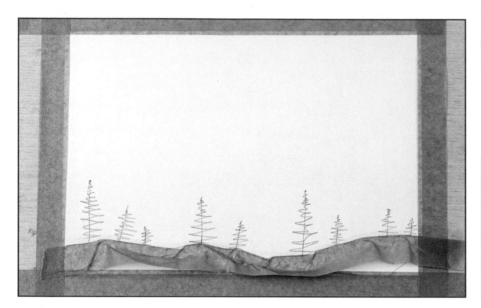

## Note

*If you do not have the Natural Collection paint colours listed above, see the colour comparison chart on page 36 for generic colours that can be used as suitable alternatives.*

**1** Transfer your outline (see pages 88–89), and secure your watercolour paper to the board on all four sides using masking tape. Add a band of masking tape along the contours of the snowy bank, removing excess stickiness from the tape by rubbing it on your clothing. Make sure the tape is firmly pressed down.

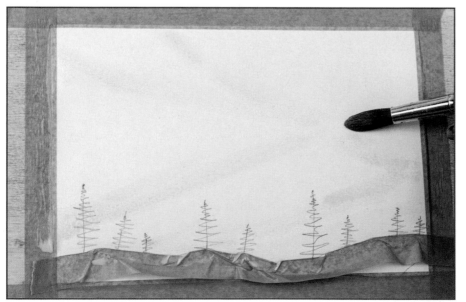

**2** Wet the paper three times with a size 20 round brush, using long horizontal strokes back and forth. Try to avoid wetting the area closest to the masking tape, to prevent seepage behind the tape. Tilt the board towards you at a 45° angle to help the paint to travel down the page. Working from the bottom in a zigzag shape across the page, apply strong natural yellow light.

## Tip

*Practise the sky on a smaller sheet of paper first.*

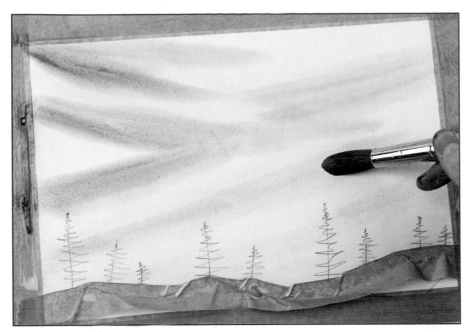

**3** Clean the brush really well and apply a natural red, continuing in a zigzag shape next to the yellow. Work rapidly before the paint dries.

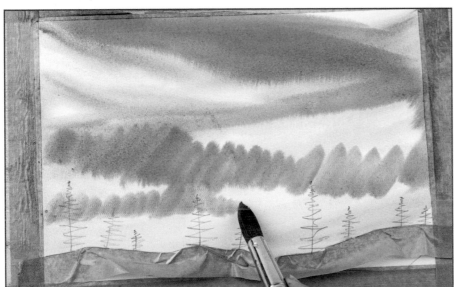

**4** Clean the brush and apply natural turquoise in the same zigzag shape at the top of the page. Lower down the page, use smaller diagonal strokes.

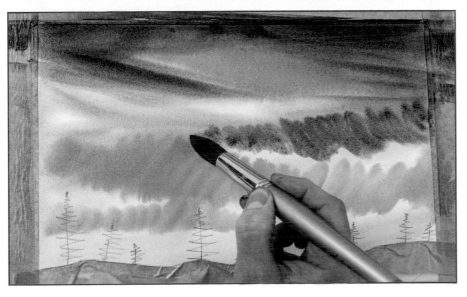

**5** Clean your brush well. Mix a strong natural grey with a touch of natural red. Work along the top of the sky, brushing in between the turquoise and the yellow. Make sure this colour is strong so you can add stars to the sky later. Make small diagonal strokes with the same colour, working about halfway down the sky.

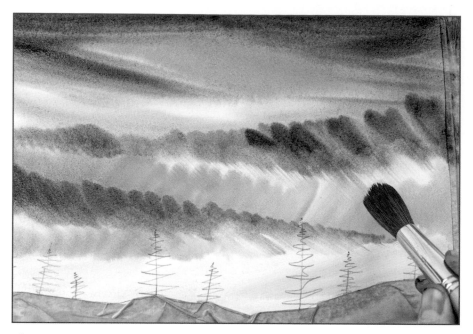

**6** Clean the brush really well and squeeze it flat through some kitchen paper. Spend plenty of time feathering the colours to create diagonal lines, dragging the paint down towards the horizon.

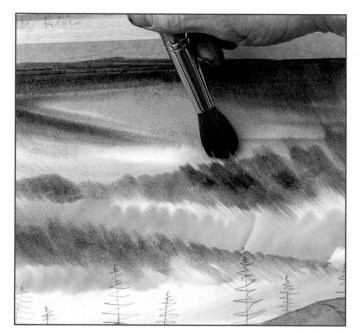

**7** Repeat this process at the top of the dark areas.

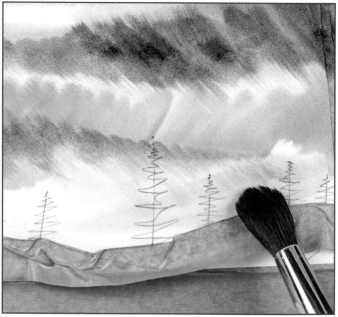

**8** Soften any hard areas of sky with the splayed damp brush. Allow to dry.

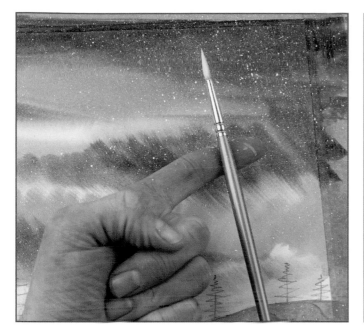

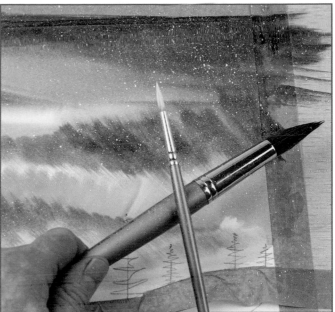

**9** Using opaque white on a size 6 brush, remove excess paint, then tap the brush against your finger to create large stars in the sky or a falling snow effect. It's a good idea to practise this technique first. See pages 62–63 for splattering technique.

**10** Repeat by tapping the brush against a larger brush to give the impression of finer stars. Add more stars to the top of the page. Allow to dry.

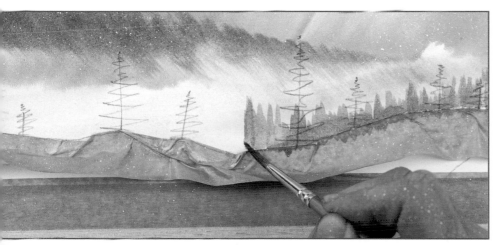

**11** Paint distant pine trees using a size 6 brush and a watery natural grey. Create lots of vertical lines of various heights down to the masking tape.

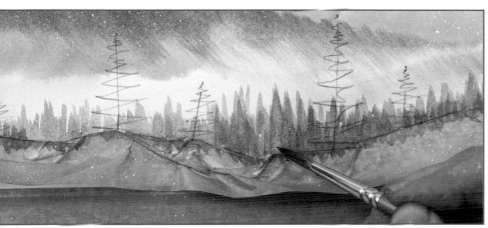

**12** Add a second coat of natural grey, varying the height to give misty layers. Allow to dry.

**13** Using a slightly stronger mix of natural grey, paint in some more detailed misty trees scattered across the horizon. Start with vertical lines.

**14** Using the tip of the size 6 brush, paint the right-hand side of the trees, making sure they have a wide base and get progressively thinner towards the top of the trees. Each branch is defined with a diagonal flick pointing towards the sky.

**15** Add some extra flicks to the base of the trees as well as on the branches to suggest shadows.

**16** Carefully remove the masking tape. If any paint has seeped behind the tape, you can hide it under texture marks later.

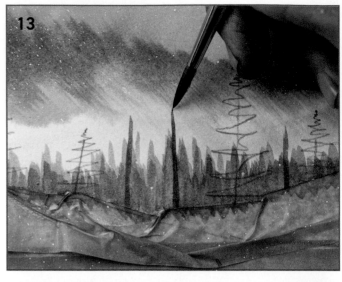

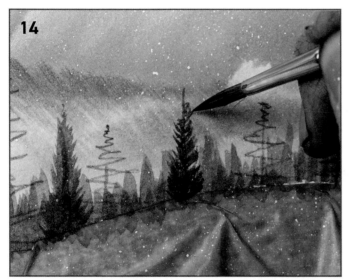

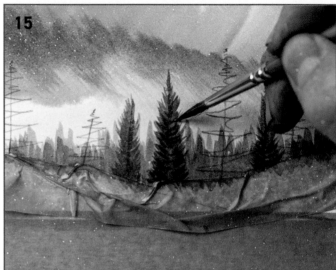

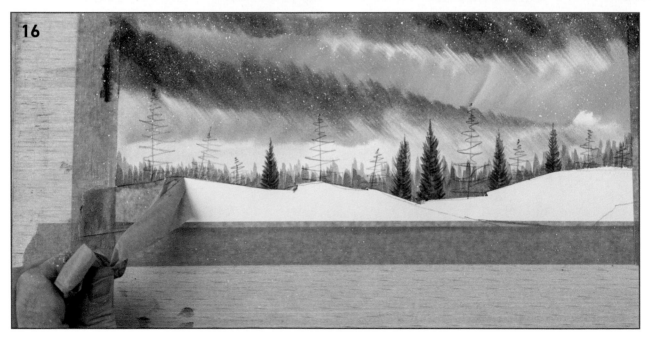

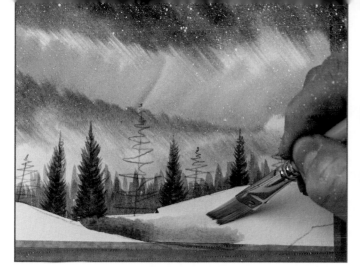

**17** Using a 12mm flat brush and natural violet, paint a diagonal line from where the two hills cross over down to the masking tape. Clean off your brush, tap on kitchen paper, then blend the line on the paper creating a separation effect.

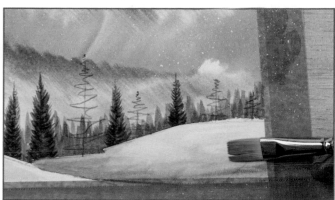

**18** Darken the bottom two corners of the paper in the same way to give a strong composition. Allow to dry.

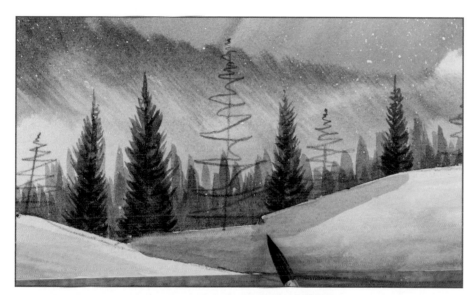

**19** Using a size 6 brush, add some transparent glazes of diluted natural turquoise at the base of the trees and in the snow area.

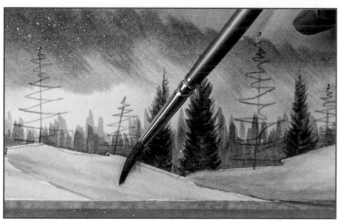

**20** Clean your brush and dab on kitchen paper then repeat with the diluted natural red.

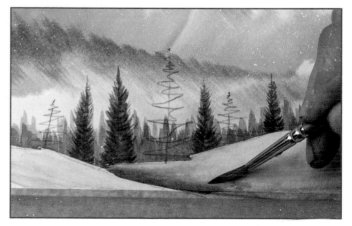

**21** Using a medium-strength natural grey, add a slightly stronger shadow in the separation between the two banks. Clean the brush and dab it on kitchen paper, then blend. Add these shadows to other areas that need definition.

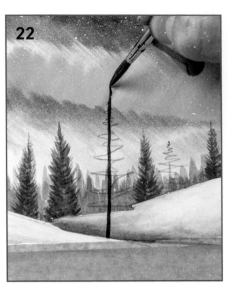

**22**

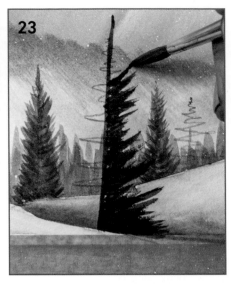

**23**

**22** Use strong natural grey with a touch of natural green and a size 6 brush. Paint in the central trunk of your first foreground tree.

**23** Paint one side of the branches then the other, slightly pointing towards the sky and reducing the length of the branches as you get closer to the top of the tree. Rotate your board if that feels more comfortable.

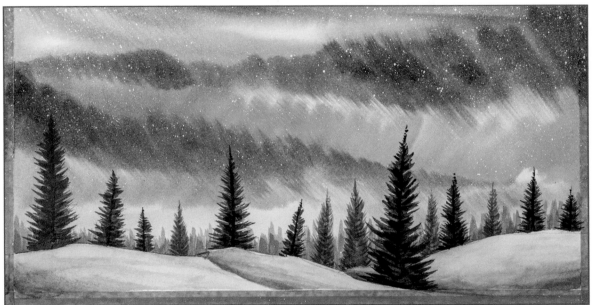

**24** Repeat until all the pine trees are completed. Allow to dry.

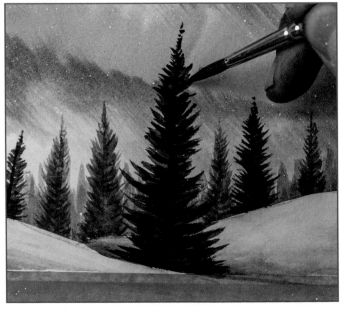

**25** Add a touch of natural brown to the natural grey and natural green mix to introduce a few shadows in the trees. Apply around the base of the tree to help ground it.

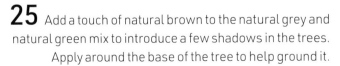

**26** Use the same dark colour to add some texture to the snow by representing grasses and dark earth underneath. Use a dry-brush method for this (see inset). Using the splayed edge, lightly skim the edges of the snowy banks to give texture. Loosely follow the contours of the snowy hillside and add to the base of the pine trees to suggest shadows. This helps ground them in the picture.

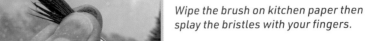

*Wipe the brush on kitchen paper then splay the bristles with your fingers.*

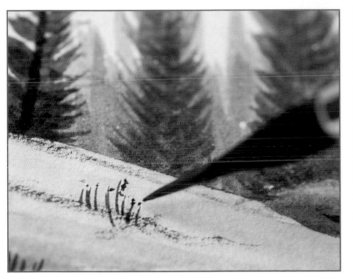

**27** Take a rigger or branch and detail brush and add a few tall grasses coming out of the dark textured areas. Add a few spots to the top of the grasses to give more detail. This helps to convey scale and also works well in the corners of the painting.

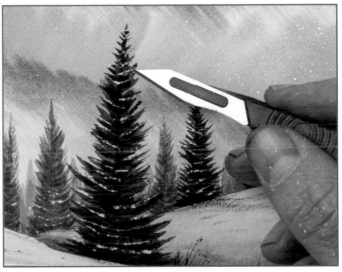

**28** Finally, use the tip of a craft knife to scrape some of the paint off the dark trees, following the curved shape of the branches. This will reveal the white of the watercolour paper underneath and give the appearance of settled snow. You can also do this to the misty background trees. The finished painting can be seen overleaf.

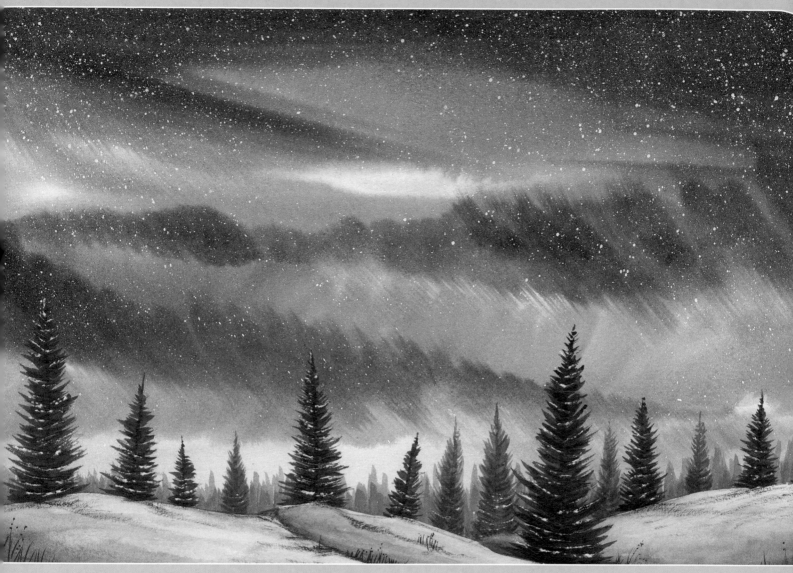

*The finished painting.*

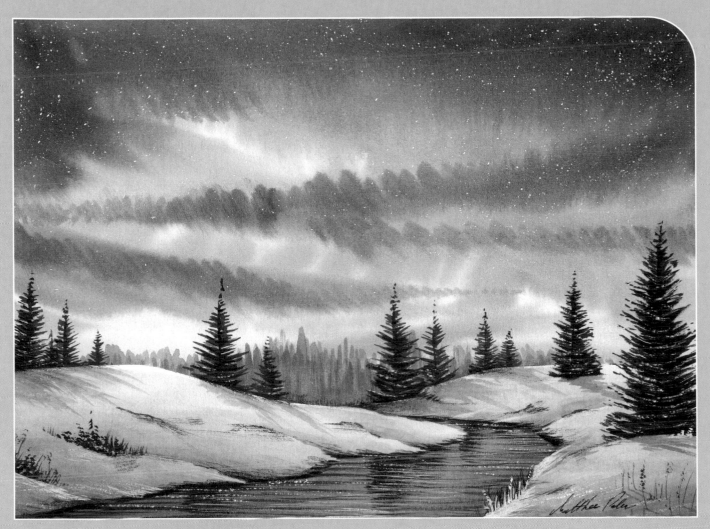

*If you want to extend this project further, you can add more snowy banks as well as a winding river, as I have done in this variation above.*

# Venice in Monochrome

I have been to Venice many times and every corner is full of inspiration. I went in early December and it was very quiet. The gondolas were stored away for the season and in the evening, they were covered up for protection. I took many photographs, and I have worked from memory to recapture this atmospheric painting in monochrome.

## You will need:

Outline 2

Watercolour paper: 300gsm (140lb) 100% cotton Not surface

Colours: natural grey; natural brown

Brushes: sizes 4, 6, 12 and 20 round; extra-large lift-out brush or 12mm (½in) flat brush

Other: pencil; masking tape; masking fluid; kitchen paper; small coin; craft knife; eraser

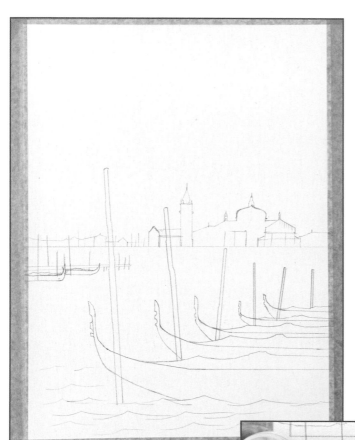

## Note

*If you do not have the Natural Collection paint colours listed above, see the colour comparison chart on page 36 for generic colours that can be used as suitable alternatives.*

**1** Transfer your outline (see pages 88–89), and secure your watercolour paper to the board on all four sides using masking tape. The board can be stiff cardboard or wood. Try not to overlap too much of the outline with the tape.

**2** Apply masking fluid using a slightly old brush, size 4. Make horizontal brushstrokes of random lengths to represent the moon reflection. As you get lower down the page towards the gondolas, make these lines longer and more spaced apart. See the section on using masking fluid on pages 54–55. Add a few masked off areas to the lapping water at the base of the outline.

**3** Prepare three shades of natural grey in your palette: a pale (30% paint, 70% water), medium (50% paint, 50% water) and dark grey (70% paint, 30% water). Once the masking fluid is dry, use a size 20 round brush to wet the entire page. I recommend doing this twice, but avoid oversoaking it. Starting with the palest grey at the base of the sky, work up to halfway, then work down, covering the entire water area. Don't be afraid to paint over the gondolas and buildings.

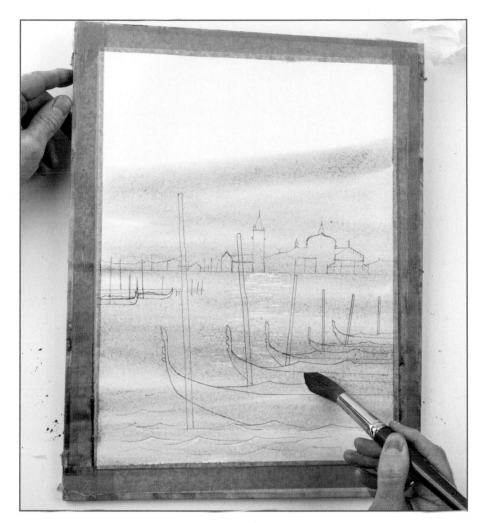

**4** Using the medium grey, start at the top of the page and work down until it meets the paler grey. Spend time smoothing out the colours so they blend together. Add some of the medium grey to the foreground, blending in to the middle of the scene.

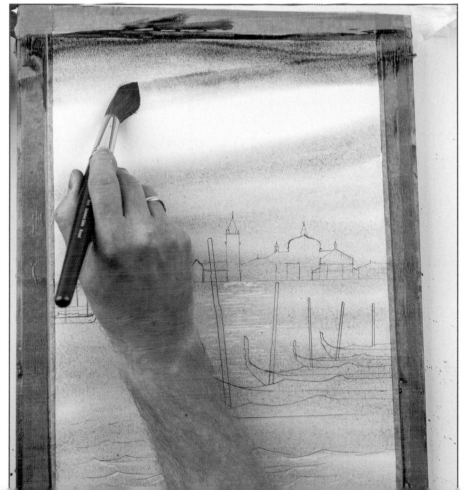

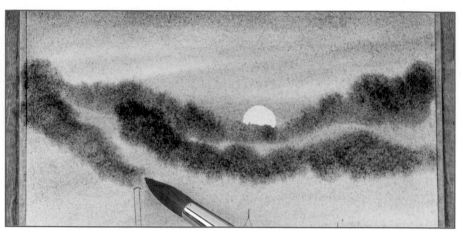

**5** Take a small coin wrapped in kitchen paper and stamp a shape for the moon.

**6** Take your dark grey, tap off the excess paint, then start at the top right of the outline if you are right-handed, twisting horizontally across the painting, painting over the moon, until you have as many clouds as you like. While the paper is wet and the paint is still spreading you can add more clouds to create atmosphere.

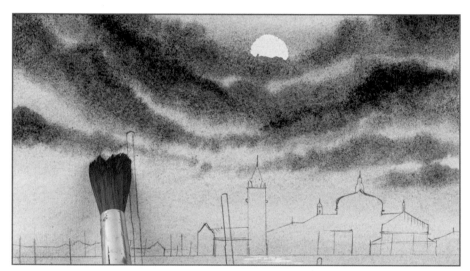

**7** Clean the brush really well in your water pot and squeeze the bristles in your hand to make the brush tip flat. Use the flattened brush to soften the bottoms of the clouds.

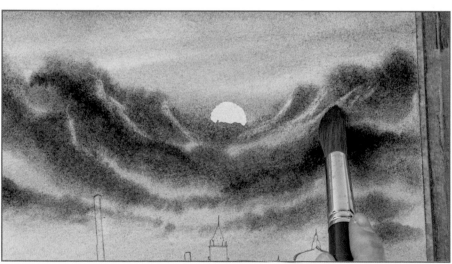

**8** Using the side of the brush, add gentle highlights to the clouds where the moon is touching the edges. Every so often, squeeze out excess water from the brush. Keep adding highlights in this way until your paper is dry.

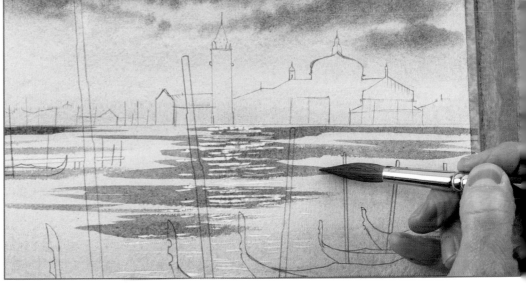

**9** The final stage of the sky is to wet a size 6 brush, dry it on a piece of kitchen paper until it is just damp then use it to feather the edge of the cloud that overlaps the moon. Allow it to dry.

**10** Using a size 12 brush and the medium grey, work on the top half of the canal. Paint random horizontal lines working down towards the gondolas, making sure you cover all of the reflection of the moon. Clean your brush really well, then give it a couple of taps on kitchen paper. Use the brush to soften the hard lines, using it to blend the lines into the canal.

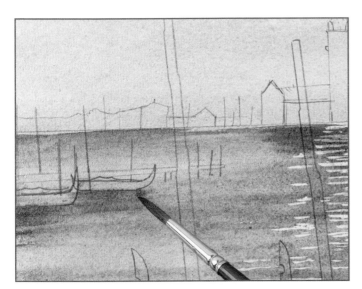

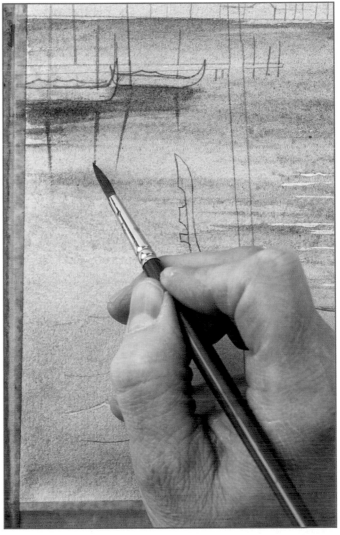

**11** While the paper is still damp, use a size 6 brush and the dark grey to add random horizontal lines focusing on the refection cast by the moon. Reflect the buildings and the small gondolas on the left side. Spend time making the reflections darker and darker as the paper dries. The horizontal brushstrokes will loosely reflect the buildings.

**12** Use a downward flick of the brush to add in a reflection of the posts where the gondolas are moored. Allow to dry.

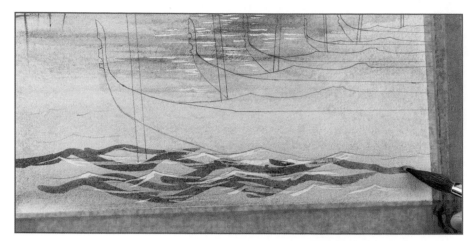

**13** Working on dry paper and using the medium grey and size 6 brush, paint in lots of loose wavy lines, repeating over the top of each other.

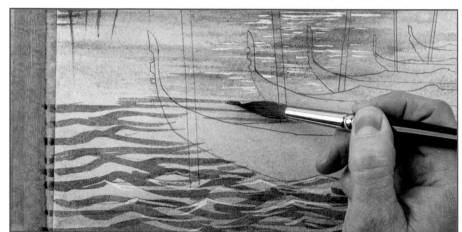

**14** Work up the page, making the waves less shaped as you go until they are horizontal. Don't be afraid to paint over the gondolas. These lines can go all the way up towards the top of the canal. Clean the brush well and wipe on kitchen paper. Use the damp brush to go over the waves to soften them. Allow to dry.

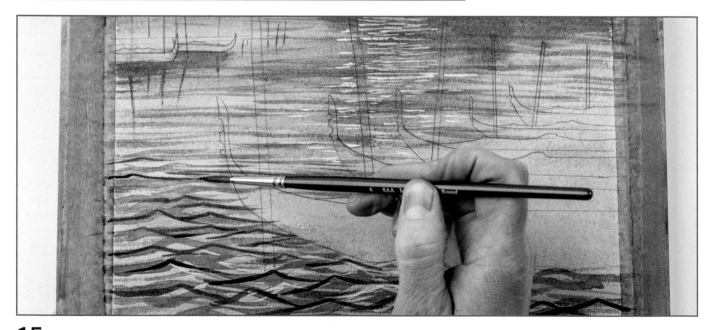

**15** Using the dark grey and the size 6 brush, add a few waves in the foreground where the water laps at the edge. Work up the left side of the gondolas until the waves go from a peak to horizontal.

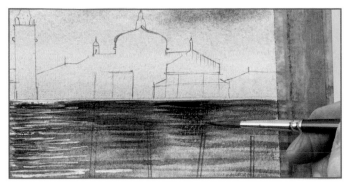

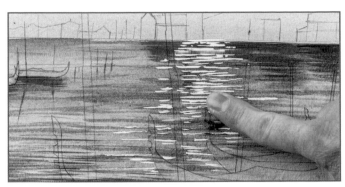

**16** Add a few darker reflections on the distant buildings and the smaller gondolas using the same horizontal lines. Clean the brush and tap off on kitchen paper. Use the damp brush to soften the foreground waves. Allow to dry.

**17** Use your finger or an eraser to remove the masking fluid.

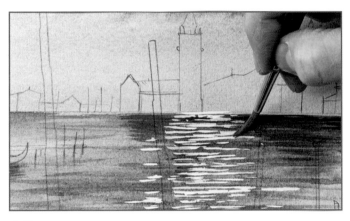

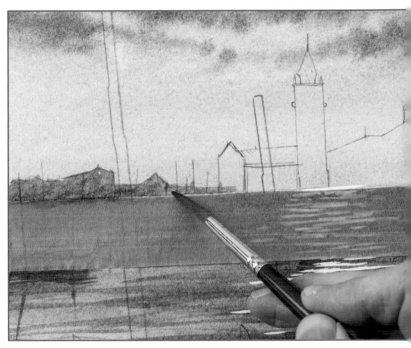

**18** Take the size 6 brush, clean it and dab it on kitchen paper to remove the excess water. Use it to lightly glaze over the edges of the white areas created by the masking fluid to gently blend the harsh white lines. (This reactivates the paint.)

**19** Apply a strip of masking tape across the base of the buildings to give a straight edge. Use medium grey and a damp (not wet) brush. (A wet brush may make the water run down behind the back of the masking tape.) Work on the left-hand side of the buildings which are in the distance. Add a layer of paint to the buildings. Add a second layer of paint to the bottom edge of the buildings to ensure that they have a dark base.

## Tip

*Remove excess stickiness from the masking tape by rubbing your hands across the back of it, or by wiping it on your clothing. This makes it less likely to rip your paper when you remove it.*

**20** For the larger buildings in the foreground, add a touch of natural brown to the medium grey to make it a slightly warmer grey. Paint the larger buildings with the colour mix.

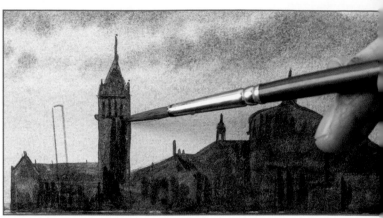

**21** Use the same colour mix and a size 6 brush to add some contour lines to give depth to the shape and form of the buildings.

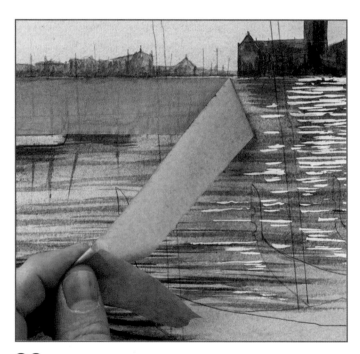

**22** Very carefully remove the masking tape by pulling it away from the centre.

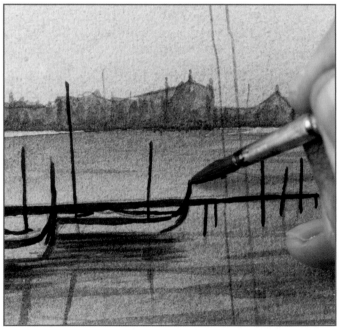

**23** Paint this warm colour mix in the distant pier, posts and gondolas, blending it as you go. Paint a line across the top of the gondolas and the gondola covers.

## Tip

*For the top gondola, paint all the way along the top edge of the cover. On all the other covers, paint only the part of the cover that is exposed against the adjoining gondolas, not where the gondola meets the water.*

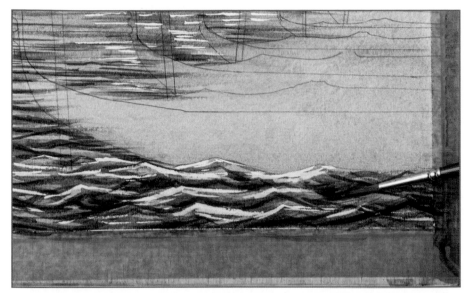

**24** Clean your brush and tap it on the side of the water pot. Blend it down to the water. Add a few horizontal lines below the buildings and the gondolas to give a warmer colour to the reflections. Add some of this same warmer colour into the foreground waves. Use water to soften it in.

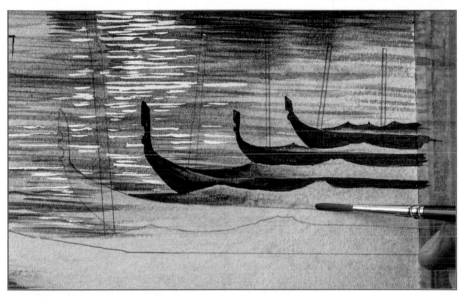

**25** Using a size 6 brush and the same warm colour mix, paint a line along the top edge of the gondola cover. Clean your brush, dab it on your kitchen paper then blend the paint down. To paint the hulls of the two furthest gondolas, fill in with a solid colour. For the middle two gondolas, fill in except where the gondola cover sits against the edge of the hull.

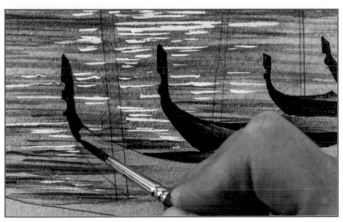

**26** Use a size 4 brush to paint the ferro (the metal blade on the prow of the boat).

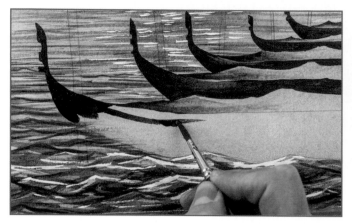 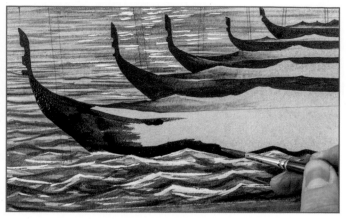

**27** When painting the adjoining gondolas, leave a small gap at the top of the hull where the dark gondola cover meets it, otherwise the dark will meet the dark and lose its definition.

**28** Where the outline of the gondola meets the water, follow the contours of the waves to show how the water laps against the edge of the gondola.

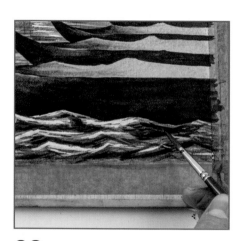 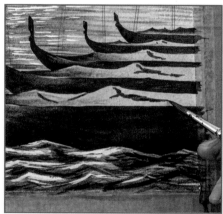 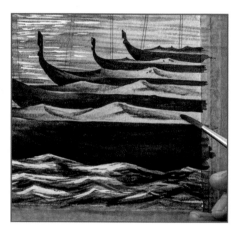

**29** Using the same colour and a size 6 brush, paint in a few random lines in the foreground to represent a reflection of the closest gondola. The lines will be wave-shaped to mirror the water. Wet your brush then tap off excess water on kitchen paper. Use it to gently soften any hard, dark lines in the reflection of the gondola, especially where the gondola meets the canal.

**30** Using the same colour and size 6 brush, add some creases to the gondola covers. These follow the contours of the shape of the gondola.

**31** Clean the brush and tap it on kitchen paper. Use the damp brush to blend the lines into the cover, again following the contours, being careful not to wash away the shadows.

**32** Using the same colour and the same brush, paint the posts. Paint the left half of the closest two posts, ensuring the colour is strong and dark. Paint the remaining posts with a size 4 brush, on the right-hand edge only. This is where the shadow falls.

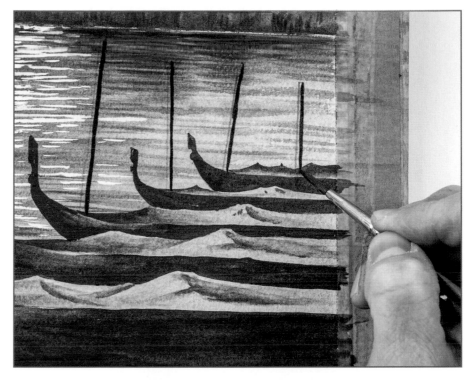

**33** Clean the size 6 brush, dab it on kitchen paper then blend the right half of the two closest posts. This contrast shows the reflection that the moon casts on the post. Use the size 4 brush in the same way for the remaining posts. Keep refreshing your brush in the water and dab it on kitchen paper before continuing.

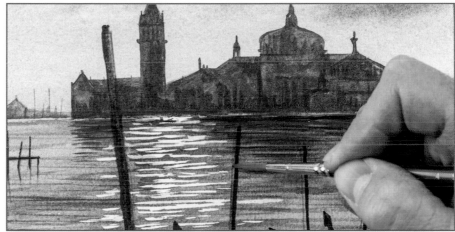

**34** Add a reflection in the water of the large post in the foreground. Allow to dry.

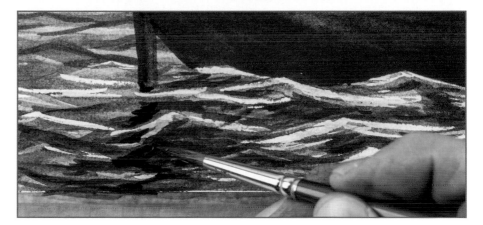

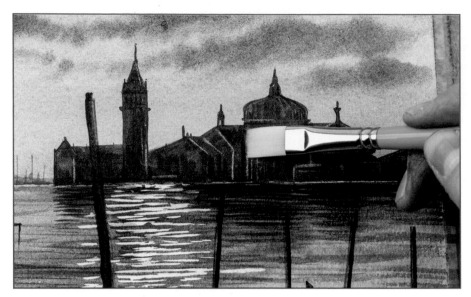

**35** Pinch a wet 12mm (½in) flat brush with your fingers to remove excess water. Using the flat edge of the brush, make gentle brushstrokes following the contours of the area where the highlight is to be added.

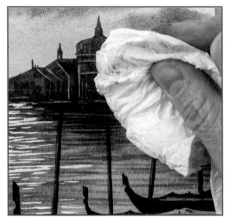

**36** Using kitchen paper, firmly dab the area where you have lifted out the paint. This will remove the paint you have lifted off. This process adds a three-dimensional highlight to your scene.

**37** These highlights can also be reflected in the canal below the buildings and are created in the same way.

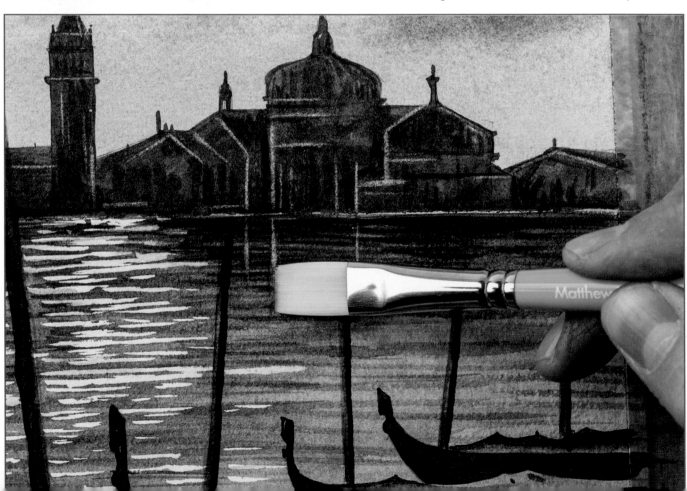
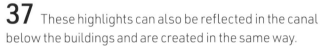

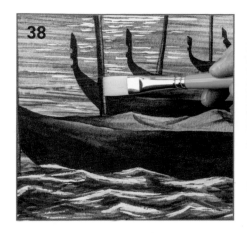

**38** Add highlights to the posts in the same way, working on the paler side of the posts. This works especially well where the post overlaps the gondola. Add some highlights on the foreground gondola, towards the top of the hull. These should run parallel with the top of the hull, to add some detail. You can repeat this on all the gondolas. Add a few more highlights in the foreground waves following the direction of the lapping water. Repeat this technique on the paler side of the posts and down the right edge of each ferro.

**39** Using the point of a craft knife, scrape horizontally across the paper at the base of the buildings and underneath the distant gondolas to create a sparkling moonlit effect on the water.

**40** Finally, do the same on the tops of the waves lapping in the foreground, as well as on the paler side of the posts where the moon catches them. This provides definition. The finished painting can be seen overleaf.

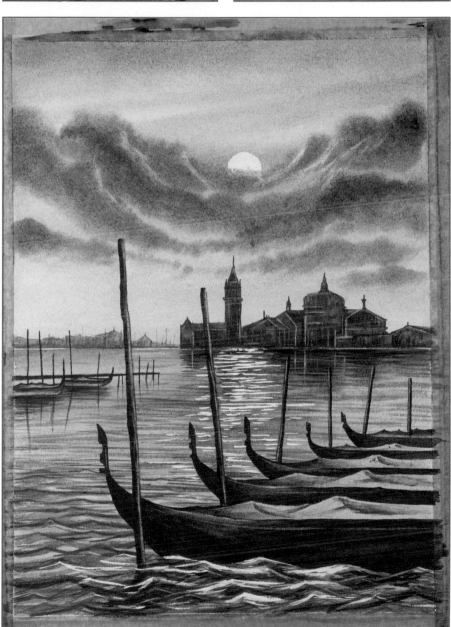

## Tip

*Don't be afraid to press firmly with the craft knife – the watercolour paper is thick enough to tolerate it.*

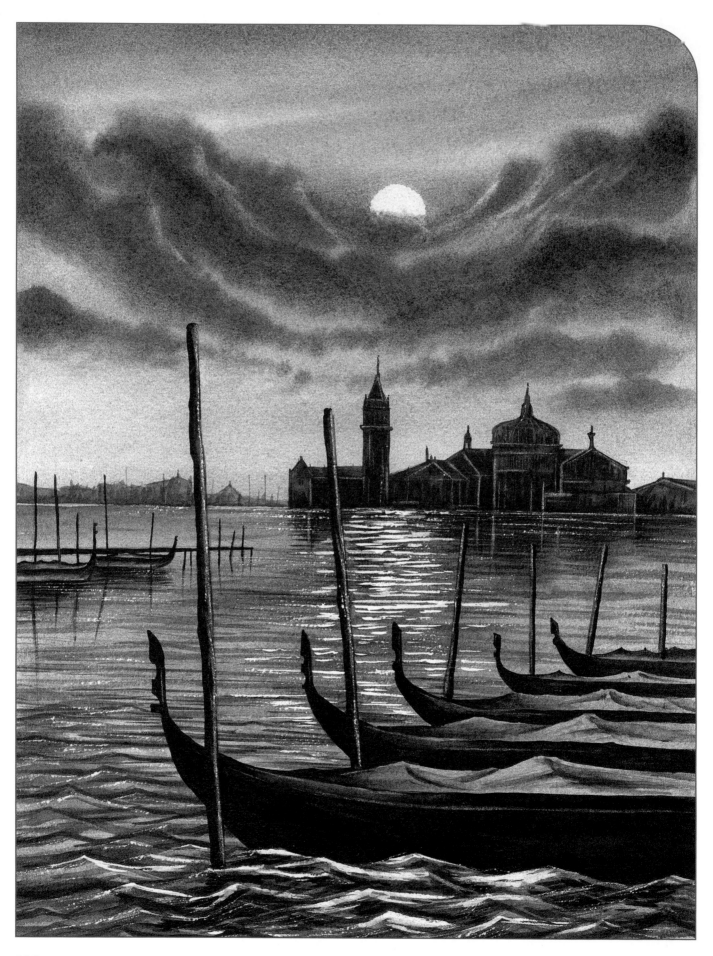

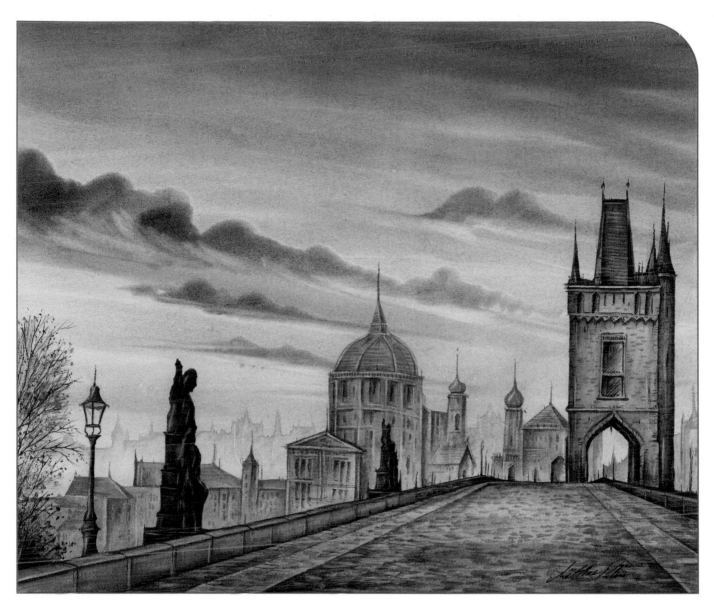

**Prague in Sepia**

*Monochrome is wonderful and using brown tones gives a lovely old-time feeling. In this scene of the Charles Bridge I used burnt umber, adding touches of French ultramarine blue to make it darker. I also used a pale yellow ochre at the base of the sky.*

**Opposite**

*The finished painting.*

# Hawaiian Sunset

**Sunset and vivid skies are a dream to paint and adding silhouetted clouds really brings atmosphere to your scene. Some great techniques feature in this painting. Enjoy!**

## You will need:

Outline 3

Watercolour paper: 300gsm (140lb) 100% cotton Not surface

Colours: natural yellow light; natural orange; natural violet; natural grey; natural brown; natural green light; natural green; natural yellow

Brushes: sizes 4, 6, and 20 round; medium-size fan brush; lift-out brushes or 12mm (½in) flat brush; 6mm (¼in) flat brush

Other: pencil; masking tape; kitchen paper; craft knife

## Note

*If you do not have the Natural Collection paint colours listed above, see the colour comparison chart on page 36 for generic colours that can be used as suitable alternatives.*

**1** Transfer your outline (see pages 88–89) and secure your watercolour paper to the board on all four sides using masking tape.

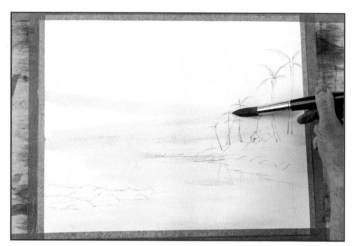

**2** Using a size 20 round brush, wet the entire outline with water twice, taking care not to oversaturate the paper. For the first application use broad horizontal strokes and for the second use vertical strokes. Apply a background wash for the sky and sea. Make a strong mix of natural yellow light and lay in just above the horizon line into the sky and down to the water, not covering the entire water area. The stronger the colour the better.

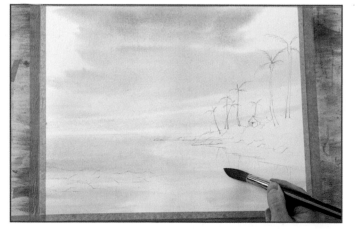

**3** Clean the brush and mix a strong natural orange. Paint from the top of the page, working down in the centre towards the yellow, making the colours mix on the page. Apply the orange to the left and right sides of the sea, making sure you cover all of the sea.

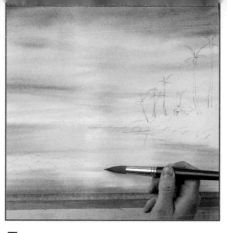

**4** Clean the brush and mix a strong natural violet. Paint in the top left and right sides, working across into the orange. When the violet mixes with the orange, the colour will become more like grey. Be careful to create individual strokes at this point for the clouds.

**5** Apply some violet into the sea in the foreground, keeping the lines horizontal, as well as on the left and right side below the mountains and below the beach.

**6** While the paper is damp, paint the clouds with a medium-size fan brush. The dampness helps the paint spread. Alternatively, flatten the bristles of a size 10 round brush into a spade or paddle shape. Take a medium to strong mix of natural orange on one side of the brush. On the other, add natural grey.

## Tip

*Keep your lines horizontal and remove excess paint on kitchen paper before applying to the page. This gives more control to the brush.*

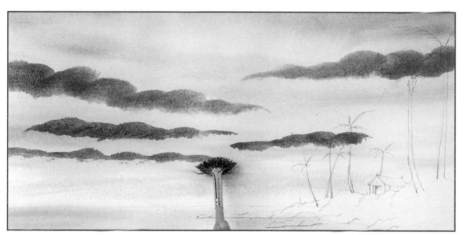

**7** Lay your brush flat to the paper and twist it along the page to distribute both paint colours equally. Keep reloading the brush with the two colours and repeat. Paint thinner clouds as you work your way down the page.

**8** Clean the brush really well then blot on kitchen paper until almost dry. Use the damp brush to soften the base of the clouds, slightly curving the brush upwards to give a highlighted base to the damp clouds. If the paint is dry, don't worry – the highlights can be added later.

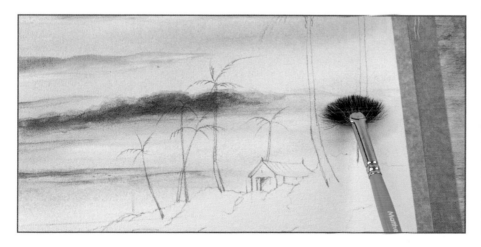

**9** Use your brush to taper out the ends of the clouds so they fade out to nothing at each side. When you do this, you might lift off some of the paint you have already applied. This helps to illuminate the clouds.

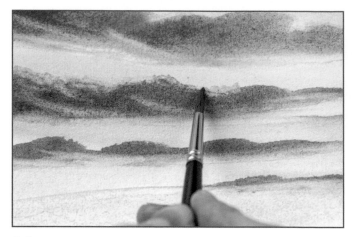

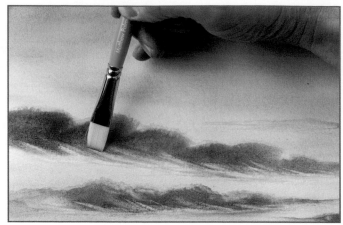

**10** Using a size 6 round brush, clean it in the water and gently tap away excess water on kitchen paper. If you have any hard lines at the top of the clouds, gently feather them to allow them to blend with the sky. It is almost tickling the edge of the cloud. Allow to dry.

**11** Use a 12mm (½in) flat brush or an extra-large lift-out brush to add extra highlights to the bottom of the clouds, slightly angling up into the clouds in a diagonal. Clean the brush in water then pinch out excess water with your fingers. Use the tip of the brush to scrub the base of the clouds to gently curve them up. This gives the effect of the sun lighting up the underside of the clouds.

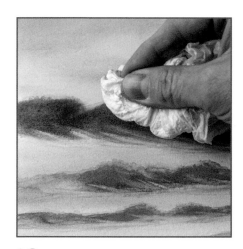

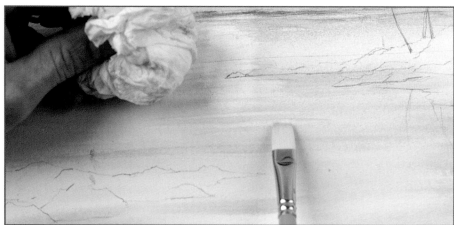

**12** Use kitchen paper to dab off the paint you have scrubbed off.

**13** Using the 12mm (½in) flat brush and the same technique of gently scrubbing the page with your brush in horizontal lines, choose a space on your scene to add some highlights, then dab away the paint with your kitchen paper. Do the same below the horizon line, working down into the sea area. Still keeping your lines horizontal, make the lines wider as you move down the page, stopping about halfway down the page. Allow to dry.

**14** Add a piece of masking tape across the horizon line where the mountain meets the sea. Use a size 6 round brush and a pale natural grey (see pages 40–45 for colour mixing), a pale natural orange and a medium-strength natural grey. Starting with the pale grey, paint the contours of the mountain.

## Tip

*Remove excess stickiness from the masking tape by rubbing your hands across the back of it, or wipe it on your clothing. This makes it less likely to rip your paper when you remove it.*

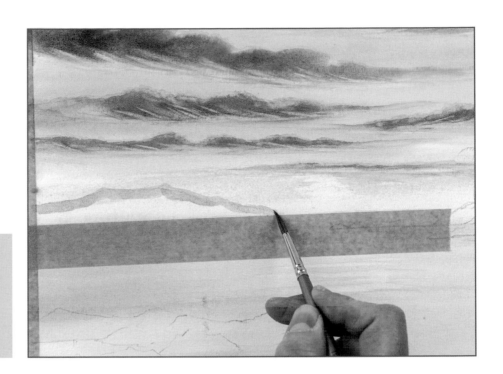

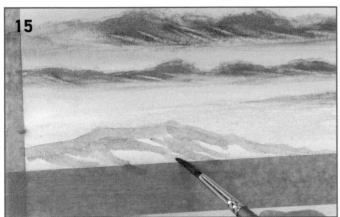

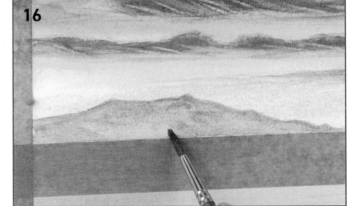

**15** Add a few random strokes of this grey on a diagonal towards the masking tape.

**16** Fill in the rest of the mountain with the pale natural orange, ensuring that the brush is not too wet, otherwise the paint may seep down the back of the masking tape.

**17** Using the medium grey and tapping off excess paint on kitchen paper, darken the base of the mountain where it meets the masking tape.

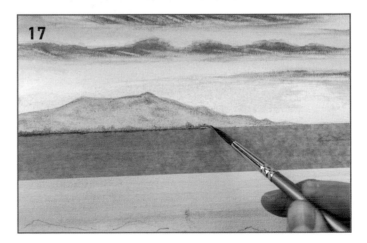

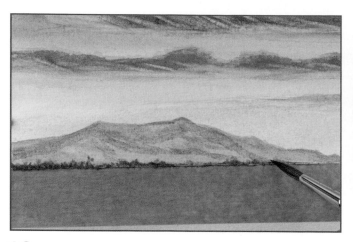

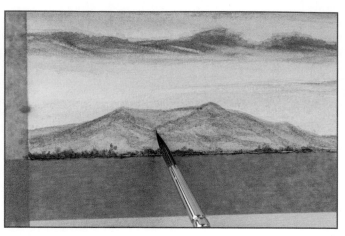

**18** Keep working over this area as it starts to dry, to add extra detail and darkness. Allow to dry. Add any final dark detailed areas at the base of the mountain in spots and stipples.

**19** Using the pale grey, add some contour lines following the diagonal ups and downs of the mountain. Place these anywhere along the mountain shape to give the mountain definition. Soften any hard lines with a damp brush.

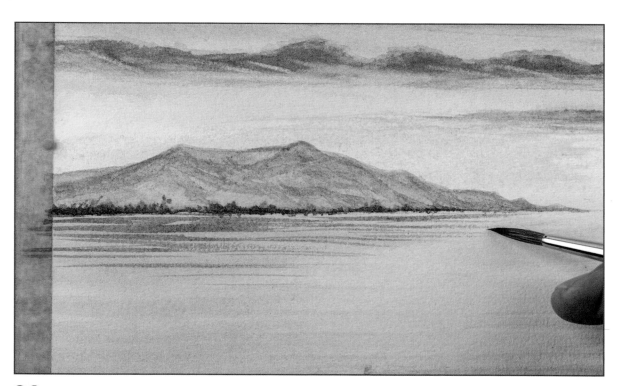

**20** Very carefully remove the masking tape. Paint horizontal lines in one long flick using the medium grey to create the mountain's reflection. If any of the paint has seeped through the masking tape, you can conceal this within the reflection. Continue using these horizontal strokes to complete the reflection.

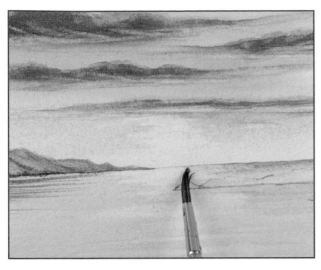

**21** Using the same grey, paint in the right-hand side of the horizon, leaving the white area of the sun's reflection untouched. Clean your brush, tap it on kitchen paper and blend in the paint to complete the sea.

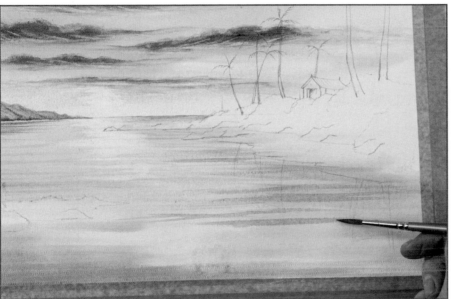

**22** Using a very pale violet and holding the brush about halfway down, use quick, horizontal brushstrokes to paint movement and ripples in the water, loosely avoiding the area where the sun will reflect in the centre of the sea. Try to make the lines wider as you move further down the paper.

### Tip

*Stand up to paint this stage – it will make the process more fluid.*

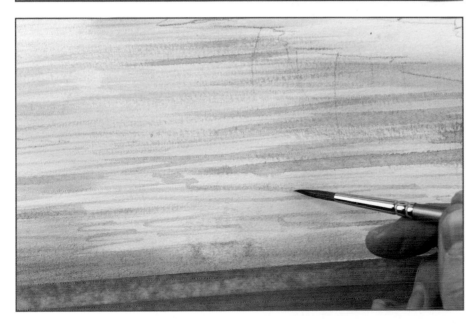

**23** Change these horizontal lines to rippling zigzags as you get further down the page. Allow to dry.

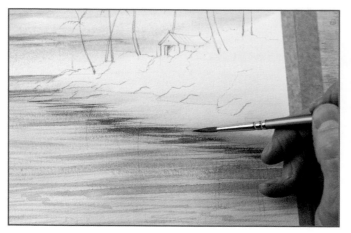

**24** Change to a medium grey and repeat the quick, horizontal brushstrokes in the foreground and along the edge of the beach. Tap off excess paint on kitchen paper before applying the paint. Start off at the edge of the beach where it meets the sea on the right-hand side of the painting.

**25** Apply the same horizontal lines and rippling zigzags under the foreground rocks.

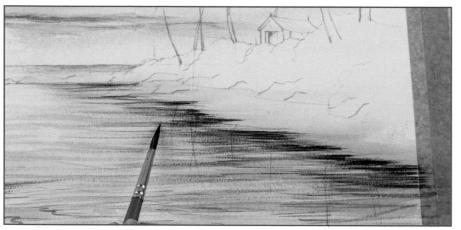

## Tip
*You might find it easier to turn your board upside down to paint the bottom of the outline.*

**26** Using a strong natural grey, improve the clarity of the edge of the beach by using horizontal flicks from the edge of the beach tapering into the sea. Tap off excess paint on kitchen paper before applying these quick brushstrokes.

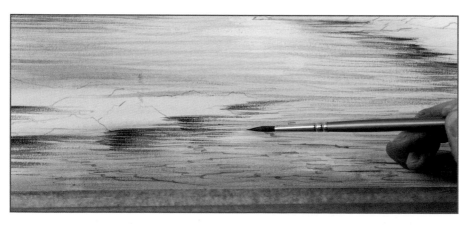

**27** Repeat below the foreground rocks, again tapping off excess paint on kitchen paper before applying these tapered horizontal strokes.

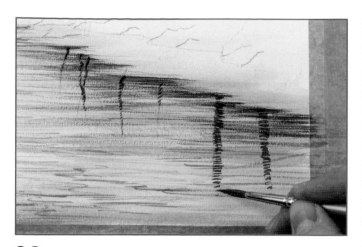

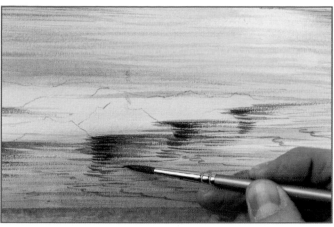

**28** Add the reflections of the palm trees in the water using the same strong natural grey. These reflections will be wiggly lines as they are distorted by the water.

**29** Use more wiggly lines to add reflections of the rocks in the bottom-left of the scene.

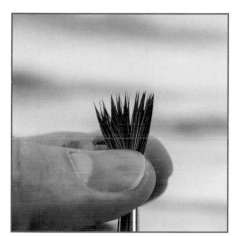

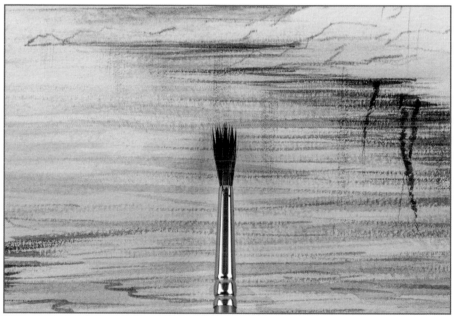

**30** With the same strong natural grey on your brush, spread out the bristles so they fan.

**31** Use the tip of the splayed bristles to paint faint incidental dry lines which are perfectly vertical. This gives a sense of reflection. Try this technique on scrap paper first. Tap off the excess paint on kitchen paper. Apply these vertical lines wherever the sea meets the land.

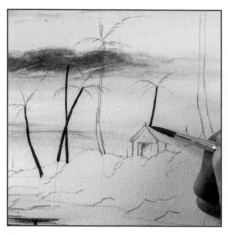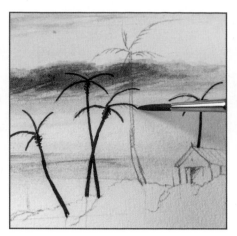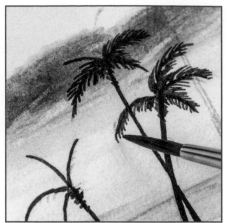

**32** Using a size 4 brush, mix a strong natural grey and add a touch of natural brown. Paint in the furthest three palm tree trunks as a solid colour, making the base of the trunks wider. Repeat for the palm tree behind the shack.

**33** Add a few spots at the tops of the trees to represent the coconuts and tree fibres. Clean your brush and take a strong natural grey to paint the fronds on the tops of the trees. Start by painting in the central line of each frond.

**34** Using the same colour, wipe off excess paint from the brush. Add in individual leaves on each tree, completing one side of the frond before starting the next. Hold your brush like a pen, right at the tip and rest on the paper. Add extra fronds as required.

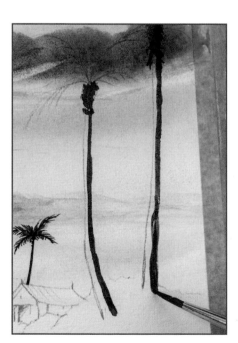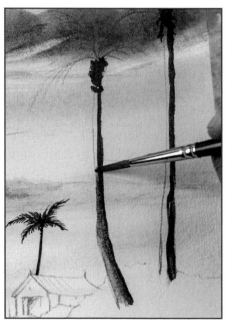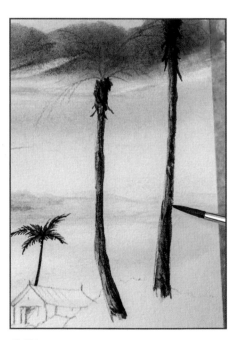

**35** Add more natural brown to the mix. Paint the right-hand side of the trunks of the remaining palm trees and add in coconuts at the top.

**36** Clean the brush, tapping off excess water on kitchen paper. Blend the paint from the right-hand side of the trunks towards the left.

**37** Pick up some strong natural grey and add a few spots of shadow to the right-hand side of the trunks to give them texture. These strokes can be random, horizontal, diagonal or curved.

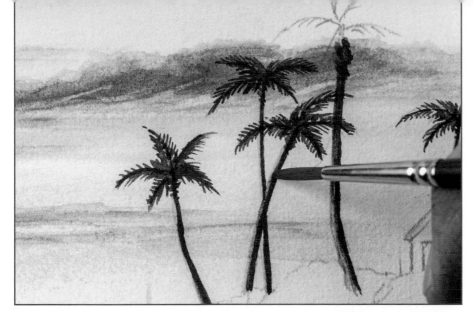

**38** Clean the brush and tap off excess water on kitchen paper. Very carefully add a touch of lightness to the four distant palm tree trunks, feathering the left-hand edge where the sun catches them.

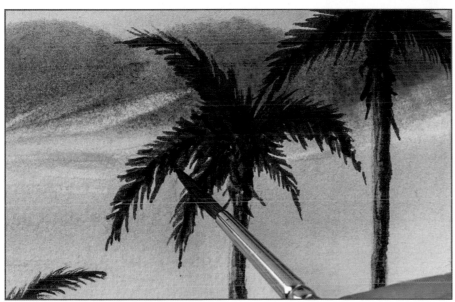

**39** Mix a strong dark green from natural green and natural grey (or see page 38 for shadow green). Paint the large fronds in the same way as before. Take a strong natural grey and add some darkness to the base of the fronds where they meet the trunk. Use small flicks from the centre of the fronds. Allow to dry.

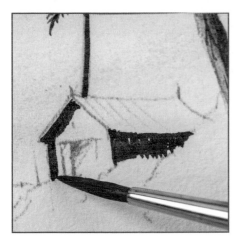

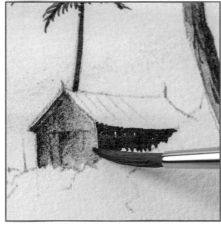

**40** Using the same natural grey and natural brown mix, paint the right side of the shack wall as a solid block of colour. For the left side, paint a line down the furthest left edge.

**41** Clean the brush and tap off excess water. Blend the colour towards the right edge.

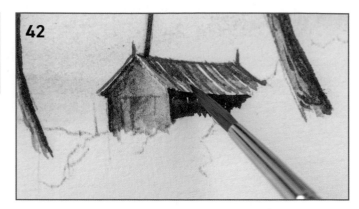

**42** Using a strong natural orange and the size 4 brush, paint in the rusty diagonal lines on the shack roof. Add some natural brown to the same mix, tapping off the excess paint on kitchen paper, then add some shadow areas to the roof, following the same direction as the previous lines. Also paint in the spikes on the roof and the left-side edge of the roof.

**43** Using strong natural grey, paint inside the open doorway of the shack. Make a frame by painting a vertical line down the left side, across the top then down the right side, ensuring the left side is wider.

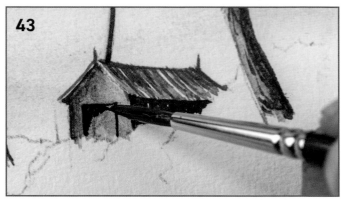

**44** Clean and dab the brush on kitchen paper then blend the rest of the inside of the shack doorway. This gives a sense of depth.

**45** Add final detail to the shack and surrounding areas with the strong grey, wiping off excess paint on kitchen paper first. Start by darkening the underneath of the roof on the left side of the apex. Add a few downward lines over the left side. Darken the top of the roof, across the ridge and a couple of random lines following the angle of the roof. With a very fine line, paint in some distant masts to the left of the shack. Add a small window to the front of the shack and add a second shadow to the inside of the doorway in the same way as before, painting a right-angle shape that is thicker on the left side. This gives the impression of distance.

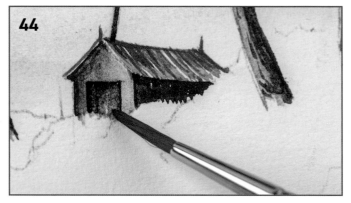

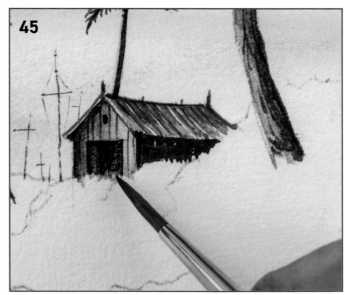

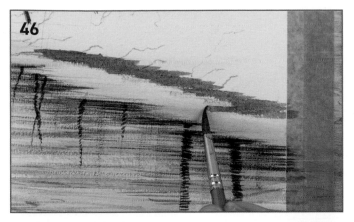

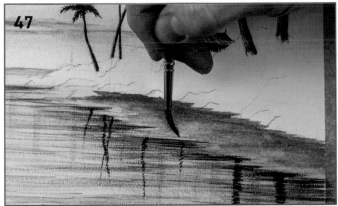

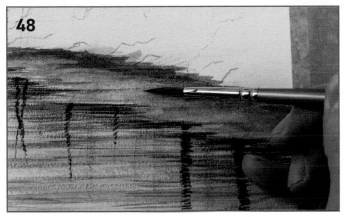

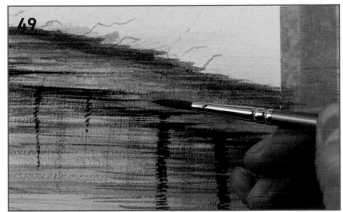

**46** Mix some sand colours: natural brown with natural yellow is good for a medium tone. Use natural yellow on its own for the light sand tone and a strong natural grey for shadows. Using a size 6 brush and the natural brown and natural yellow mix, begin on the right-hand side of the beach, adding paint below the base of the rocks.

**47** Use the natural yellow to blend in towards the water's edge. Clean the brush and tap off excess water on kitchen paper.

**48** Using the strong grey and tapping off excess paint onto kitchen paper, add horizontal lines across the beach working towards the rocks. This will add shadows to the beach.

**49** Revisit the water's edge and make sure it is darker than the beach. Add horizontal lines from the water towards the beach. This will give a crisp separation. A few random spots on the beach will add to the texture. Use the same colour mix of brown and yellow for the foreground beach, created from a series of horizontal brushstrokes.

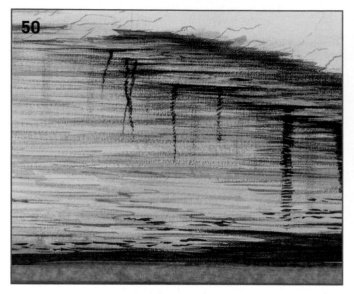

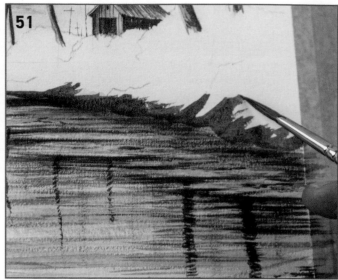

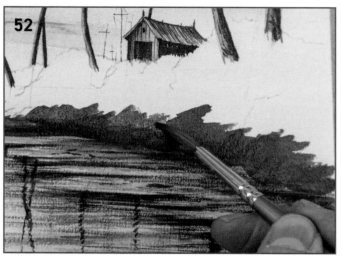

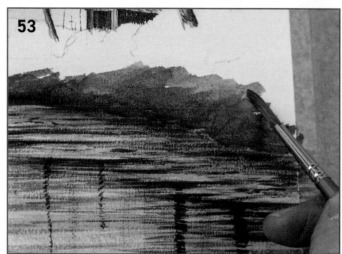

**50** Using dark natural grey, darken the bottom corner of the beach. Add details to the sand in the foreground with the natural brown and natural grey mix.

**51** Mix natural grey and medium brown to a medium strength, fairly thin mix. Apply to the base of the rocks, working along the edge of the rocks and up at an angle into the rocks.

**52** Using a fairly thin mix of natural brown and natural yellow, paint the middle of the rocks, blending the two colour mixes into each other.

**53** At the top of the rocks, apply natural yellow, again blending with the colours underneath it.

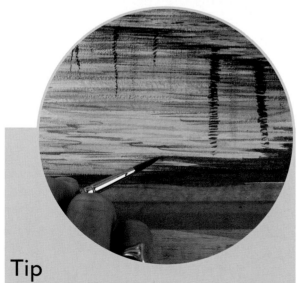

## Tip
*The ends of the lines should be a dry tapered flick to make them look like they are under the water.*

**54** Clean your brush and tap it on kitchen paper, then use water to blend the top of the rocks into the bushes above.

**55** Using a plastic card, scrape up and away from the centre to remove the paint, following the contours of the rocks to give them definition. Only gentle pressure is required. If the paint does not come off with the card, reactivate the paint by glazing over the surface again.

**56** Repeat this effect on the rocks in the bottom left-hand corner, taking time to separate areas of rock that reach different heights.

**57** Using the natural brown and natural yellow mix, add some horizontal reflections below these foreground rocks to help ground them in the picture.

**58** Pick up some strong natural grey and add dark shadows at the side of the light areas that the plastic card created. Blend away any hard lines with a damp brush if needed. This helps to ground the rocks. Repeat these shadows on the larger section of rocks.

**59** Add dark ripples slightly below the rocks.

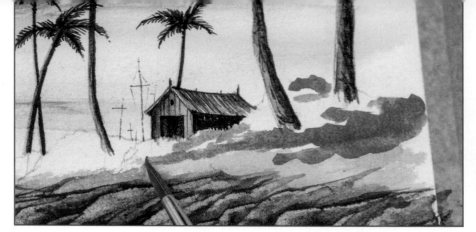

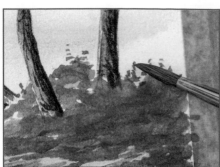

**60** Refer to page 38 for how to mix the greens. Mix natural green light with natural green, to a medium consistency. Using a number 6 brush, make swirls in the same way as we did for the clouds. Switch between this mix and natural green and keep alternating between the two colours. Swirl over the top of the bushes once the section dries, to create texture.

**61** On the tops of the bushes add some dots to suggest foliage.

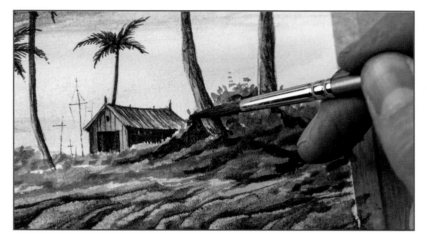

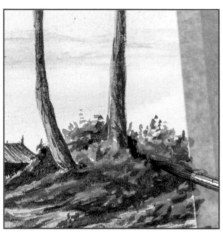

**62** Use strong natural grey to add shadow areas to the base of the bushes, following their contours. Use the same twisty brushstroke effect. Try to add these shadows working against the left-side of the base of the palm tree trunk. This is a great way to add shadow, shape and form.

**63** To soften these shadows, use the green mix to add spots to the top of the grey shadows to make them look more incidental. Allow to dry.

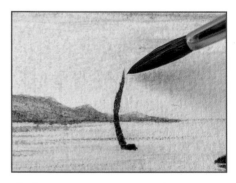

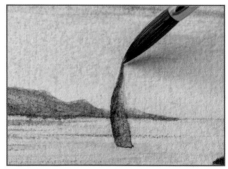

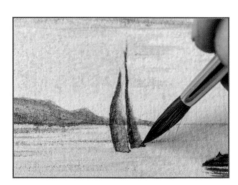

**64** Using a size 6 or size 4 brush, paint in a distant sailing boat using strong natural grey. Start by painting a curved 'l' shape for the sail.

**65** Clean your brush and tap off excess water on kitchen paper. Blend the line towards the sun so it's not as dark.

**66** Paint in the smaller sail and mast, using the same technique.

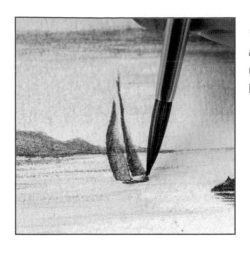

**67** Using a clean brush that is almost dry, paint the hull of the boat using a thin horizontal line along the base. Blend the line upwards.

**68** Add a few horizontal lines below the boat to convey its reflection.

**69** Finish off your painting by adding highlights using a 6mm (¼in) flat brush and water, remembering to squeeze out excess water through your fingers. Add light to the left-hand side of the three largest palm trees, just underneath the fronds by using the tip of the damp brush to gently scrub off the paint and dab it with a piece of kitchen paper. Do the same at the base of each trunk where it meets the bushes. Also add highlights to the fronds and the tops of the bushes.

**70** Add final highlights to the recess inside the doorway of the shack as well as the right side of the distant mountains and the reflection of the foreground rocks, mirroring what is above. This gives the impression of the sun catching them.

**71** Using the point of a craft knife, add horizontal scratches to the sea. This will make it appear to sparkle. Do the same along the edge of the beach and along the base of the rocks. Finally, make smaller scratches on the foreground beach to represent pebbles. The finished painting can be seen overleaf.

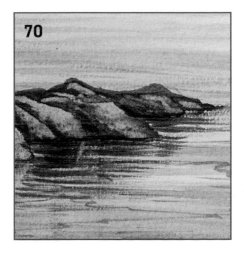

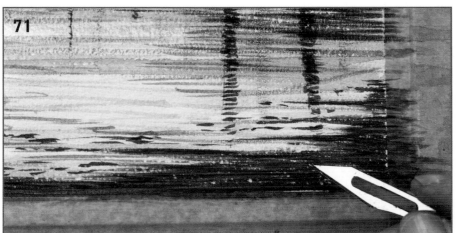

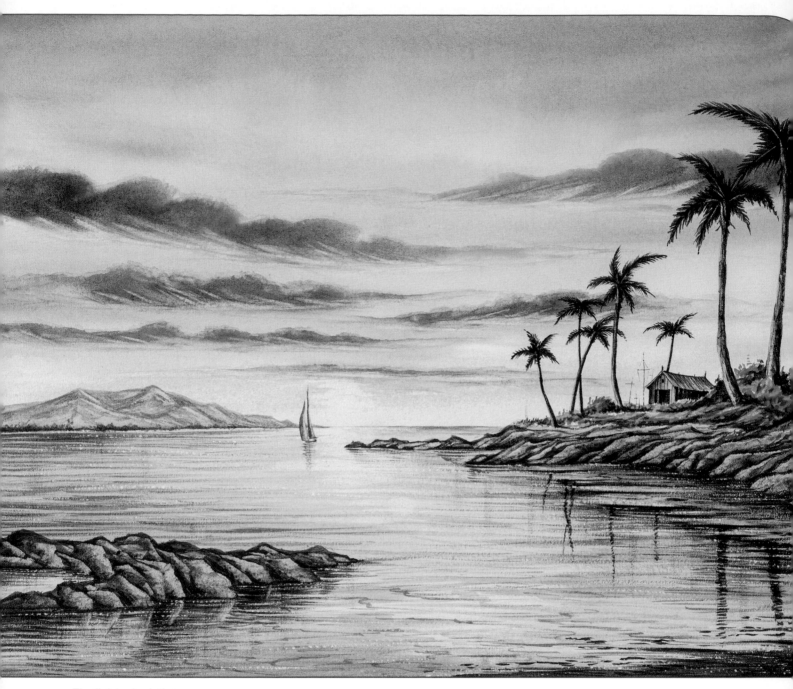

*The finished painting.*

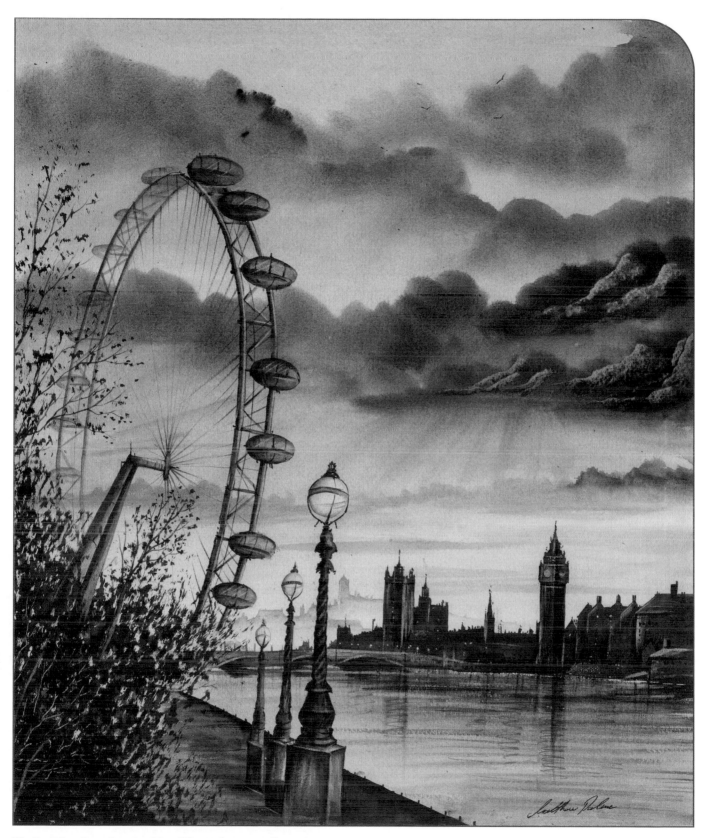

**The London Eye, Overlooking Westminster at Sunset**

*30.5 x 38cm (12 x 15in) painted on 300gsm (140lb) Not surface watercolour paper.*

*This painting relies on strong heavy natural grey mixes (see page 44). Painting everything but the background sky in silhouette works well for sunsets. The lift-off technique (see page 51) was used to add in all the highlights for the clouds, London Eye and buildings.*

# Night-time Snow Scene

Snow is one of my favourite subjects to paint in watercolour. I love the way in which shadows can be used to create three-dimensional landscapes. By using the white of your paper, you can create some wonderful snowscapes.

I often work from my imagination – I love the possibilities of the empty white paper and the challenge of creating a scene from nothing. I started with the theme of a snow landscape and then made a few sketches (see below) which evolved into a painting.

## You will need:

Outline 4

Watercolour paper: 300gsm (140lb) 100% cotton Not surface

Colours: natural yellow; natural blue; natural grey; natural violet; natural yellow light; natural brown; natural orange; natural white

Brushes: sizes 6, 10 and 20 round; size 2 rigger; small and medium Tree & Texture brushes; large lift-out brush or 6mm (¼in) flat brush

Other: pencil; masking tape; masking fluid; applicator brushes; kitchen paper; small coin; craft knife

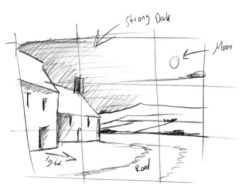

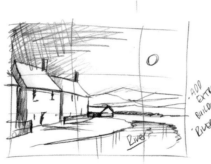

## Note

*If you do not have the Natural Collection paint colours listed above, see the colour comparison chart on page 36 for generic colours that can be used as suitable alternatives.*

**1** Transfer your outline (see pages 88–89) and secure your watercolour paper to the board on all four sides using masking tape. With a large applicator brush and masking fluid, mask off the top edges of the buildings, including the chimneys. Mask off a little bit of snow on the top of the walls in front of the house and on the porch roofs, including both sides of the apex. Feel free to use smaller applicator brushes for finer details. Once dry, use the size 20 round brush to paint a night sky following the instructions on page 66, starting with a wet into wet base of pale natural yellow.

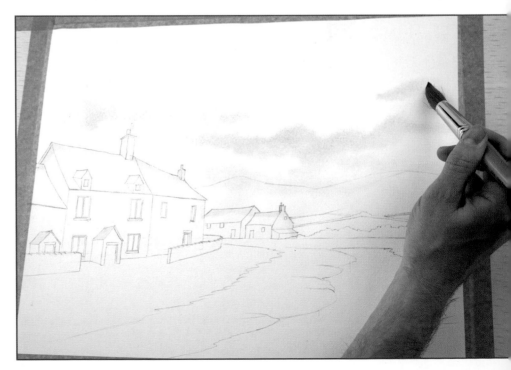

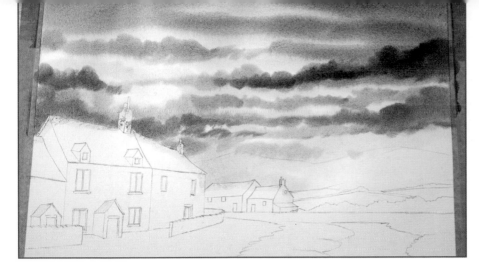

**2** Lay in natural blue for the top half of the sky, and a strong mix of natural grey and natural blue to add in the clouds over the top of the base washes.

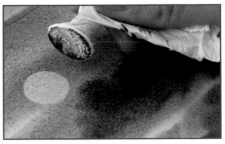

**3** Wrap a small coin in kitchen paper. While the paint is still wet, apply this stamp to the sky area to create the moon. Natural white will be added later on to give detail to the moon.

**4** Dilute the blue-grey mix to make it less strong. Working wet on dry (see page 48), and making use of the point of the size 20 brush, fill in the top edge of the distant hills, then work your way across the paper, right up to the masking fluid on the buildings again.

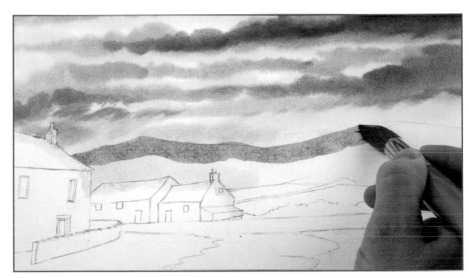

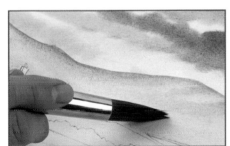

**5** Smooth the blue-grey mix so that it blends into the white snow lower down on the hills. Clean your brush again, wipe it and blend the colour so there are no hard lines, then lift out a little colour for highlights.

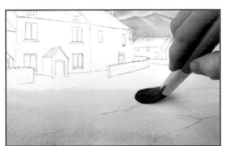

**6** Combine natural violet with a tiny amount of natural grey to make a shadow mix of a medium consistency. Working wet on dry and starting in the bottom-left corner, paint a broad line across the foreground of the picture, then blend upwards towards the bases of the cottages.

**7** Switch to a dry size 10 round brush and add some natural yellow light brushstrokes coming from the front of the cottage over the snow bank, as shown. Then, with a damp brush, smooth.

**8** Take up natural violet on its own on the size 10 brush to fill in all the contour shapes. Start at the top of the footpath and sweep the colour around from behind the curve of the wall, all the way down to the bottom of the scene. Go back over the line to freshen it.

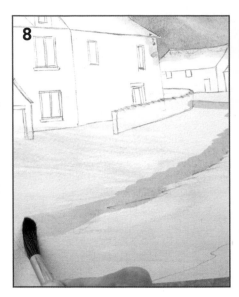

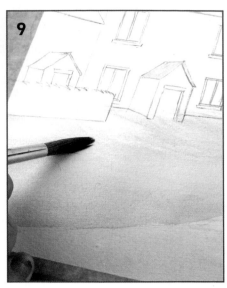

**9** Clean the brush, then soften the line using the same damp brush to drag the colour up into the hills towards the centre of the picture.

**10** Working around the riverbank with fairly pale natural violet, create areas of separation in the snow. Go in along the top edge of the bank, working towards the right-hand side of the picture. Work on one section of the riverbank at a time to prevent the paint drying and staining the paper. Clean your brush, wipe off any excess, then softly drag away the hard line at the top of the painted area so it completely disappears towards the distant hills. Repeat all the way down the right-hand side of the river.

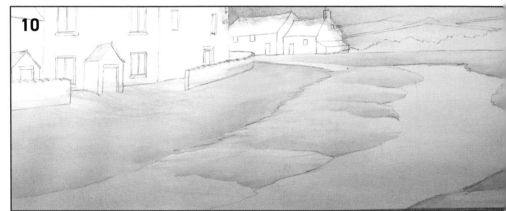

**11** Use the shadow mix to balance the sky by darkening the foreground. Rotate your board to help the paint blend. Next, use a dampened brush to blend the foreground shadow in the bottom-left corner back towards the foremost cottage. Continue to add dark shadows in areas where you feel they are necessary – coming around the curve of the wall, for example, or at the base of the distant cottages.

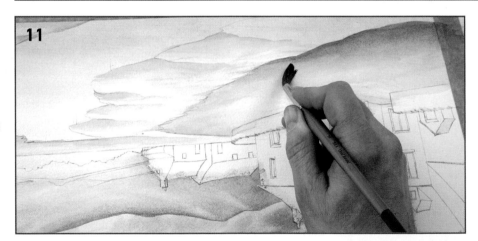

**12** Working around the edges of the river, fill in the shadows on the bank.

**13** Darken across the foreground riverbank area with the same grey and violet mix and blend the colour upwards to create a vignette effect.

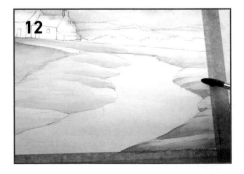

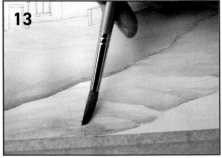

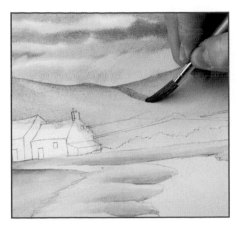

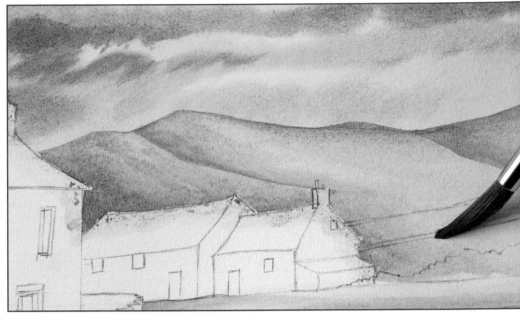

**14** Lay in some shadows on the background hills. Imagine a valley between each hill and paint a line in the violet and grey mix that comes down into the hills towards the fields. Blend the shadows off to the right with a clean brush.

**15** Darken the area to the right of the distant cottages where the masking fluid overlaps the hills. This will ensure that the cottages stand out against the background. Work right into the masking fluid areas all the way across the front of the smaller cottage. Clean and wipe off your brush, then soften the shadow into the hills, following the contours of the hills as you do so.

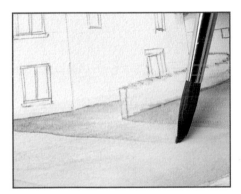

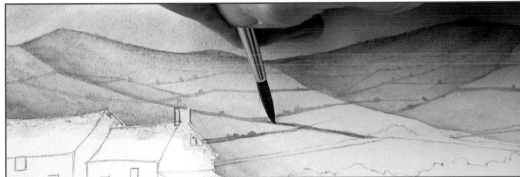

**16** With the same brushes and mixes, paint in the shadows cast by the light coming from the doorways and windows.

**17** Starting halfway up the hill, add distant hedgerows that follow the contours using natural grey and the tip of the size 6 round brush. Every so often, drop in a couple of spots to represent trees and hedges. Make the lines thinner and lighter – by adding a touch more water – as they go higher up into the hills. Add a tiny bit of natural brown to the mix to paint in the hedgerows at the foot of the hills. Merge the brown hedgerows with the grey hedgerows where they touch. Add larger spots and dabs for foliage in these closer hedgerows.

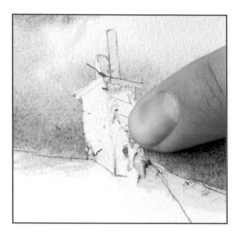

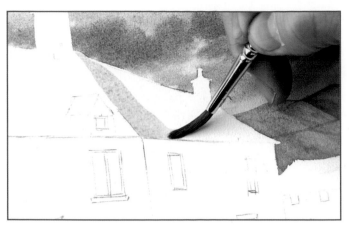

**18** Use your finger to remove the masking fluid from the edges of the roofs, buildings and chimneys – leave the fluid intact on the porches and the tops of the walls for the time being.

**19** Using a pale natural violet on the size 6 brush, paint a line to separate the roofs of the two large foreground cottages.

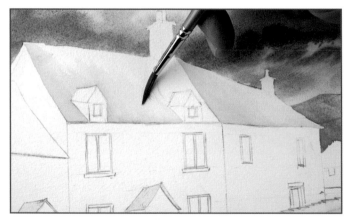

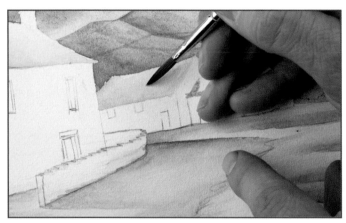

**20** Blend the colour away, then repeat on the other foreground cottage roof. Paint an 'l' shape, rather than a line, taking the colour as far as the first dormer window, but not over it.

**21** Paint the roofs of the rearmost cottages in the same way.

**22** Add natural grey to the violet, and use it to add small, fine shadows on the roofs for additional detail.

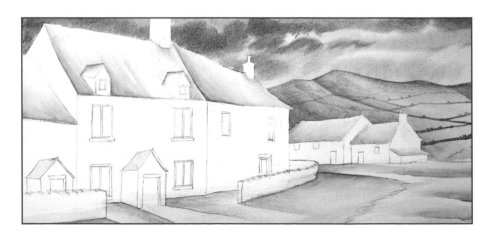

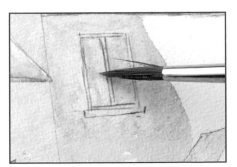

**23** Block in the two chimneys with pale natural yellow on the size 6 brush, leaving an area of white at the top where the snow has settled. Use a little strong natural grey on the tip of the brush for shading under the ridge of each chimney.

**24** Using the same colour, change to the size 10 round brush and block in the walls of the cottages, starting from the left of the painting.

**25** Switch to the size 6 brush and paint in some fairly strong natural yellow light over each window in turn. Let the colour spread outside the window area to give the impression of glowing light. Carefully add a tiny dot of natural orange to the corners of each of the windowpanes.

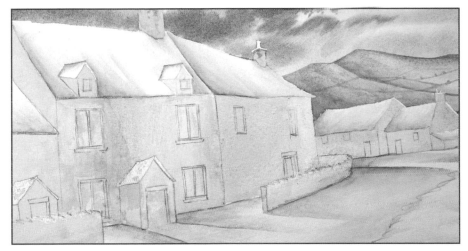

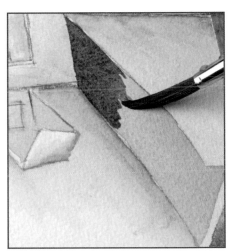

**26** Use natural yellow to fill in the walls of the two adjacent cottages completely, imagining that there are no lights on inside. Fill in both parts of the wall running along the front of the foreground cottages, but do not fill in any shadows yet. When working on the background cottages, be careful to paint around the snow-covered roof of the lean-to, and the snow on top of the chimney. Allow to dry.

**27** Take the size 6 brush. Using natural grey in a medium consistency, fill in all the outstanding shadows, beginning with the side wall of the largest cottage. Turn the board around if you need to. Clean and wipe off your brush, then blend the grey into the sandstone colour of the wall.

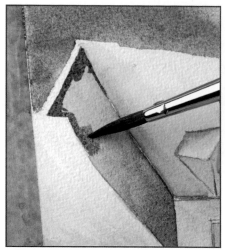 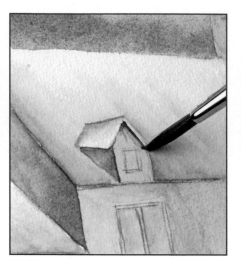 

**28** Turn the board back upright. Add a shadow in natural grey under the eaves at the top of the wall. Work around the snow-covered roofs. Clean the brush, wipe off any excess on kitchen paper and blend the shadow down.

**29** Add shadows to the dormer windows then with a clean brush, blend the shadow into the face of the window.

**30** Lay in the shadows on the chimneys in the same natural grey. Begin at the top of each chimney, under the top ridge, and pull the colour downwards. Make the shadows stronger around the foremost edge of each chimney, then strengthen the dark lines under the ridge.

**31** Take up a medium natural grey. Add a line of natural grey shadow where each foreground cottage connects to the next. Clean your brush, wipe off the moisture on kitchen paper, then blend each shadow diagonally down to the right.

**32** Separate the two rear cottages with a line of medium natural grey that runs under the eaves, then down the right-hand edge of the front wall of the cottage. With a clean brush, blend the shadows down towards 'seven o'clock'.

**33** Darken the wall as it curves around the cottage, using a paler grey, in an elongated, upside-down 'l' shape. Clean your brush, wipe off any excess on kitchen paper, then soften the shadow towards the top of the wall.

**34** Using pale grey on a size 6 brush, add shadows to the walls alongside the porches and soften them to the right into the wall, to make the porches stand out. Soften the shadows with a clean brush. Do not be afraid to take the colour over the windows.

**35** Using the size 2 rigger and a very strong natural grey, paint in the guttering under the eaves, using the tip of the rigger and twisting it gently. Add a downpipe if you like. Take your time working in this detail.

**36** Paint in fence posts in the same dark grey at the open end of the right-hand wall. Lay in the vertical posts in a thin, double line on a rigger, then add the crossbars between the posts in a single line.

**37** Use the rigger and the same dark grey to add a dark line under all the visible eaves on the windows and the apexes on the porches. Paint in a thin flick line between the foreground cottages with the tip of the rigger.

**38** To suggest brickwork, apply pale natural yellow with the large lift-out brush. Use the flat tip to add tiny downward strokes here and there, next to the windows and doors, and on the chimneys. Do the same on the smaller cottages: tap the edge of the brush rather than making strokes.

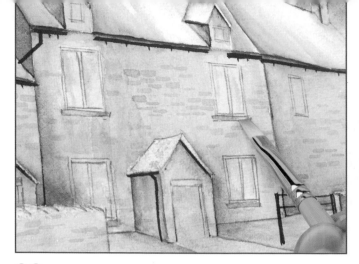

**39** Add a touch of natural grey to the yellow, then fill in the windowsills and the lintels above the doorways.

**40** Using the flat edge of the lift-out brush, drop in some diagonal strokes on the exposed top edge of the walls, and horizontal strokes to suggest windowsills and lintels.

**41** Take up more strong natural grey on the size 6 brush; paint a thin line across the top, and down the right-hand edge of each pane of glass. Blend the shadow inwards, leaving the frame itself light. Use this mix to draw in the right edge of the open porch doorway.

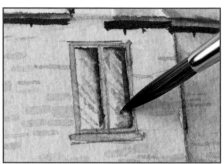

**42** Using a dry-brush technique, draw in a few diagonal flicks over the panes of glass to suggest reflection. Use the rigger with a dark grey to outline the window frames, including the porch lintel. Add a dark flick under the recess of the darkened porch.

**43** Use a tiny amount of grey paint on your rigger to add a few outlines on the brickwork to polish off the buildings. Use the point of the rigger like a pen to achieve a fine grey line.

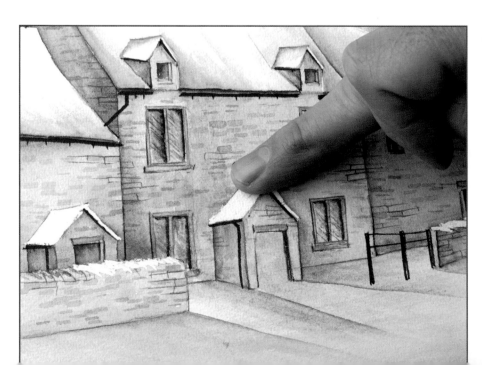

**44** Use your finger to remove the masking fluid from the porches and the foreground walls. Soften any harsh white areas with natural violet on a size 6 brush. Use this colour to dot in shadows on the snow from the fence posts.

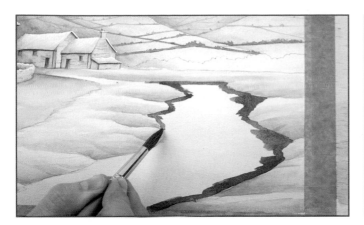

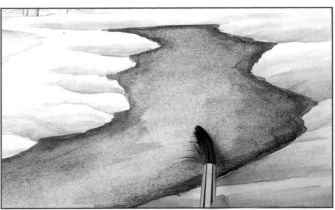

**45** Take up the size 10 brush with medium-strength natural grey. Lay in the grey around the edges of the river to give the impression of the depth of the water. This detail should be about 1cm (½in) wide; and should be painted neatly against the bank.

**46** Blend diluted natural brown out from the grey, towards the middle of the river. Finish off by blending in pale natural blue in the middle, with lots of water, and connect the colours together.

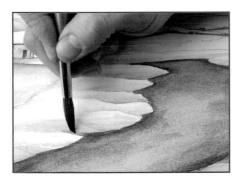

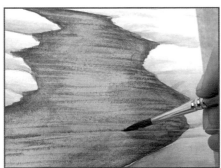

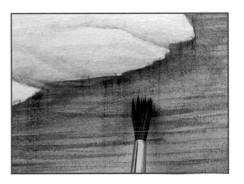

**47** Drag the colour out of the river area at each indent along the bank, on both sides, so that the colour overlaps the snow. This will help the water sit better in the painting, and give the impression of the river twisting in front of the rear cottages.

**48** Using the size 6 brush and natural grey, add some horizontal ripples into the water coming from the sides of the banks, while the background is still damp. Add in more fluid ripples; hold your brush loosely and rock it from side to side.

**49** Pinch the brush bristles open to splay them. Draw in vertical flick lines down from the bank on both sides of the river, to reinforce the depth of the water. Allow to dry.

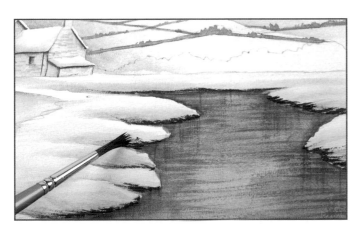

**50** Use a strong mix of natural grey and brown with a dry size 6 brush. Where the bank touches the water, paint in flicks of dark colour as appropriate. Then make flicks along the riverbanks, to suggest grasses emerging from the snow.

# Dry-brush technique with pinched bristles

*Pinching and splaying the bristles of your round brush into small spikes is another way of applying the dry-brush technique.*

*Using a damp brush, pick up some paint and dab off the excess on kitchen paper. Pinch the base of the hairs to splay them open. A good brush will retain this shape and allow you to skim lightly over the textured surface of your watercolour paper.*

*Try holding the brush at a low angle to make use of the flat side of the splayed brush.*

*You may find it useful to practise this technique first on scrap paper.*

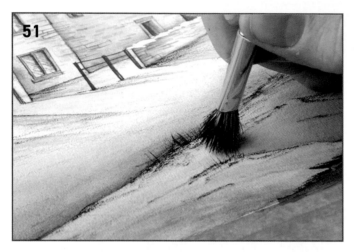

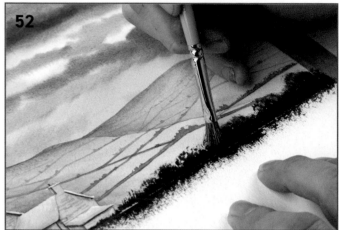

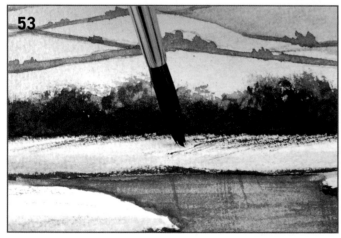

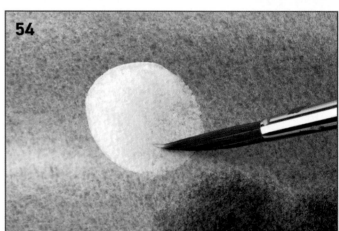

**51** Take up a strong natural grey-brown mix on the medium Tree & Texture brush; bend the bristles backwards, then flick them along the riverbank area to dot in the occasional blade of grass.

**52** Stipple in a hedgerow in the grey-brown mix across, and in front of, the distant cottages. Switch between the medium and small Tree & Texture brushes and use the straight edge of a piece of card as a guide.

**53** With a very dry size 6 brush, use a diagonal brushstroke to break up the hard bottom edge of the foremost hedgerow. Feel free to paint in some more individual blades of grass as you see fit.

**54** Mix a tiny amount of natural white with a dot of water and use the size 6 round brush to paint in the left edge of the moon. Clean and wipe off the brush, then blend the white until it disappears into the moon.

**55** With a sharp craft knife, reflect the moon in the river with horizontal scrapes. Make the scrapes wider as you move down the painting, using the point of the knife. Make little flicks in the hedgerow with the knife where the snow has settled: this takes the darkness away from the hedgerow area.

**56** Finally, scratch in a few diagonal lines over the large, illuminated windows in the foreground to give the impression of the moonlight catching the glass.

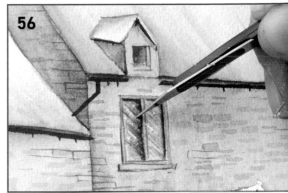

*The finished painting.*

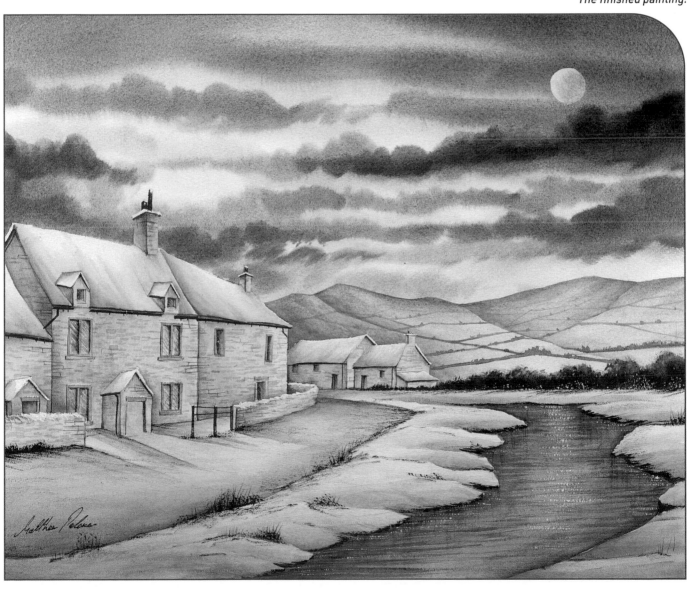

**A Moonlit Alpine Scene**

*38 x 50.8cm (15 x 20in) painted on 300gsm (140lb) Not surface watercolour paper.*

*You too can paint this wonderful, atmospheric landscape using the night sky technique on page 66, and a piece of kitchen paper to tap off excess light in the clouds. Use the snowy shadow techniques you have learnt in the Night-time Snow Scene project starting on page 132. Adding the tiny buildings gives a grand scale.*

**Ashness Bridge, Cumbria**

*50.8 x 38cm (20 x 15in) painted on 300gsm (140lb) Not surface
watercolour paper.*

*I have used a pale natural grey for the distant mountains to give
depth and a pale natural violet for the foreground snow shadows.*

# Waterfall in Summer

**Summer woodlands make fascinating subjects and the flowing waterfall provides a great focal point. Using a combination of Tree & Texture brushes and natural green pigments you can paint some wonderful foliage effects. Adding a rusty roof to the boathouse really makes the painting come alive. This scene is a variation of the painting on page 21.**

**Begin by dampening your masking brushes and protecting their bristles with household soap (see page 54).**

## You will need:

Outline 5

Watercolour paper: 300gsm (140lb) 100% cotton Not surface

Colours: natural yellow; natural blue; natural yellow light; natural green light; natural green; natural grey; natural brown; natural orange

Brushes: old, small and large brushes for masking; sizes 6, 10 and 20 round; small, large and extra-large Tree & Texture brushes; large lift-out brush or 6mm (¼in) flat brush; size 2 rigger

Other: pencil; masking tape; masking fluid; craft knife; small palette knife; plastic card; scrap paper

## Note

*If you do not have the Natural Collection paint colours listed above, see the colour comparison chart on page 36 for generic colours that can be used as suitable alternatives.*

**1** Transfer your outline (see pages 88–89) and secure your watercolour paper to the board on all four sides using masking tape. Switching between a large and a small masking brush, mask out the waterfall, the splashes at the base of the waterfall – these can be added using the masking fluid with the splattering technique (see pages 62–63) – and parts of the boathouse and the low outer wall as shown. Apply the masking fluid with precision and attention. Dot in a few flowers around the bases of the trees as well. Allow to dry.

**2** Wet the whole sheet of paper with the size 20 round brush. Keep your board tilted, and repeat this a couple of times to make sure the paper is saturated. Working wet into wet (see page 68), twist in dilute natural yellow, beginning in the centre of the sky area. Take the colour over the distant hills. Then add some of this dilute yellow in horizontal strokes to the water in the midground and foreground.

**3** With a clean brush, go over the same areas, with the same strokes, with pale natural blue to create the impression of clouds, laying your brush almost flat against the paper. As you reach the bottom of the sky area, let the colour blend with the yellow. Make a few horizontal strokes in the midground and foreground as before.

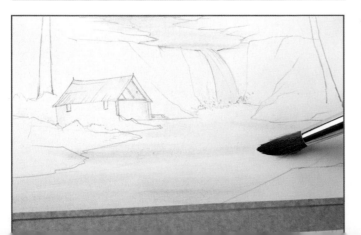

**4** Use natural yellow light on the size 20 brush to twist over the foreground trees on both banks. Don't worry if the yellow blends with the blue of the sky. Bring the colour all the way down the trees and behind the boathouse.

**5** While the paper is still damp, switch to the extra-large Tree & Texture brush and stipple in the foliage of both trees in natural green light. Make sure the coverage is solid behind the boathouse, as this will make the building stand out.

**6** Switching to dark natural green and keeping the colour strong on the Tree & Texture brush, stipple over the foliage while it is still wet. Darken the foliage more with a touch of natural grey mixed in with the natural green in the palette.

**7** Take up the grey-green mix on the large Tree & Texture brush, and tidy up the foliage behind the boathouse. Make gentler taps with the brush as you move up the foliage area to blend the colours. Repeat on the bottom of the right-hand tree.

**8** Use the plastic card to scrape out the forms of the trees amid the foliage. Switch to a small palette knife for finer branches. Ease off the pressure with both the card and the palette knife as you move upwards to make the branches look thinner. Make sure the foliage is still damp when you scrape out the trees.

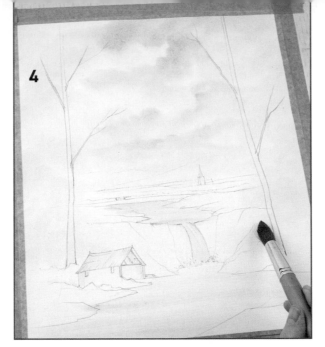

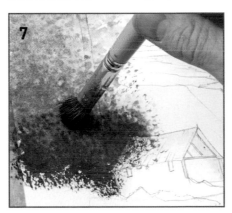

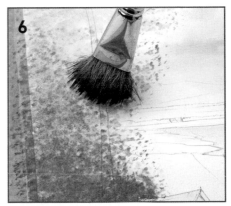

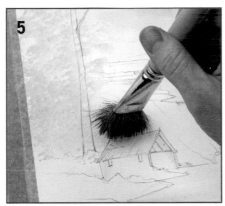

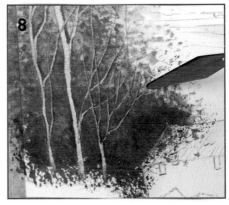

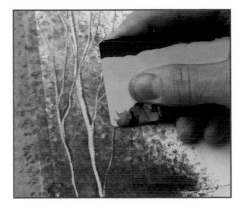

*Using a plastic card to scrape out the branches gives them definition.*

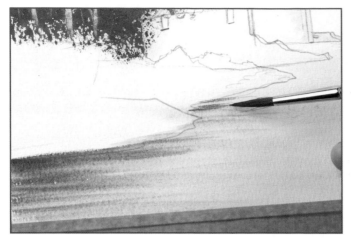

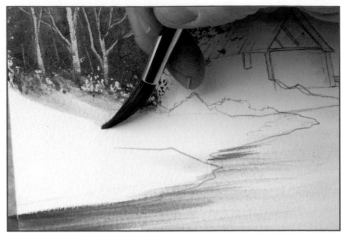

**9** While you have greens in your palette, add a few reflections in the lower water area. Wet the area first with the size 10 brush, then stroke in the reflections, starting with natural green light, in horizontal lines where the trees stand on both banks, coming away from the banks themselves. Go over the reflections on both sides of the water with the darker green, rotating your board if you need to.

**10** Soften the rough bases of the trees on both banks into the landscape with the clean, damp size 10 round brush. Work on a slight diagonal and make sure the brush is not too wet.

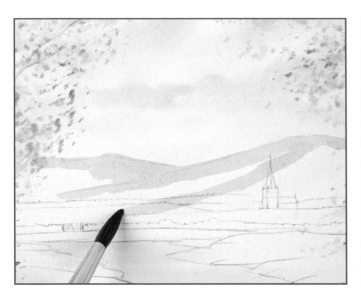

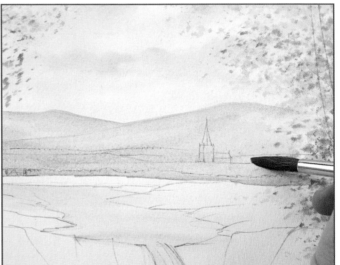

**11** Mix pale natural grey and natural green light, and outline the top line of the background hills with the size 10 round brush, overlapping the foliage slightly. Make the line quite broad and bring the lines down into the hillsides, stopping short of the gate.

**12** Change to a pale natural green on its own, and retrace your steps over the tops of the hills. Work this colour down towards the church – don't worry about overlapping it – then use pale natural yellow to add a slight difference in colour to the hills. Next, mix the two natural green shades to create a medium tone and work it down to the gate and the midground hedgerow. Work the colour back up until it blends and disappears into the hills.

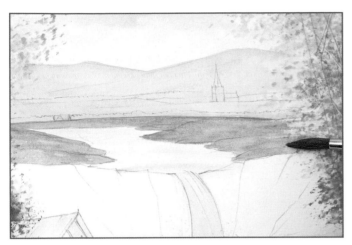

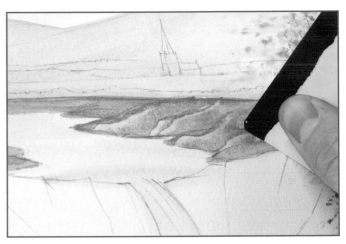

**13** Working just below the hedgerow, paint in the midground bank in the natural green-natural green light mix. Start from the rear and move forward, stopping short of the waterfall. Clean your brush, then use natural yellow with a tiny hint of natural brown to add variation to the colour. Work the yellow and brown into the green areas to ensure that there are no obvious, hard lines visible.

**14** Use the plastic card to scrape into the midground banks to shape them. Make sure the paint is still wet – reactivate it by dampening the area before applying the card. Start from the water's edge each time, and scrape upwards into the land.

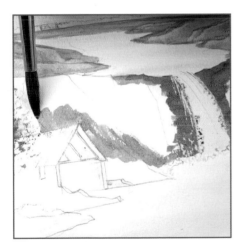

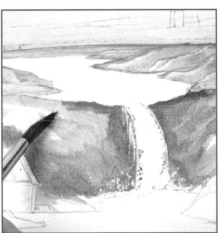

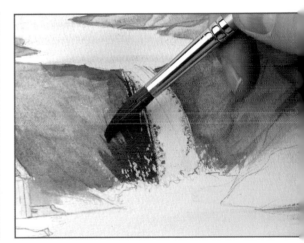

**15** Paint into the rocky area around the waterfall with natural brown on the size 10. Work on either side of the waterfall, making sure the colour goes right down to the splashes, around the waterfall and right up to the edge of the boathouse.

**16** Scribble in natural yellow over the brown so it blends. Then, as you move away from the water, introduce the natural green and fill the whole bank area.

**17** Make an earth-brown mix using natural grey and natural brown. On a fairly dry size 10 round brush, work around the bottom-left edge of the waterfall and a little on the bottom-right edge to create shadow and separation on both sides of the water.

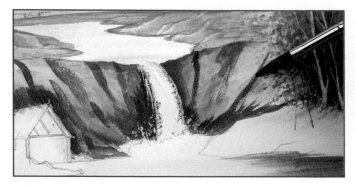

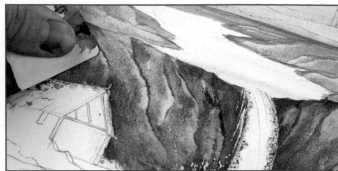

**18** Bring the earth-brown mix down over the top edges of the bank on either side of the waterfall, then with a clean damp brush, soften these shadows and separations.

**19** Using the plastic card, scrape down from the top edge of the banks of the waterfall a few lines to represent rocks. Work in opposite directions on either side of the bank: you can rotate your board if it feels more natural to do so. Allow to dry, then use a damp brush to soften any hard lines.

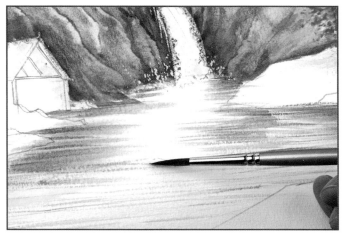

**20** With the size 10 round brush, rewet the water in front of the boathouse. Switch to the size 6 round brush and with the brown-grey mix used for the rocks, lay in the horizontal reflections of the rocks coming from both banks. Avoid the bottom of the waterfall.

**21** Lay in rippled reflections below the foreground tree trunks: make sure that the angle of the reflection matches the angle of the trunk itself (refer to the outline).

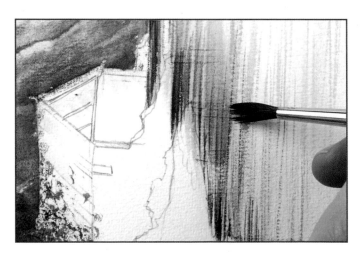

**22** Turn your board 90° anticlockwise. Splay the bristles of the size 10 round brush, then, using the same brown-grey mix, make downward vertical flicks away from the rocks on either side of the waterfall, applying minimal pressure. This will give a sense of depth to the water.

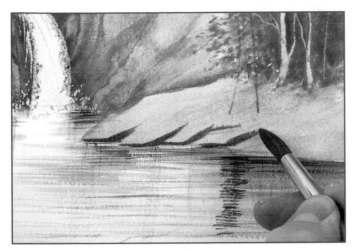

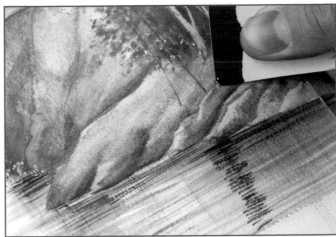

**23** Mix natural green with natural green light and develop the bank on the right-hand side. Go along the edge first, then bring the colour up towards the base of the rocks and the tree line. While the paint is still damp, fill in some divots along the water's edge with the earth-brown mix. Clean your brush, wipe off any excess moisture, then encourage the earth-brown mix up into the areas of green to reactivate the pigment.

**24** With the plastic card, scrape off the colour at the same diagonal as the dark divots, starting from the water's edge and working back into the tree line. Repeat steps 23 and 24 on the left-hand bank, once again working from the water's edge back into the land. Then fill in the area of land in the bottom-right corner of the scene with the green mix. Brush in some of the earth-brown mix, wet into wet (see page 68), to give the land texture, then scrape out the surface with the card.

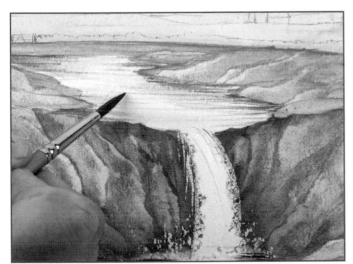

**25** Switch to the size 6 round brush and add in a few horizontal reflections in the natural green-natural green light mix at the top of the waterfall. Work the reflections in from the bank towards the centre, then use a small amount of the natural grey-natural brown (earth-brown) mix to add a few darker areas at the very edges of the water.

**26** Once the water area has dried, add some more splayed, dry-brush strokes in the brown-grey mix, coming from the farmost bank down towards the rocky area. It may help to rotate your board 90° anticlockwise and work horizontally.

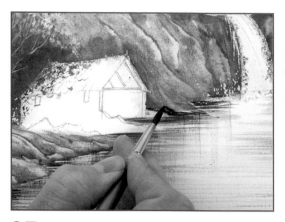

**27** Still working with the brown-grey mix on the size 6 round brush, add dark lines into the bank wherever it touches the water. Focus on the top of the waterfall to suggest the curve of the river as it moves off to the left of the scene, and the area behind the boathouse.

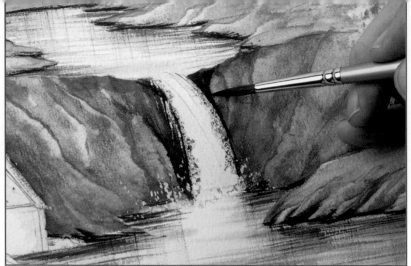

**28** Work in some shadows around the rocks and the waterfall itself. Add more grey to the mix, and create some darkness to the left of the waterfall to 'lift' the water away from the rocky area. Soften, then add shadows elsewhere into the rocks and banks as appropriate. Blend upwards.

**29** Remove the masking fluid from the waterfall and the boathouse. Next, use the large lift-out brush to soften the area at the top of the waterfall where it meets the river so there is no obvious join.

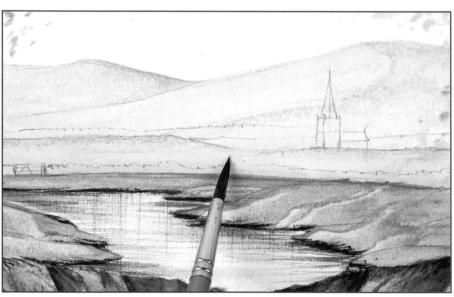

**30** Use pale natural grey on the size 6 brush to separate the distant hills, starting with a triangular shape that goes between the hills. With a clean brush, soften the shadows down to the left. Continue to separate the hills with shadows, moving down into the foreground. Mix natural green with the natural grey, keeping the colour light, and add shadows under the hedgerow. Add shadows in the same mix over the foreground bank.

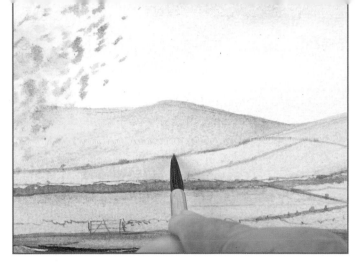

**31** Use natural green on its own on the size 6 round brush to add in some distant hedgerows, twisting the brush in places to represent individual trees and bushes here and there. Make the hedgerows disappear into the trees on both sides of the painting, and stop and start again on either side of the church. Keep the hedgerows finer as you work up into the hills, and allow the lines to follow the shapes of the hills.

**32** Load a small Tree & Texture brush with natural green and stipple in a midground hedgerow that leads to the gate. Work along the straight edge of a piece of scrap paper or card. Blend your stippling into the foliage of the trees on both sides of the painting. Put aside the scrap paper then use the same green on a size 6 round brush to tidy up the bottom edge of the hedgerow.

**33** Switch to a rigger and use the same natural green to put in some odd blades of grass on both riverbanks.

**34** Use the piece of scrap card and small Tree & Texture brush to add more foliage at the bottoms of the large trees, which are still to be painted in.

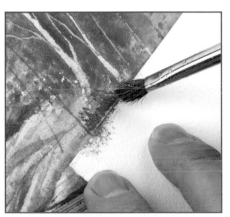

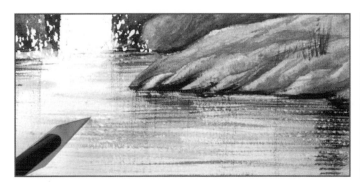

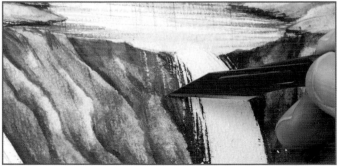

**35** Use the point of a sharp craft knife to add a few horizontal ripples of light in the water, focusing around the edges of the lower body of water first. This effect works well to suggest the reflection of the waterfall itself.

**36** Next, use the craft knife to lay in some vertical scratches at the top of the waterfall as it spills over the rocks.

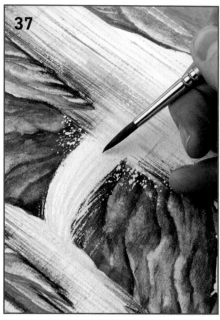

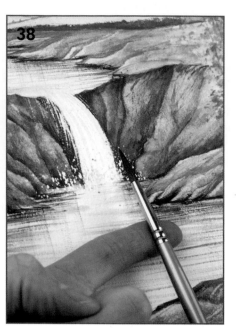

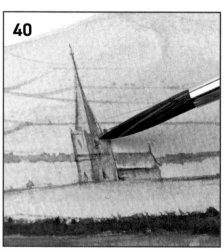

**37** Use the size 6 round brush with pale natural blue to add extra movement to the waterfall – rotate the board if you need to. Start from the top and follow the curve down. At the bottom, put in a few spots of blue to suggest the froth.

**38** Splatter the colour into the bottom of the waterfall as well, then stroke in a few horizontal lines at the top and bottom of the waterfall.

**39** Use the flat edge of a clean, damp large lift-out brush to wash out the shape of the church from the hillsides. Allow to dry, then with pale natural yellow on the size 6 brush, paint in the entire church, except for the roof. Allow to dry again.

**40** Using a fairly pale natural grey on the size 6 round brush, fill in the outlines of the church, then soften the shadows down to the right. Use the same grey to shade the roof of the church, and the point of the brush to fill in the fine details of the spire and the tower.

**41** Paint in the gate in the midground hedgerow in the same grey on the same brush.

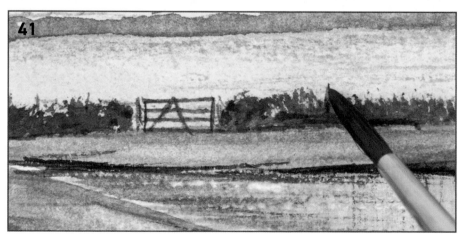

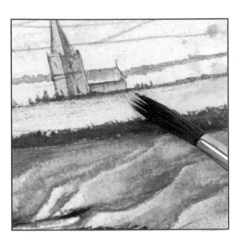

**42** Dot in a hedge across the front of the church in natural green, then sweep the same green down in front of the church using a fairly dry brush with its bristles splayed.

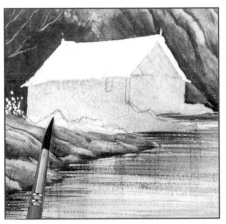

**43** Still working with the size 6 round brush, paint in the walls of the boathouse in the same pale natural yellow used on the church. Allow to dry.

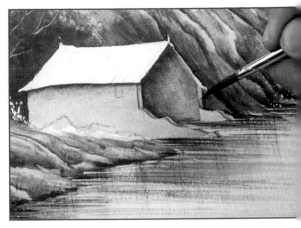

**44** Use natural grey on the inside of the boathouse, and soften the shadows downwards. Run a line of natural grey under the eaves, and define the edges of the front-facing walls in the same way.

**45** Using natural yellow on the large lift-out brush, or a 6mm (¼in) flat brush, embellish the stonework on the walls of the boathouse with tiny downward brushstrokes. Change to natural grey or pale natural brown for darker bricks, concentrating especially on the lower walls near the water's edge.

**46** Clean the lift-out brush, squeeze out any excess water but keep the tip damp, and lift out the beams and gables within the roof of the boathouse. Switch back to the size 6 round and with a natural grey-natural brown mix, paint in the dark edges of the gables, beams and eaves.

**47** Define and soften the shadows in between the gables. Paint in some hatched lines to suggest the texture of the inner roof. Then, with the same brown-grey mix, paint upside-down 'l' shapes into both windows, and soften the shadows down.

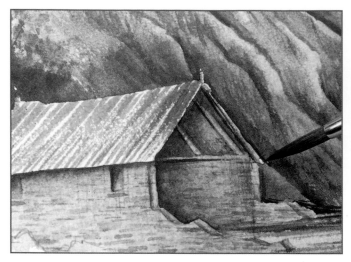

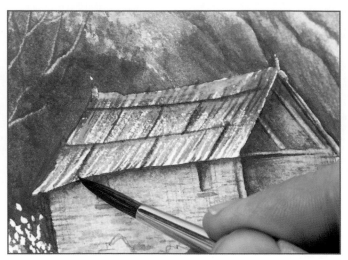

**48** Mix natural orange with natural brown. Using the size 6 brush or a size 2 rigger, fill in the sills of the two windows of the boathouse. Use the same mix on the size 6 to lay in the rusted, corrugated metal roof of the boathouse in diagonal strokes from the top edge down towards the eaves. Go over the orange-brown mix with natural brown on its own.

**49** Use the natural grey-natural brown mix from step 46 on the size 6 round brush to define the top edge of the roof. Then paint in two horizontal lines along the side of the roof, followed by staggered, diagonal marks, to suggest individual corrugated metal sheets. Feather the brown-grey lines up to the right.

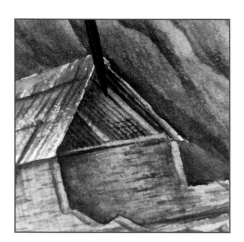

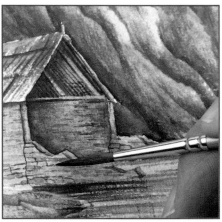

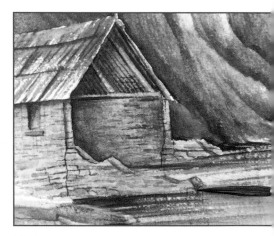

**50** Load a rigger with strong natural grey. On the underside of the corrugated roof, add some fine angled lines to indicate the shadows of the corrugations.

**51** Use the same grey to separate the low, broken walls of the boathouse from the main structure, and, following the shapes of the bricks, suggest cracks in the brickwork on both low walls.

**52** Still using the grey, run an upside-down 'l' shape under each of the sills of the windows. Then strengthen the colour at the very tips of the broken outer walls of the boathouse where they touch the water.

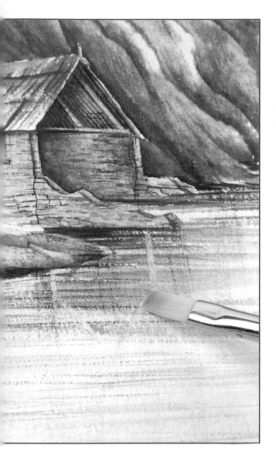

**53** Dampen the tip of the large lift-out brush. Working from the broken walls down into the foreground water, lift out the impressions of reflections from the boathouse. Follow the lines of the boathouse to describe the reflections underneath. Keep wiping the lifted-out areas with kitchen paper to remove the traces of paint. Lift off a little of the detail of the broken walls in front of the boathouse. At this stage you can also lift out the details of a fence running behind the boathouse on the left.

**54** Switch to the natural orange-natural brown mix from step 48. Using horizontal strokes on the size 6 brush that flick away to the left, reflect the roof of the boathouse in the water below the left-hand bank. Repeat with natural grey within the same area to reflect the inside of the roof.

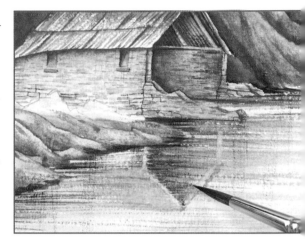

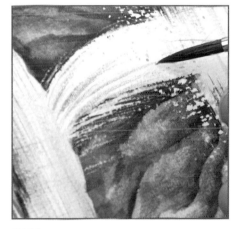

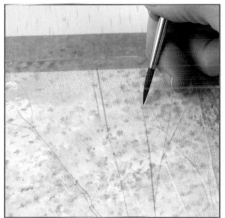

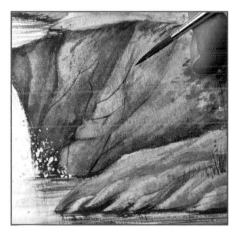

**55** Use natural grey to add extra movement into the waterfall, in very dry, loose strokes. The greatest concentration of paint should be over the top of the fall. Rotate your board if you need to.

**56** Add a couple of darker, incidental tree branches with the same grey into the foliage of the foreground trees.

**57** Strengthen the grey, and use the rigger to put in cracks, crevices and detail in the rocky bank behind – and around – the waterfall. Work from the water up, in the same way as you would lay in tree branches. Soften these details with natural green on the size 6 brush, kept quite dry.

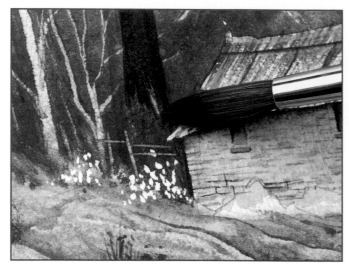

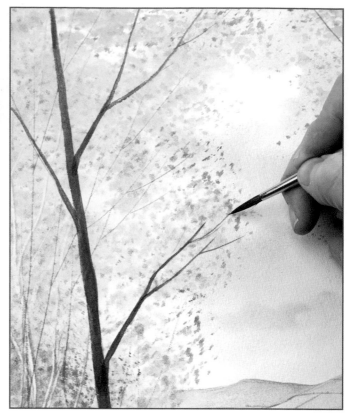

**58** You can now begin to lay in the foreground trees. Use the size 10 brush and a fairly pale mix of natural grey and natural brown for the trunks and branches. The tree on the left can begin partway up from the shadowed area behind the boathouse, and should be softened down.

**59** Switch to the size 6 brush for the finer branches.

**60** Give scale to the picture by adding in some rustic fence posts using a darkened trunk mix on a fine-tipped brush.

**61** Use the large lift-out brush to put in areas of light and texture on the tree trunks, focusing on the left side of the trunk where the light would be hitting. Follow the instructions on page 76 for guidance on using the lift-out brush to add highlights.

**62** Mix more natural green and natural green light. On the size 6 round brush, dot in a few loose leaves on the trees, going over the branches and the trunks and into the foliage areas. 'Dance' your brush over the paper to add individual leaves.

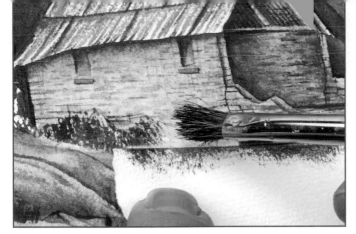

**63** Stipple in some greenery along the side of the boathouse with natural green on the small Tree & Texture brush, using scrap paper as a mask again. Alternate the angle of the scrap paper for interest. Next, brush in some looser strokes at the top of the foliage with the size 6 brush.

**64** Splatter in some darker (natural) green in the top corners of the painting to reinforce the foliage. Be careful not to overdo this effect at this stage.

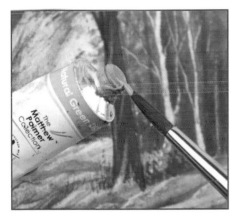

**65** With any left-over dark grey-brown trunk mix, paint in a few birds in the sky using the rigger.

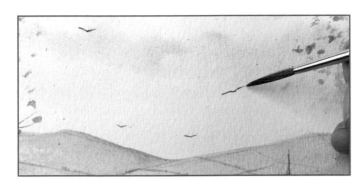

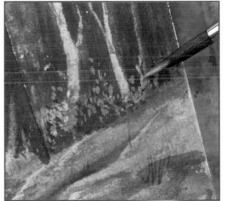

**66** Dampen the size 6 brush and take a thick blob of natural green light straight from the tube. In one or two areas in the foreground greenery, add some bright green light.

**67** Dot the bright green into the base of the trees on both sides of the water with the size 6 round brush.

**68** Finally, to complete the piece, lay in a few dark shadows on the right-hand edges of the trunks using the size 6 round brush loaded with natural grey. The finished painting can be seen overleaf.

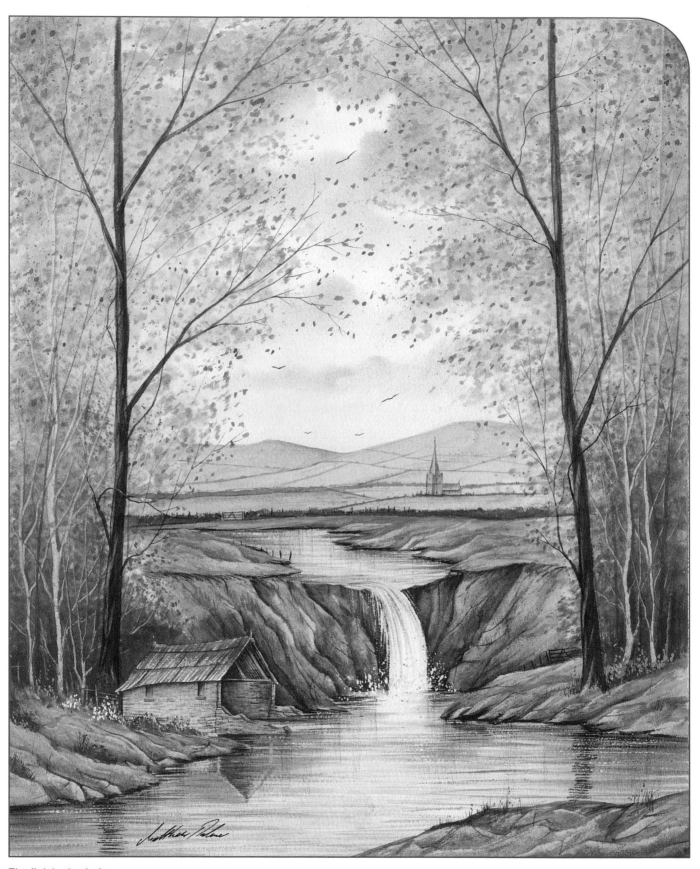

*The finished painting.*

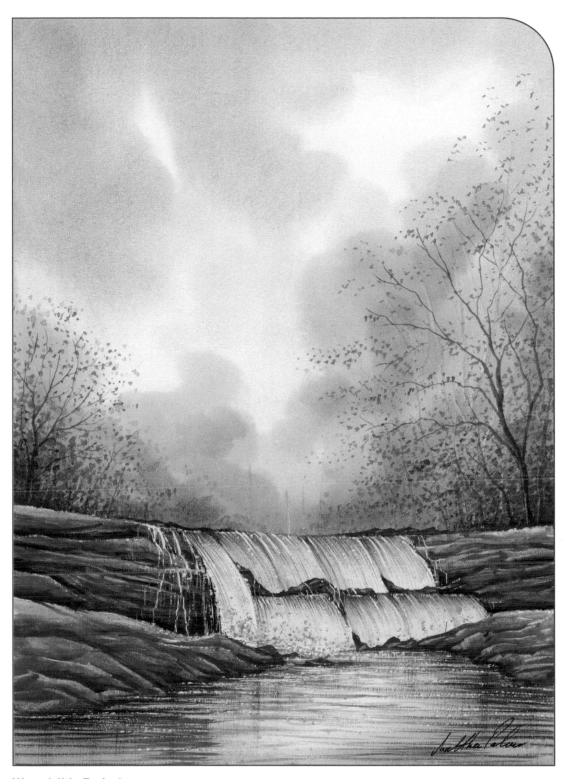

## Waterfall in Early Autumn

*This painting focuses on the waterfall and makes the flowing water the focal point. The trees, worked in wet into wet (see page 68), look as if they are receding into the distance. The strong contrast of dark shadows and vivid greens gives an atmospheric, warm evening light to the painting.*

*The shadows behind the waterfall show exactly how effective and important natural grey is. The depth created by this shade is amazing – as I always say, 'Don't be afraid of the dark'. Good, dark shadows are essential in watercolour painting.*

# Wildflower Meadow

A wildflower meadow is the epitome of 'idyllic'. This watercolour painting, capturing a soft evening glow, gives a real sense of warmth. The red of the sky and the red flowers balance the painting, while the track leading towards the cottage completes a wonderful composition.

Transfer your outline (see pages 88–89) and secure your watercolour paper to the board on all four sides using masking tape. When you trace in the distant trees on the left of the scene, do not make the pencil line too strong.

## You will need:

Outline 6

Watercolour paper: 300gsm (140lb) 100% cotton Not surface

Colours: natural red; natural blue; natural grey; natural green; natural green light; natural yellow; natural violet; natural brown; cadmium red; natural yellow light

Brushes: small, round brush for masking; sizes 6, 10 and 20 round; small, medium, large and extra-large Tree & Texture brushes; small lift-out brush or 3mm (⅛in) flat brush; large lift-out brush or 6mm (¼in) flat brush; size 2 rigger

Other: pencil; masking tape; masking fluid; kitchen paper; palette knife; table salt; craft knife; masking fluid remover (optional); hairdryer

## Note

*If you do not have the Natural Collection paint colours listed above, see the colour comparison chart on page 36 for generic colours that can be used as suitable alternatives.*

**1** With masking fluid, mask off the building and the surrounding wall. Use nice, broad lines especially on the rear left wall of the cottage below the eaves. Dot masking fluid into the meadow to represent light flowers. Make the flowers smaller as they recede towards the cottage, and concentrate the dots around the very edges of the track. Allow to dry, then mask off the top of the meadow on either side of the wall with two strips of masking tape – remove the stickiness first, then angle the tape on either side of the cottage to follow the angles of the meadow.

**2** Wet the entire sky area using a size 20 round brush and clean water, then lay in a pale natural red for the lower sky – this will complement the poppies. Dust the colour over the bottom of the sky, and over the roof of the cottage. Clean your brush and wipe off any excess. Working quickly, use natural blue, in a slightly thicker consistency than the red wash. Go across the paper using the whole brush, and work down. Keep replenishing the paint and blend the blue with the red. Keep the blue moving down past the red, and blend so that no hard lines appear in the sky.

**3** Scrunch up a tiny piece of kitchen paper. Use the paper to lift out some small clouds at the top of the sky (in the blue area). Make tiny twists with the kitchen paper, almost in the manner of a Chinese Dragon dancing. Replace the scrunched-up paper with a clean piece every so often.

**4** Use a pinched piece of kitchen paper and soften down any hard lines with gentle strokes so they disappear into the blue. Allow the sky to dry thoroughly: use a hairdryer if necessary.

**5** Use the size 20 brush to rewet the whole sky area. Then with natural grey on a size 6 round brush, add some silhouetted clouds against the pink sky. Make little twists with your brush to create the clouds, and work in horizontal rows. Make the clouds thinner as you move down the paper. Soften the bottoms of the clouds with a clean, wet brush to remove any hard lines.

**6** Pick up the large Tree & Texture brush. Stipple a mix of natural green and natural green light gently along the top edge of the masking tape to give the impression of trees on the left of the cottage. Switch to the medium Tree & Texture brush on the right-hand side. Avoid overlapping the wall or the cottage with the green. Try to capture the shapes of the trees, and feel free to use the medium brush on the left-hand side as well for added detail and shape.

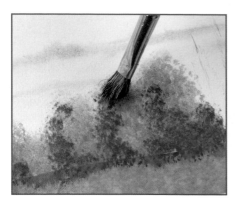

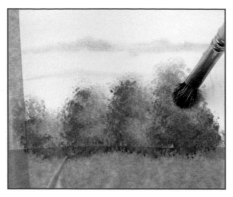

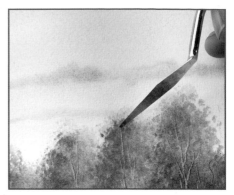

**7** With a strong natural green, add darkness to the bottoms and shadow sides of the trees, wet into wet (see page 68) – imagine that the light is coming from the right of the scene. Apply these shadows to the trees on both sides of the cottage.

**8** Tap over the dark areas so they soften into the lighter areas of the trees.

**9** Using a palette knife, scrape out the forms of branches and trunks within the tree foliage.

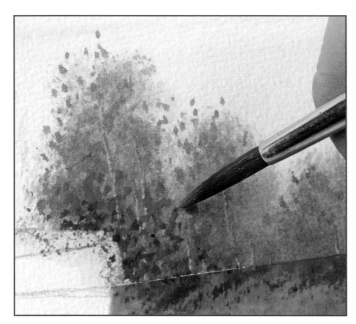

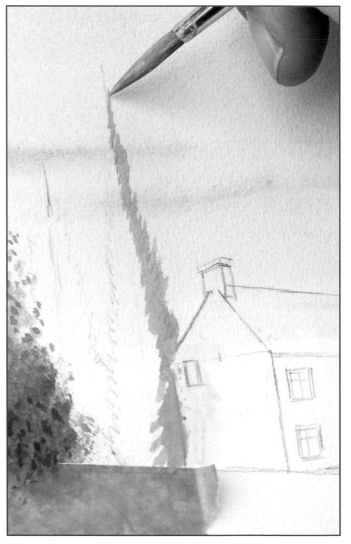

**10** In the same dark (natural) green, spot in extra leaves around the trees, concentrating on the tops of the crowns. Do the same at the bottoms of the trees to give them extra depth, especially on the taller trees.

**11** Paint in the light sides of the three tallest trees on both sides of the cottage in strong natural green light, keeping a tiny bit of water in your palette to dilute the green. Flick the brush outwards on a diagonal, working upwards.

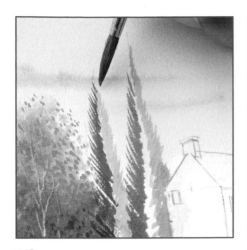

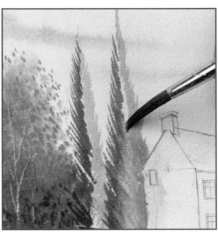

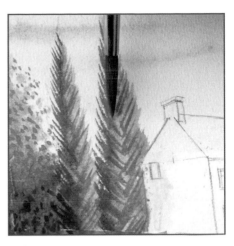

**12** Use strong natural green to paint in the shadowed sides of the three tall trees. Work the diagonals upwards in the opposite direction from those on the right-hand side of each tree.

**13** Clean your brush, then soften the two greens together using a diagonal scribble movement. Keep refreshing your brush with water, tapping off any excess as you do so.

**14** Using a mix of the two greens on a slightly dry brush, add some additional diagonal strokes on both sides of each tall tree. Add in a few extra spots at the tops of the tree, then some darker details at the bottoms of the trees, using dry-brush flicks in both directions.

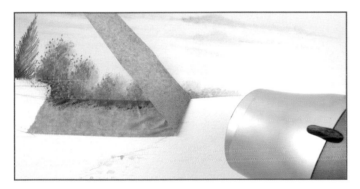

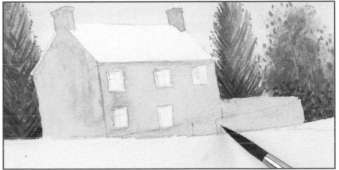

**15** Remove the masking tape by applying heat with a hairdryer – this will reduce the risk of the tape ripping. Then use your finger to remove the masking fluid from the cottage and the wall (but not the flowers).

**16** With pale natural yellow on the size 6 brush, paint the walls of the cottage, its surrounding wall and the two chimneys. Leave the windows and doorway clear. Feel free to add a hint of natural red to the yellow to add variation to the stonework.

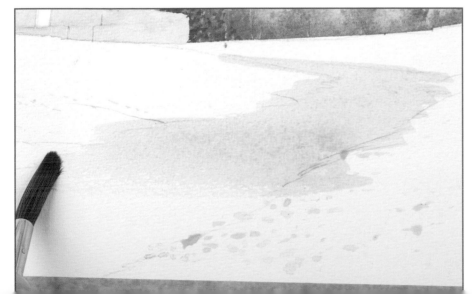

**17** Switch to the size 10 round brush. Still using the pale natural yellow, paint in a very loose wet-on-dry wash over the track leading up to the cottage.

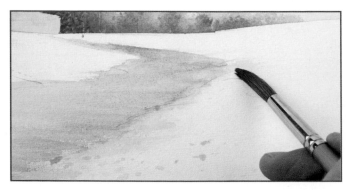

**18** Working quickly, wet into wet (see page 68), darken the track with natural grey as it curves, using horizontal strokes. As you move towards the foreground, focus the strokes on the right-hand side of the track to suggest cast shadows. With a clean brush, soften the edges of the track into the meadow. Allow to dry.

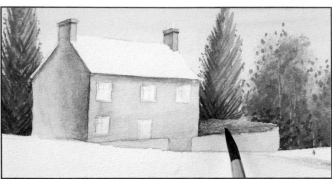

**19** Take up the size 6 brush with the natural grey, and add shadows to the cottage and its walls, including the eaves and underneath the ridges of the chimneys. Feather these shadows down to the right in each instance. Make sure the shadow on the far-left chimney comes straight down into the left-hand wall of the cottage. Begin the shadow on the curved wall on the right as an 'l' shape and soften this shadow upwards.

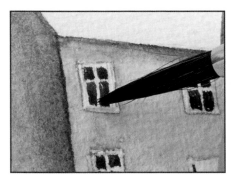

**20** Use a strong natural grey to paint in the dark windows. If you feel the size 6 is too large, change to a size 2 rigger. The windows can be shown as four dark panes within a white frame.

**21** Paint in the doorway in the same dark grey by laying in an upside-down 'l' shape along the left and top edges of the doorway, then softening the colour down.

**22** Use a similar technique to mark in a window on the side wall of the cottage, then paint in its panes.

**23** To create the impression of a slate roof, mix a fairly strong 50:50 mix of natural grey and natural violet and paint the left-hand edge of the roof with the size 6 brush. Run the colour down along the edge of the gable, across the roof and up the right-hand edge in a fairly wide line (a couple of brushstrokes wide). Leave a thin white line to give a separation between the roof and the eaves. Work carefully around the bases of the chimneys.

**24** Fill in the roof to about halfway up with the slate mix of natural grey and natural violet. Then, with a clean brush wiped on kitchen paper, pull the colour up to the top of the roof to give it a lighter effect, making sure the line along the top edge is clean. Paint a very thin line down the back-left side of the roof – a rigger may be better for this. The chimneypots can also be painted in the same colour.

**25** Add a thin line, in the slate mix of natural grey and natural violet, under the eaves to suggest guttering. Next add a few horizontal lines along the roof to give the impression of slates.

**26** Dilute the slate mix slightly, and use it to add lintels and sills above the windows, and a lintel above the door. Then add a shadow to the left edge of the curved wall.

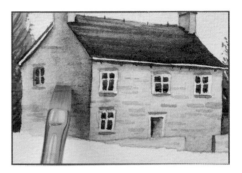

**27** Using the large lift-out brush or a 6mm (¼in) flat brush, add some bricks in natural yellow or pale natural grey on the walls of the cottage, and the low wall in front of the cottage.

## Tip

*To lay in smaller bricks at step 27, change to the small lift-out brush, or a 3mm (⅛in) square or flat brush. Use the smaller brush on the chimneys and make tiny brushstrokes to dot in the bricks.*

**28** Change to the small lift-out brush to add bricks on the top edge of the peripheral wall on a diagonal to give the impression of coping stones.

**29** In the same mix, go back over the lintels of the windows with the size 6 brush, then define the frames along the top, left and bottom edges.

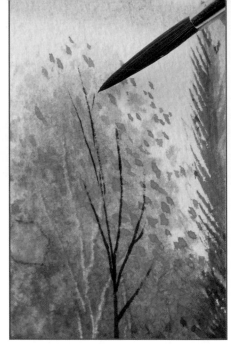

**30** Darken the grey-violet mix again, and with the size 6 brush fill in the gate, and put in a few lines of separation between the coping stones on the top edge of the peripheral wall.

**31** Switch to a size 2 rigger, and using a mix of natural brown and natural grey put in a few branches in the distant trees to sit alongside the branches you scratched out using the palette knife (see step 9, page 164).

## Colour changes

From time to time it is good to introduce different colours into your palette: for this project, we are introducing cadmium red for the poppies in the meadow.

**32** Take up the size 20 round brush. Lay a mix of natural green light with a small amount of natural green into the meadow area, working on one side of the track at a time. Start at the base of the cottage, leaving a thin, white line under the tree line and drag the colour back up into the scene to keep it light.

**33** Load the extra-large Tree & Texture brush with cadmium red. Using extremely light taps, dot in this red for the poppies, starting halfway down the meadow.

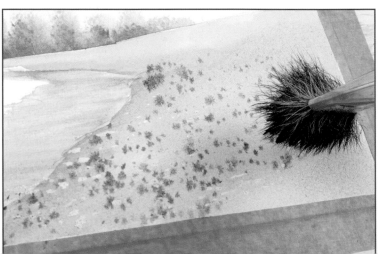

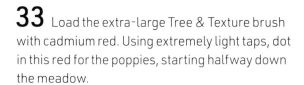

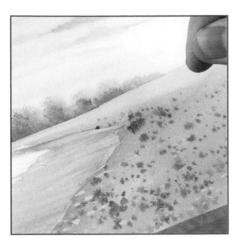

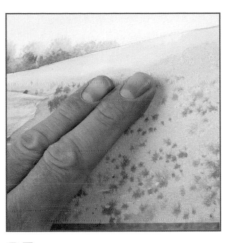

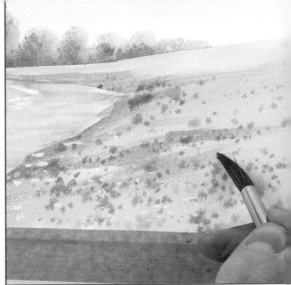

**34** While the paint is still wet, sprinkle a tiny amount of salt, from between two fingers, into the meadow, moving your hand around as you do so. Then repeat steps 33 and 34 on the left-hand side of the track. Allow the paint to dry naturally to allow the salt to absorb and give the most effective textural results.

**35** Once the paint has dried, very gently brush away the salt grains from the paper with your hand.

**36** Take up the size 10 round brush: with a pale mix of the two natural greens, sweep in around the edge of the track and up into the meadow, following the contour of the slight hill as it goes up. This will give shape and add texture to this area.

**37** Sweep the brushstrokes diagonally downwards from the top edge of the meadow to reinforce the shapes of the low hills. Keep your brush moving fairly quickly. Repeat steps 36 and 37 on the left of the track: run the colour to the left from the track backwards.

**38** Using the size 6 brush and a mix of natural green light and natural green, work around the edges of the path in a dry-brush style to give a natural edge to the track. These can be almost horizontal lines that bleed into the picture.

**39** Lay in some of these darker lines from the bases of the trees on the left side of the painting to add direction – keep your brush fairly dry and sweep down towards 'four o'clock'. Repeat this on the right-hand side of the track, then allow to dry.

**40** Using the large Tree & Texture brush, mix a new green from the natural green and natural green light. Stipple the texture brush in the palette then spot the brush lightly across the foreground, on both sides of the meadow.

**41** Dilute the colour, tap off any excess water then make some lighter stipples moving towards the back of the meadow.

**42** Rotate your board 90° anticlockwise, switch to the size 6 round and with natural green, add some splatters into the foreground. Mask off any areas you don't want to cover with the green, including the sky, using kitchen paper.

**43** Using the medium Tree & Texture brush, add some tall grasses to the foreground edges of the meadow. Mix strong natural green with a tiny bit of natural green light, and stipple in the palette. Flick the colour upwards along the edge of the path for a textured grass effect.

## Tip
*Splatter in any other colours you feel would enhance a wildflower meadow, such as natural violet and natural yellow light on the size 10 brush, keeping the colour strong.*

**44** Use dark green (natural green) on the size 2 rigger to lay in some more definite tall grasses in the foreground. Add some tiny green dots at the tops of the grasses for extra detail.

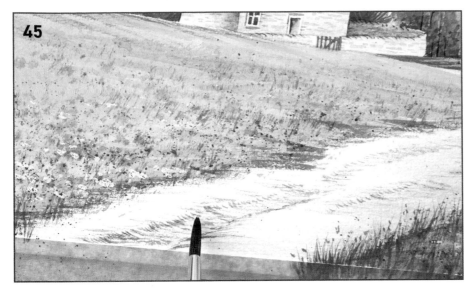

**45** Using the size 6 round brush with a mix of natural brown and natural grey, add some texture with a very dry brush along the track, to give the impression of tyre tracks sweeping around the bend. These can be a series of horizontal lines that are larger towards the foreground. Add a downward diagonal stroke to the left here and there for a raised effect along the track. Add some concave strokes to reinforce the indents of the tyre tracks, but keep your strokes light and timid.

**46** With the natural grey only on the brush, splay the bristles and add a few horizontal lines out to either side of the tyre tracks.

**47** To finish off the track, turn your board back on its side, protect the meadow areas on either side of the track, and put in more splatters with the dark brown-grey mix from step 45.

**48** Using a craft knife, scrape off some horizontal lines down the middle of the tracks to create some puddle effects – more so in the foreground. Scrape a few little flicks from the meadow areas with the knife to suggest white flowers.

**49** Once everything is dry, remove the masking fluid from the flowers.

**50** With a clean, damp size 6 round brush, glaze over some of the white masking fluid areas to soften any hard lines and settle the flowers into the picture.

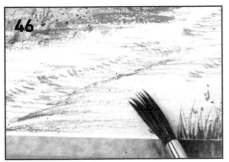

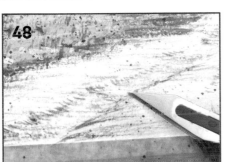

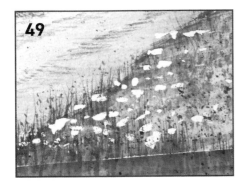

171

  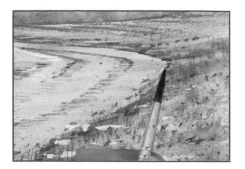

**51** Use the size 6 round brush and cadmium red to add in a few more poppies over the edges of the track where the grasses are, and sporadically over the meadow. Make the red stronger wherever you feel it is necessary.

**52** Change to the size 2 rigger and use the brown-grey mix in the foreground on the left of the track to add a dark, broken line around the area where the track meets the meadow. Put in a few dots at random along the tyre tracks.

**53** On the right-hand side of the meadow, where the track sweeps off towards the cottage, use the same dark, broken line to bring some clarity to the edge of the track.

 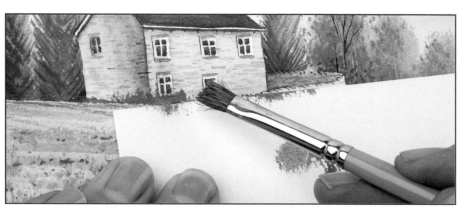

**54** Add some birds in the sky on the right-hand side of the meadow in the same mix. You are nearly ready to add the final touches to your painting.

**55** Stipple in some more foliage, working back up to the background trees and the cottage. Use the straight edge of a piece of card and paper as a mask, and, using the longer bristles of the small Tree & Texture brush for finer details, stipple in a mix of light and dark green along the side and the front wall of the cottage. Take the foliage all the way back across towards the background trees to embed the cottage into the picture, then over the peripheral wall.

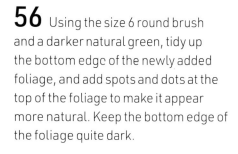

**56** Using the size 6 round brush and a darker natural green, tidy up the bottom edge of the newly added foliage, and add spots and dots at the top of the foliage to make it appear more natural. Keep the bottom edge of the foliage quite dark.

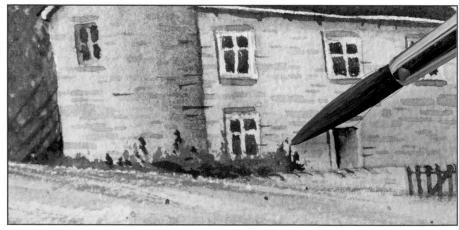

**57** Mix natural grey with dark natural green and darken the bottom of the tree closest to the back of the cottage, where it sits level with the wall. Create the shadow in a back-to-front 'l' shape to help bring the cottage forward in the painting, and flick the paint in the direction of the tree foliage.

**58** Repeat for the tall tree on the right of the cottage, then fill in darker foliage areas wherever you feel they are needed – to the right of the wall, for example. Use the same dark green to put in a few spots and dots at the base of the wall to represent foliage that is creeping up the wall.

**59** This is a good time to ensure that the track tapers off to a nice point as it runs around the back of the meadow on the left.

**60** Finally, use the mix of two greens to put a few more little spots of foliage around the distant trees, working over the tops of the dark branches and anywhere you feel needs more leaves. This helps the branches become part of the background foliage. Trace over the branches and trunks to reinforce them. The finished painting can be seen overleaf.

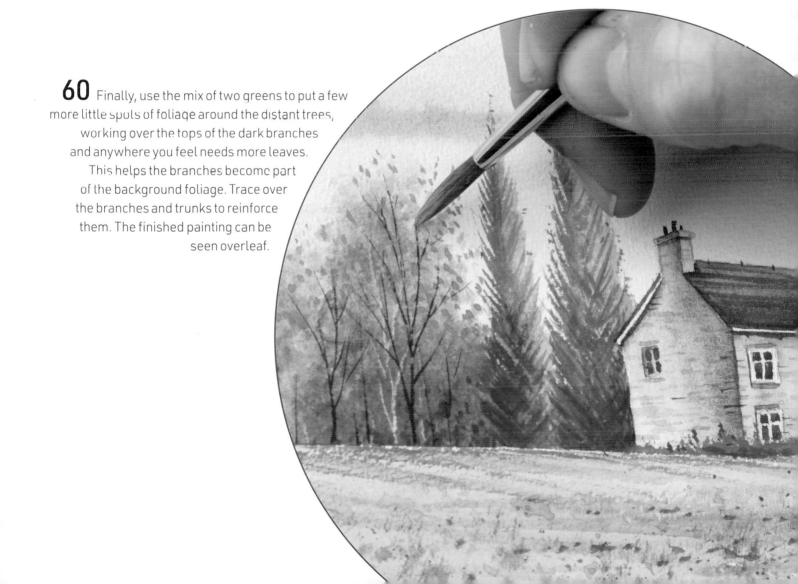

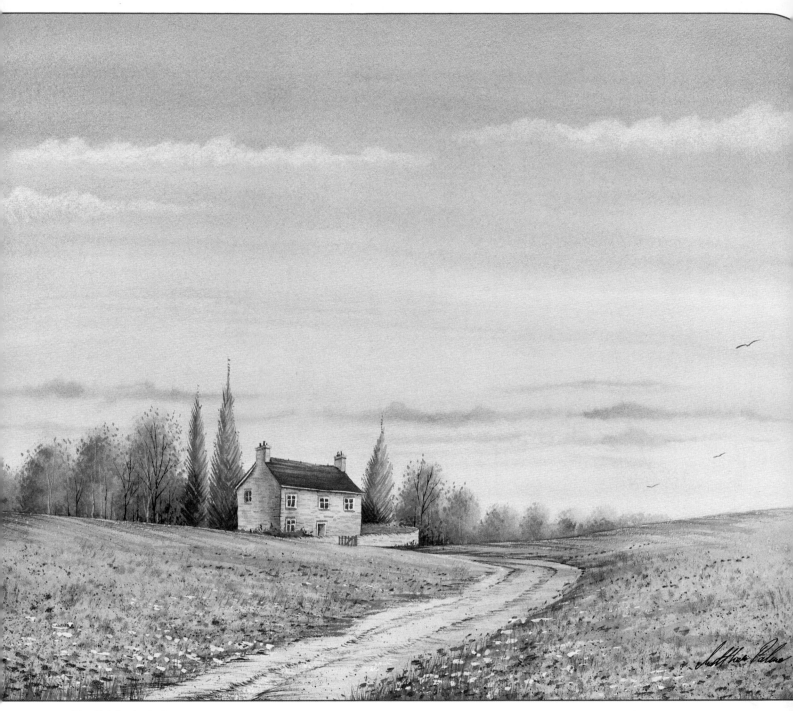

*The finished painting.*

## Thatched Cottage and Garden

*38 x 50.8cm (15 x 20in) painted on 300gsm (140lb) Not surface watercolour paper.*

*Using similar techniques to the Wildflower Meadow project, I created this cottage and garden in a vignette style. This is simply not painting all the way to the edge. It makes a very pleasing watercolour style. Look closely at the flowers and you'll notice they are painted in a series of 'dots' – hundreds of quickly painted spots – that make a beautiful effect of random flowers. Masking fluid was used to protect the cottage from the drier background, to give clean edges (see page 54).*

# Index